Reading into Photography

READING INTO PHOTOGRAPHY
Selected Essays, 1959–1980

Edited by Thomas F. Barrow,
Shelley Armitage,
and William E. Tydeman

University of New Mexico Press
Albuquerque

Library of Congress Cataloging in Publication Data
Main entry under title:

Reading into photography.

Includes bibliographical references.
1. Photography, Artistic—History and criticism—
Addresses, essays, lectures. I. Barrow, Thomas F.
II. Armitage, Shelley, 1947– III. Tydeman,
William E., 1942–
TR642.R4 1982 770 81-52051
ISBN 0–8263–0597–0
ISBN 0–8263–0647–0 (pbk.)

International Standard Book Number (clothbound) 0–8263–0597–0.
International Standard Book Number (paperbound) 0–8263–0647–0.
Library of Congress Catalog Card Number 81–52051.
First edition

This project is supported by a grant from the
National Endowment for the Arts.

Contents

Contents

Preface

During the last decade it has become increasingly apparent to me that despite a vast increase in the quantity of writing on photography, there has not been a corresponding increase in the quality of thought about photography. When a piece of some distinction appeared, one that dealt with ideas, asked provocative questions of the medium or the artist, or simply described a problem with some elegance, it seemed almost a gift, and I saved it for some future use. Assisting Nathan Lyons with the production of his anthology *Photographers on Photography* made me appreciate the utility of a compilation of essays from unfamiliar and out of print sources. An anthology of these relatively recent articles seemed to be useful and desirable, and I began to discuss it with my colleagues. Many people listened patiently to the ideas that the anthology might include: Van Deren Coke was one of the first to hear of it and hence the longest suffering; Nicolai Cikovsky, Jr., offered skeptical queries that led to significant revision; Christopher Burnett shared his discovery of Owen Barfield; and Gus Blaisdell and Beth Hadas gave all-encompassing support at every phase of development and subsequent production. However, none of the ideas were pursued with any discipline until Shelley Armitage and William Tydeman re-

sponded strongly to the material and asked if they might present it to the University of New Mexico Press.

Many familiar critics of photography have not been included in this anthology for the simple reason that their very popularity has made them accessible. A significant number of the essayists selected are practicing artists. This, of course, reflects in photography a tradition that is common in the visual arts. Artist-writers such as Marsden Hartley, Fairfield Porter, and Robert Motherwell come readily to mind as examples of excellence in this genre. The pieces themselves, with some minor displacements, are arranged in chronological order of their publication. As indicated above, grounds for selection were various, but intelligence, provocativeness, and freshness of approach were outstanding among the criteria. The early pieces by John Szarkowski and Nathan Lyons serve as examples of their important contributions at a time when the literate discussion of photography was virtually unknown. The more recent selections are a testament to their early concerns and simultaneously give evidence of the proliferation of scholarly tools now used to pry meaning from photographs.

The variety of excellent material published since 1975 is an indication of the changing status of photography, an indication, too, of what has contributed to these changes. An increased interest in the collecting of images for their own value and an accompanying increase in monetary values, the generous support of exhibitions and publications by the National Endowment for the Arts, and the increasing scholarly attention to how photography has permeated virtually every aspect of twentieth-century culture have all caused thoughtful individuals from various disciplines to analyze a vast, often confusing medium—a medium that, despite its comparatively recent invention, is inextricably bound with the phenomena of contemporary life.

THOMAS F. BARROW

Introduction

In most areas of intellectual inquiry photographic meaning remains a paradox. The medium has been embraced by art, analyzed by cultural historians, and viewed by most other disciplines as supplemental and illustrative; its nature has been the subject of persistent debate. The compelling effect of photographic images has resulted in a critical literature to explain the hypnotic fascination of photographs and at the same time to justify the medium's claim to a position in the art pantheon. Yet, as this anthology suggests, photographic criticism has reached a level of maturity that enables the critic to move beyond the narrow limits of the nature of the photograph and concentrate on the photographic work itself.

Photography has always been more than art, a fact which continues to confuse the debate. The photograph's very status as mechanically generated fact makes it difficult to understand a medium that can be art and artifact simultaneously. The photograph as a cultural product has been so ubiquitous as to deny serious consideration as an art form. Gary Metz notes that "the serious photographer must work with a medium of ordinary and practical use, a medium where familiar objects are generally recorded; a medium having traditional formats of use from the family album to the slickest billboard adver-

tisement; a medium which many people practice and can thereby claim some knowledge of. Paradoxically, the serious photographer must use such related 'familiar' photographic phenomena for the explication and expression of an intensely personal sensibility in a social context where photography has statistically, as if by accident, become a pervasive ingredient for our collective experience."[1] What Metz says is by no means new; yet little analysis has been applied to the connection between photography as collective experience and its consequences for photographic criticism.

The resolution of the critical paradox lies in the peculiar position the photograph occupies in American culture and in the polarities expressed in the terms *art* and *artifact*. The photograph can be a work of art and simultaneously an artifact of popular tradition, and it is on this theoretical axis that the debate on photographic criticism revolves. Many of the current generation of critics have been attracted to writing about photographs as much for their cultural properties, their ability to depict society, as for their inherent characteristics. The writer and critic Susan Sontag was briefly attracted to the medium as the best way to understand the debilitating influences of modernism on contemporary American society. Popular critic A. D. Coleman is fascinated by photography's ability to mirror social realities. Writers from disciplines as diverse as anthropology and literature have demonstrated an interest in the photograph as cultural artifact—as an expression of the values of the larger culture.

It is possible, of course, to argue that the failure of photographic criticism is the failure of its critics and thinkers. Henry Holmes Smith argues that photographic scholarship has been generally disappointing and "it won't be corrected until fine minds get into the field, not just careerists. . . . You need people with sensibilities and intellectual rigor and we just haven't attracted many."[2] But if the situation was once this bleak, it is certainly less so now. Over the last decade Sontag, Owen Barfield, William Gass, and other literary critics and philosophers have turned their critical attention to the nature of photographic meaning.

A more direct explanation for the current interest in photography is the medium's role as a link to the past. Industrial civilizations' tendency to render a past obsolete has created an ideal set of circumstances for the flourishing of interest in the historical photograph. Coffee-table "photo-histories" abound. There seems to be no end to

the public appetite for measuring the vanished past against the present. The often used photographic terminology of time frames, mirror with a memory, image freezing, and the like all suggest the relationship among photography, nostalgia, and the past. Our desire to find continuity in civilization is best fulfilled by the evidence we find in photographs.

The widespread dissemination of historical photography and its relatively rapid acceptance by the public have had enormous consequences in the criticism of photography. The trend has led critics to an emphasis on simplistic realism. It has limited the recognition of conceptual traditions, and consequently has produced an almost complete denial of photography as a vehicle for the expression of ideas. Few critics have understood V. F. Perkins' point that photography has no distinct essence which can be used to justify their critical standards. "We do not deduce the standards relevant to Rembrandt from the essence of paint; nor does the nature of words impose a method of judging ballads and novels. Standards of judgment cannot be appropriate to a medium as such but only to particular ways of exploiting its opportunities."[3] If more critics had been willing to embrace this stance, realism would not have become the burden of photography and criticism would not suffer from such simplicity.

Even when we grant the necessity of the straight and documentary traditions, it is significant that scholars who use the photograph as evidence continue to use it in ways which violate canons of scholarship. Historians, whose methods depend on the reliability of the document, never raise the questions about the authenticity or reliability of the photograph that they raise of the written document. One measure of the immaturity of photographic scholarship is that we have had no analysis of realism in photography comparable to the analysis of realism in painting. As Neil Walsh Allen and Joel Snyder indicate in their article in this volume, assumptions about truth and realism are hopelessly naive.

The lack of a sophisticated methodology for analyzing photographic intent has inhibited the critics and historians in their search to find in the photograph some expression of cultural values or to uncover hidden social realities. As Carl Schorske notes, "The weaker the social consciousness of its creator, the greater need for specialized internal analysis on the part of the social-historical interpreter."[4] Much of the evidence the photographic document offers cultural histori-

ans since the late nineteenth century is of the anonymous snapshot variety. The carefully detailed analysis of creative intent to which Schorske refers has to this point been utterly missing in the analysis of photographs. Of course, John Szarkowski has given us his now famous list of photographic properties in *The Photographer's Eye*, but until we know a great deal more about the photographic conventions of a given period, the accepted formulas for posing, composition, and the like, most reconstructions of social meanings are nothing more than imaginative juxtapositions.[5] Few scholars and critics have followed the lead of Estelle Jussim or Neil Harris in emphasizing the effects emerging photographic technologies had on the kind of information presented to the general public.

These observations are not meant to excoriate any one discipline for its methodological sins. The entire field of cultural history suffers from an array of such problems. Indeed, it may be that such investigations should be modeled on the kind of close analysis of related phenomena that Carl Schorske undertakes in *Fin-De-Siècle Vienna*. In the final essay in this volume, Andy Grundberg notes several identifiable schools of photographic criticism. Yet all these areas lack the scope Schorske's work exhibits. Each exists almost in a vacuum, with little attention directed to the useful insights of other disciplines. Why is it that photography critics fail to utilize insights from literary criticism, for example? Clement Greenberg is one of the few to recognize this connection when he asserts that the art of photography is literary art

before it is anything else; its triumphs and monuments are historical, anecdotal, reportorial, observational before they are purely pictorial. The photograph has a story to tell if it is to be a work of art. And it is in choosing and accosting this story, or subject, that the artist-photographer makes the decisions crucial to this art. Everything else—the pictorial values and plastic values, the composition and its accents—will more or less derive from these decisions.[6]

If photographic critics could derive new insights by striving toward interdisciplinary criticism, their efforts still would be undermined by a lack of bibliographic apparatus. All mature scholarly and critical disciplines depend on access to current and historic literature for comprehensive indexing and abstracting tools. Indexes and bibliographies provide complete coverage, for example, of art scholarship in America and abroad. In contrast, the photographic critic or

historian works with very few aids amid a bibliographic wasteland where each piece of research or writing uncovers new information reported nowhere else. Though the situation is improving, it still is lamentable; and it seems unlikely that photographic criticism will reach maturity until it attains bibliographic comprehensiveness. One of the great challenges of the 1980s will be to develop an indexing and abstracting apparatus that can achieve comprehensive coverage while expanding the descriptions of individual holdings to include the vast numbers of photographic collections that exist in the United States.

The preponderance of images buried in collections—many of them uncatalogued and unexamined—underscores another problem in photographic criticism: the difficulty of examining the work firsthand. Much current photographic criticism leaves the impression that the original photographs have not been examined; in a time when the book is the principal medium of photographic dissemination, second-hand analyses abound, even though this approach is almost unthinkable in the plastic arts. The very problems that make the critical enterprise so unmanageable suggest the magnitude of the historical undertaking. Any criticism must be soundly grounded in the historical past, and yet, for photography, that history remains to be written. We are fortunate to have the pioneering work of Beaumont Newhall and Helmut Gernsheim, yet with new photographic discoveries made almost daily, the historical work only has begun.

A solution to the problems of photographic research and scholarship over the next few years would be welcome, but we should also consider the consequences. Will more sophisticated critical methods result in a sacrifice of vitality and diversity? Will we create accepted schools of criticism that address only limited audiences? Will we allow the critics to indulge themselves in the manner Saul Bellow attributes to literary critics: they "have done little more than convert the classics into other forms of discourse, translating imagination into opinion or art into cognitions. What they do is put it all differently. They redescribe everything, usually making it less accessible. For feeling or response they substitute acts of comprehension."[7]

As photographic criticism attempts to perform the scholarly and historical tasks before it, it does so for an underlying and ironic reason: the photograph continues to defy interpretation. Critics progress in their readings because of the restless creativity of the artists;

even if criticism is inflexible and immature, photography and its creators proliferate. This proliferation demands an increased critical response to fill the gap that has opened between the work and its audience. The artists often challenge the limitations of a reductive or unchanging criticism by creating photographic forms that call into question the premises of such criticism.

A classic example of the critical challenge engendered by the photograph's resistance to interpretation is seen in the movement labeled "New Topographics"[8]—contemporary "landscape" photographers whose work appears to be both document and art. Depicting ordinary and transitional landscapes of the suburban West, these photographers prompt at least two contrary responses. The layman asks: "Why picture *that?* It's ugly." The critic's question is, "Why picture *that that* way; it's too beautiful to be social criticism." Each response suggests that the meaning of the subject is confused by conditioned expectations about the photograph's style. On this level, then, the problem of interpretation hinges on the audience's expectations. But the problem is compounded by the conventions of the subject matter itself. Members of other disciplines—for example, architects, planners, environmentalists, social critics—define the subject by pointing to suburbia's virtues or vices. Examples of these extremes include Reyner Banham's celebration of Los Angeles and Bill Owen's indictment of middle America, *Suburbia*. But these new landscape photographers claim a middle ground, one they say is intellectually and emotionally neutral and thus, *documentary*. Whatever the critical baggage the word *documentary* suggests, these photographers know that documentation today means considering not only the connotation of subject and expected, "appropriate" style, but also the photograph's inherent ambiguity—the curious interplay of subject and style—and the role it plays in renewing exhausted forms. According to Nicholas Nixon, a photographer whose work is included with the New Topographics, contemporary documentary "hovers between fact and point of view."[9] Thus, this work addresses the primary issue of contemporary photographic criticism: ambiguity is not only the "nature" of the photograph, it is cultivated to combat the exhaustion of conventions that numb the viewer's reading of the subject. A photograph may exist simultaneously as art and artifact; indeed, in the case of the New Topographics, as artifact revealed through art.

That most criticism until recently has contested photographic am-

biguity by insisting on known categories and previously stated pur-
poses signifies the failure of the critics to understand how or why
photographers put ambiguity to use. For example, the New Topo-
graphics collectively and two photographers specifically have been
accused of polar topographical errors. Robert Adams' photographs
are said to be subjects without statements; Lewis Baltz's strong, for-
mal referents are said to obliterate the subject. Such commentary
illustrates the critics' wish to perpetuate what Allen Sekula calls "bi-
nary folklore"[10]—the interpretation of photographs as art *or* docu-
ment. It's easy to understand why critics persist in these convenient
dichotomies: without such basis for interpretation, they are at a loss
to evaluate the medium; they may be forced to invoke other systems—
structuralism, for example, or Marxism—none of which consistently
explains *all* photography. And the abandoning of these traditional
or invented modes raises disturbing questions: if the photograph is
consistently ambiguous, is it inherently untruthful? does it lie when
it tells us it won't? is it a frozen instant in time ambiguously related
to the real world? To many critics, such questions, when articulat-
ed, admit a loss of faith in the integrity of the medium—its capacity
for "truth."

Yet if there is any medium suited to the modern mind and its cul-
ture, it is photography, for the dilemma of the photograph's ambi-
guity is the dilemma of contemporary reality. Realism becomes *how*
something means, not just what it means. Baudelaire observed of
ambiguity, that "suggestive magic" essential to the discovery of the
subject's real meaning: "it includes at the same time object and sub-
ject, the world outside the artist and the artist himself."[11] Arthur
Koestler argues the creative essence of ambiguity, "biosociation,"
he calls it, "the perceiving of a situation or idea in two self-consistent
but habitually incompatible frames of reference which produces a
transitory state of unstable equilibrium where the balance of emo-
tion and thought is disturbed."[12] The creation of such worlds nec-
essarily involves photographer and viewer. When we look at these
landscape photographs, we participate in new "truths." And since
photographs fix ambiguity—give it permanent form—they are a his-
torical act in an ahistorical world. The depiction of Allen Sekula's
"binary folklore" is the "reality" of such pictures.

A like critical fate has been suffered by a group of writers who
ostensibly experimented with ambiguity in the interest of "truth."
The New Journalists, like the New Topographics, depict the ordi-

nary landscape and its people in, among other areas, the West. Their use of fictional devices to report the new landscapes of Las Vegas, Southern California, and other western environments is disparaged for the ambiguous relationship of its subject and style. Although literary criticism recognizes that ambiguity can generate multiple meanings, journalism traditionally is expected to be impersonal and rooted in fact. Documentary writing, therefore, should come from observation and objective reporting. But the New Journalists' most vociferous spokesman, Tom Wolfe, argues that the use of fictional techniques promotes a "higher" truth—that of the novel—and, co-existing with reporting, forges a new objectivity that places moral judgment squarely in the audience's lap. Attention to technique, argues Wolfe, allows for the absence of moralizing, and when derived from literary tools used to suspend disbelief, ideally unites artist, subject, and audience. Moreover, the "nonfiction novel," as Truman Capote calls it, because it depicts the actual world, places the reader in the scene and maximizes his comprehension of it. Thus, a concern for style that may appear self-indulgent really nudges the reader into a participatory awareness. Crucial to this feat is the New Journalists' use of point of view. To isolate the innate power of a real event, these writers narrate from a peculiar position. An ironic, composed, and rational narrator relates each piece, a technique which both unites the reader with his subject (persuades him to identify with the actuality of the scene) and implies objectivity (as he understands it through the ironic voice). The result is a dislocated perspective designed to destroy the reader's previous cliched and hence unperceptive relationship to the all-too-familiar subject.

This dislocated perspective is crucial to making "new" photographic statements as in the case of the New Topographics whose work appears simply to be ecological or artistic treatments of suburban landscape. Moreover, because the viewer has been stultified by years of either sublime or documentary approaches to landscape, he cannot recognize the familiar, ordinary landscape. His vision derives from traditional images estranged from their source. This is the dilemma of the artist too, who, as Wright Morris points out of American writers, can be dangerously cut off from experience: "Within the scope of a century, since Whitman, native raw materials have lost their rewards, and most writers of fiction have their beginnings as readers of fiction. It is the written image that now shapes the writer in his effort to become his own image-maker."[13] Thus, Mor-

ris adds, "furnishing the mind with artifacts and symbols that began with Walt Whitman is increasingly a matter of salvage. For the American writer, repossession is an act of recreation."[14] Similarly, John Barth observed in 1970 the paucity of fiction is due to "exhaustion."[15] Ten years later, his recommended antidote was what he described as a "postmodern" sensibility:

Postmodernism is the synthesis or transcension of the antithesis of pre-modernist realist and modernist modes of writing. My ideal postmodernist writer neither merely repudiates his nineteenth century grandparents nor imitates his twentieth century modernist parents. . . . He has the first half of the century under his belt, but not on his back. He aspires to a fiction more democratic in its appeal than late-modernist novels. The ideal postmodernist novel will somehow rise above the quarrel between realism and irrealism, formalism and "contentism," pure and committed literature, and coterie and junk fiction.[16]

Both Barth and Morris critically pinpoint a richness characteristic of the kind of photography that inverts and combines stylistic conventions while attending to actual experienced landscapes. To argue the essential "postmodern" quality of this photography is perhaps to create yet another meaningless category. Yet this term, at least in the manner Barth defines it, clarifies the essence of the dislocated perspective: meaning is created from the tension between the esthetic revelations and what we know about their referents. If this style were merely parodic, it would soon exhaust itself as does any genre simply feeding for its meaning off another. But that it is ironic[17] assures its greater effectiveness—an ability to "rise above the quarrel" of rigid critical dichotomies, as Barth says. Moreover, the ironic melding of realistic and modernist modes creates meaning through the language of the immediate photograph and through the larger context of other photograhic modes as well. Thus, to return to our extended example, those photographers grouped in the movement New Topographics make pictures about surfaces; the *event* of the photograph is *how* we interpret it.

For criticism, the consequences of such photography are considerable. Photography confronting itself as well as its ostensible subject calls for renewed attention to the role of the maker and the creation of "new contexts." The disruption of the viewer's expectations owing to the apparent gap between subject and style historically is typical of any artist's attempt to make new meaning by

remaking old forms. What George Kubler calls "a disjunction between form and meaning"[18] has always been an essential artistic step toward new ideas. Therefore, critics who attend to this process must necessarily exercise considerable intellectual breadth. They must implement a broader view of cultural and art historical contexts in order to read the work itself.

The interpretation of disjuncture (the dislocated perspective) is particularly fascinating when we remember that the photograph still carries at least a ghost of objective reality. Though it has relinquished its powers of social criticism to film, photography's dichotomous nature continues to provoke interpretation outside the traditional critical arena. And these observations are important to formal criticism. An example is the use of photographs by certain cultural geographers to interpret landscapes. In its early history, the measure of a photograph's verisimilitude was how true it was to nature. Current cultural geographers such as D. W. Meinig, David Lowenthal, Yi-Fu Tuan, and J. B. Jackson concern themselves with vernacular landscapes which they recognize as transitional. Meinig describes these landscapes as "existential," "without prototypes, absolutes, devoted to change and mobility and free confrontation of men."[19] In their use of the photograph to examine these landscapes (for example, Jackson's request for aerial photographs which he thought would reveal *human* geography),[20] these social scientists suggest an even more provocative area for the critic cognizant of changing contexts and meanings. It would seem, finally, that the truth of the photograph is no longer held up to nature. Rather it is nature—the validity of the subject itself—that is measured against the photograph.

Notes

1. Quoted in Nathan Lyons, *The Great West: Real/Ideal* (Boulder: Department of Fine Arts, University of Colorado, 1977), p. 9.

2. "Henry Holmes Smith" in *Dialogue with Photography,* edited by Paul Hill and Thomas Cooper (New York: Farrar, Straus, and Giroux, 1979), p. 155.

3. V. F. Perkins, "Form and Discipline," in *Film Theory and Criticism,* edited by Gerald Mast and Marshall Cohen (New York: Oxford University Press, 1979), p. 45.

4. Carl F. Schorske, *Fin-de-Siècle Vienna* (New York: Vintage Books, 1981), p. xxi.

5. For a useful delineation of the agenda for interdisciplinary photographic research see Marsha Peters and Bernard Mergen, " 'Doing the Rest': The Uses of Photographs in American Studies," *American Quarterly* 29, 3 (Summer 1977): 280–303.

6. Quoted in Lyons, *The Great West*, p. 9.

7. Saul Bellow, "Cloister Culture," in *The Best of Speaking of Books*, edited by Francis Brown (New York: Holt, Rinehart and Winston, 1969), p. 5.

8. William Jenkins first applied this term to a group of young photographers and their work in his introduction to the catalogue of their exhibited works: *New Topographics: Photographs of a Man-Altered Landscape* (Rochester, N.Y., 1975).

9. Quoted in Jenkins, p. 9.

10. Allan Sekula, "On the Invention of Photographic Meaning," *Artforum*, January 1975, p. 45.

11. Quoted in Northrop Frye, *The Educated Imagination* (Bloomington: Indiana University Press, 1964), p. 23.

12. Arthur Koestler, *The Act of Creation* (New York: Macmillan, 1964), p. 195.

13. Wright Morris, *Earthly Delights, Unearthly Adornments* (New York: Harper and Row, 1978), p. 48.

14. Morris, p. 43.

15. See Barth's first essay on this matter, "The Literature of Exhaustion," *Atlantic Monthly*, December 1970, pp. 29–34.

16. "The Literature of Replenishment," *Atlantic Monthly*, January 1980, p. 70.

17. In *The Anatomy of Criticism* (Princeton: Princeton University Press, 1957), p. 48, Northrop Frye places irony in the realm of ambiguity.

18. George Kubler, "History—or Anthropology—of Art?" *Critical Inquiry* 1 (June 1975):761.

19. "Reading the Landscape," in *The Interpretation of Ordinary Landscapes: Geographical Essays*, edited by D. W. Meinig (New York: Oxford University Press, 1979), p. 225.

20. *Landscape* 1, no. 1 (1951):4.

1

Photographing Architecture

John Szarkowski

Most architects think that the central essence of architecture is beyond the scope of photography. They are probably right.

Most photographers think that buildings are among the most interesting of subjects—but that photographing architecture is a pretty dull business. They are also right.

Architectural photography, as generally practiced, is the product of a wary collaboration between these two unconvinced principals, with the architect sometimes represented by his institutional promotion service, the professional magazines. The photographer provides a service similar to that of other commercial artists: his function is to make the building look as good as possible in the light of contemporary fashion. Many of the photographs produced within this framework are handsome pictures. Some are also intelligent. A few are genuinely revealing. Most bear approximately the same relationship to real buildings as fashion photographs bear to real women.

Such photography is certainly not without value. It results, presumably, in financial profit to both architect and photographer. It

allows the architectural magazines to broadcast the aspect, if not the meaning, of those buildings that they consider most worthy of emulation. With judicious selection, the same photographs can be used by the critic-historian to illustrate and buttress a new theory. Any new theory.

Without questioning the validity of these ends, it is perhaps possible to agree that they do not exhaust the potential of photography as a tool for investigating the art of building. I submit that photography can become a technique of significant architectural criticism, capable of cohesive statement and profound insights of a new order. The question of how this potential can be realized can be approached by first answering another question: why is it that neither architect nor historian nor photographer is deeply convinced of the value of architectural photography?

The architect is concerned above all else with the organization of space; he knows that ultimately his work must be experienced as the unfolding of space in time. Certainly the sensation of architecture, an experience in four dimensions, cannot be reproduced within the two dimensions of a still photograph. A photograph can be about a building; it cannot be one. Yet the psychological authenticity of a competent photograph is so compelling that we accept its image as a substitute for the subject-fact itself. Repeated proof that a photograph is only a more or less relevant observation convinces our mind, but not our eyes. Photographers and architects know the difference between a building and a photograph, yet each for his own reasons hesitates to emphasize the discrepancy between fact and aspect. The architect publishes photographs—if not unflattering—as the equivalent of his work. The photographer, unwilling or unprepared to defend his pictures as the expression of personal understanding, hides his head under the anonymous black focusing cloth and pretends that photography is a faithful witness, automatically revealing the objective truth. His attitude, while less than candid, is economically sound. And probably esthetically sound, too, for the power of photography rests on its ability to present opinion in the guise of truth.

If the architect has reason to question the honesty of architectural photography, the photographer has equal reason to be bored by its vacuity. If on his Saturday holiday the photographer photographs an anonymous American farmhouse, he will consider the rich miscellany of life facts surrounding and attached to the building as a legit-

imate and revealing part of his subject. He will want his photographs to possess a sense of the local earth and light and weather, of the life pattern of the inhabitants, of the presence of animals, of meagerness or richness. If it is subsequently discovered that the house was derived from a design by Bulfinch—and the photographer returns on a weekday assignment—he will push these environmental irrelevancies from his mind, and restrict his attention to the division of the facades, the interior plan, the structural system, and the ornamental details. What on Saturday was a countryside has become merely a site; trees have become landscaping, the inhabitants have become residents, and life has become a circulation pattern. It is difficult to judge how much of this emaciation of subject matter is due to the prejudices of the architectural profession, and how much to the tradition of architectural photography itself.

In its earliest days, photography fell in love with the documentation of the past's great monuments—the mediaeval cathedrals, the classical ruins, the pyramids. The cultures which had given birth to these buildings were dead; only the beautiful object remained, an expression of pure form. And so the building appeared in the photographs—in the precise isolation of timelessness. These impressive and highly abstracted documents became a model for later photographers to follow. Even the newest building could be neatly insulated, in a photograph, from the environment that had helped form it.

To return to the photographer and the farmhouse. Certainly, the quality of the prairie light is not a part of the architectural solution. But it is a part of the achitectural problem—one of the subjective realities of rural life to be organized by the architect. And the photograph can tell much of the life in which the architecture found its form. The photographer must of course draw the line of relevancy somewhere. The barnyard boots, standing on the kitchen porch—surely they are irrelevant. Probably.

Perhaps the tangled ambiguities of architectural photography do sometimes serve the needs of the critic-historian. Among the hundreds of photographs of, for example, Louis Sullivan's Carson Pirie Scott building, it is surely possible to find at least one that will demonstrate beyond question that the structural concept was horizontal, vertical, skeletal, cellular, or possibly tubular. Doubtless the proof for other interpretations lies buried in a dozen undiscovered negative files. Historians, it is true, speak of objective as opposed to subjective photographs. This distinction may be a useful fiction, but

it should be understood that in fact only incompetence can rescue the photographer from the personal judgment of his own seeing. The historian's idea of objectivity in an architectural photograph seems to be defined in terms of a set technical procedure, which will automatically reveal the impersonal and balanced truth of a building. This procedure can be defined with a fair degree of precision; the photograph should be made early in the morning of an overcast day, with shadowless light and an unpeopled street. Objectivity demands that detail in the shadow of the cornice be revealed with the same clarity as that which receives direct sunlight, the intention of the architect notwithstanding. The building should be seen in two-point perspective (no converging verticals) from as far away as possible (minimum foreshortening) and from the angle shown in the architect's original rendering. The rendering was of course made as part of the architect's sales program, but has presumably gained objectivity with age. I do not of course mean to say that such photographs cannot be relevant and expressive, but merely that they are not inherently objective.

I have said that architectural photography is capable of expressing relevant, responsible, cohesive meaning, and have tried to demonstrate that this potential is not being realized. I believe that before it can be realized the photographer must be made responsible for the content as well as for the execution of his work. This responsibility cannot end with the making of the photographs. The photographer should also select, from the total number of photographs made, those that, as a group, conform most closely to his understanding of the subject. If he is to be more than a sensitive technician, it will be inconsistent for him to submit proofs—alternative versions of the truth—from which an editor will pick the most true. Even a picture sequence should be the photographer's province.

Of the various ill-fitting legacies which photography has inherited from painting, the most insistent is the idea that the individual picture must be a complete statement. Often one photograph *will* stand alone; more often, a series of photographs can convey a meaning greater than the sum of the individual images. The individual pictures of a photographic essay can be considered as sentences. Each should have clarity and precision of form, but their functions will vary profoundly. Some will define the problem and state the photographer's approach, some will be narrative, some fundamentally illustrative, some parenthetical and suggestive, some declamatory,

and some will state conclusions. Some will stand as independent statements; others will be relatively meaningless out of context. The sequence in which these photographs appear is obviously important. If a photographic essay or book is indeed conceived as a unit, and not simply as a portfolio, it should be studied from beginning to end—not perused at random.

The photographer without a working knowledge of the problems, processes, and formal concerns of architecture will, if left to his own devices, produce only a caricature of his subject. Naturally, in any field of photography the serious worker must understand his subject as well as his tools and processes.

Photography of architecture should be less preoccupied with the finished building—an object—and more interested in the human and technical processes which precede and produce it. Work progress shots are made regularly during the construction of any important building. The dreary incompetence of most such work has perhaps blinded architects and historians to the fact that perceptive photographs made during construction can often reveal aspects of a building's concept more powerfully than photographs of the completed building. They also can, and should, give a sense of the excitement of the act of building. The magnificent series by Lewis Hine on the construction of the Empire State Building, more than the countless photographs made of the finished work, conveys a powerful sense of the building's real meaning—of its technical boldness, its formal timidity, and its lack of humanity.

Architecture is not only a collection of buildings, it is a process. Perhaps the most exciting part of this process takes place before the ground is broken. Is it possible that photography (which in other contexts has recorded trust, jealousy, boredom, fatigue, tenacity, and cooperation) is incapable of documenting the marvelously complex relationship of architect, client, and contractor? A thorough and incisive documentation in photographs and text of the birth of one building—from preliminary conversations, through the struggles of concept, planning, and construction, to the use of the completed building—would be more revealing than sketchy vignettes of a hundred equally important works. Since such a project has never been tried, it cannot be confidently said to be impossible.

I believe that architectural photography will achieve its highest degree of clarity and intensity of meaning when the functions of cameraman, critic, and editor are combined in a single person. Or at

least, directed by a single person. Because of occupational prejudice I have referred to this man as the photographer; another name would do as well. It is possible that an editor knowledgeable in the substance as well as the jargon of photography could operate effectively as a photographic director, in collaboration with a skilled cameraman. Possible, but unlikely. And I believe unnecessary. In photography's early years its techniques were mysterious and intractable. The basic processes have now been simplified to the point where a high degree of competence is within the reach of any genuinely serious amateur. This amateur is in no sense a dilettante. He is free of the necessity of earning his living by photography, but not of the obligations of responsible statement and effective craft. Possibly it will be through the work of such amateur photographers—professional architects, historians, or teachers—that a new approach to architectural photography will evolve. The recent photographic book *Form and Space in Japanese Architecture*—by Norman F. Carver Jr., an architect—demonstrated both by its concept and its performance that significant architectural photography need not be the work of a professional.

But whether the work of professionals or amateurs, and with or without the general blessing of architects, critics, magazines, or even photographers, architectural photography will change, and broaden its concern. Photography will express more than a polite and circumscribed interest in a building's superficial form. It will in its own language suggest the impetus of human need underlying that form, and explore the personal and social act of creative building. Photography assumes this subject matter because it lies in the world of human values, where the camera is most at home.

2

Landscape Photography

Nathan Lyons

The landscape in photography should not be considered as an isolated category of work. Rather it should be seen in relation to the history of the medium and the changing meaning it has held for many photographers.

The central theme of the landscape in the nineteenth century was directed toward the depiction of the "ideal." Its depictive quality in its "truth to nature" was of the utmost importance. The landscape emerged in the twentieth century more as a realization of identity, the objectification of an inner landscape found in correspondence with the physical world.

At the beginning of the twentieth century, in an environment of rules for art, the structural characteristics of the landscape were discussed by F. A. Waugh, in his article from the *Photo-Miniature*, in the following manner: "An ordinary complete landscape consists of four more or less distinct parts, one or two of which may sometimes be suppressed." These he listed as foreground, middleground, background, and sky. To this would be applied the traditional pictorial

Reprinted by permission from *The Encyclopedia of Photography*, vol. 11 (New York: Greystone Press, 1962).

associations of the time, chiefly, an expression of allegorical or doctrinal ideas. Joined to this view of nature was the concern with change. The essential idea was not distinctly categorical, a landscape apart from the environment of man-made objects, but a view which pointed to man's total environment.

In 1956 Gyorgy Kepes in the introduction to *The New Landscape* summarized much of this concern: "It is not with tools only that we domesticate our world. Sensed forms, images, and symbols are as essential to us as palpable reality in exploring nature for human ends. Distilled from our experience and made our permanent possessions, they provide a nexus between man and man, and man and nature. We make a map of our experience patterns, an inner model of the outer world, and we use this to organize our lives. Our natural 'environment'—whatever impinges on us from outside—becomes our human 'landscape,' a segment of nature fathomed by us and made our home."

Within the evolution of landscape photography are to be found the traditions of landscape painting. Landscape painting in Western art is generally traced from the fifteenth century until the establishment of the "classical landscape" school in the seventeenth century. Early landscapes, such as those painted by Italian artists in the Renaissance, were used as a backdrop for the figure, and gradually moved from a position of subordinate or complementary subject matter to a position of primary importance.

Photography and Art

Photography as a means of visual expression has quite often assumed a defensive position in relation to the more formally established art forms. During the early years of its development, photography was considered primarily an aid to the painter—a sketching device—an aid to fine art rather than a fine art in itself. Also, inherent photographic characteristics were looked upon with disdain by many painters.

In England in 1853, at the first meeting of the Photographic Society, the noted miniature painter Sir William Newton suggested that when photography was to be used by the painter, he should bear in mind "that essentially speaking, the camera is by no means calculated to teach the principles of art; but, to those who are already

well informed in this respect, and have had practical experience, it may be made the means of considerable advancement. At the same time I do not conceive it to be necessary or desirable for an artist to represent or aim at the attainment of every minute detail, but to endeavor at producing a broad and general effect, by which means the suggestions which nature offers, as represented by the camera, will assist his studies materially; and indeed, for this purpose, I do not consider it necessary that the whole of the subject should be what is called *in focus;* on the contrary, I have found in many instances that the object is better obtained by the whole subject being a little *out-of-focus*, thereby giving a greater breadth of effect, and consequently more suggestive of the true character of nature.

"I wish, however, to be understood as applying these observations to artists only, such productions being considered as *private* studies to assist him in his composition; and for groups of figures, or any subject requiring to be obtained as quickly as possible, the collodion process, is, of course, the best we are yet acquainted with."

The effect of this statement on photography can be seen in an article written by Mr. George Shadbolt in 1858. "We know that it is very much the fashion with some artists to decry what they call the painful amount of detail visible in photography, and stigmatize it as hard and unpleasant; as a remedy for the evil they propose to take pictures that are a little *out-of-focus*.

"We are then advocates not only for 'sharp' focusing, but for doing this with the utmost possible distinctness attainable over the whole field of view."

Factual Representation

It was asserted, however, and maintained well into the twentieth century, that a fuzziness which produced a destruction of photographic structure was truer to natural vision and therefore one way in which a photograph would be more acceptable as a creative statement.

It is interesting to note that by the early 1850s the daguerreotype process was capable of recording views instantaneously and capable of an exceptional delineation of tone. On January 3, 1856, at a meeting of the Manchester Photographic Society, the landscape photographer James Mudd presented a paper on "The Artistic Arrangement of Photographic Landscapes."

His statement summarized much of the development of the medium and also expressed a vital concern: ". . . in the early days of photography the most commonplace objects satisfied us. The ardent experimenter of that period looked with pride and wonder at the picture of a stack of grim chimneys, taken perhaps from his little laboratory window, or his surprising view of a dead brick wall and water tubs. He could count every brick; that was the marvel. But the novelty of this soon wore off, and something more was desired, namely, *beauty in the object itself*. So the photographer went to nature, and the hills and fields and streams became fitting subjects for his art."

This assessment of topographic intent on the part of many early photographers was still maintained by Sir Howard Grubb in 1896: "In the early days of photography a photographer never thought it worth his while to point his camera to any object that had not some particular interest connected with it. It might be a building having historical interest, or architectural beauty, or it might be a well-known and favoured landscape celebrated far and wide for its beauty; the aim, in fact, of the photographer at that time was to produce a representation, or we might say, a portrait of some particular object which had a special interest in itself; but what photographer of that time would have thought of wasting his plates—as it would have been considered—in pointing his camera to those little bits of moor or fen, or some nameless brook, out of which the modern photographer has produced his most exquisite pictures."

He went on to state: "The superiority of the later efforts of photographers depend much more on the fact that, whereas in former time the photographer's aim was to produce a representation or a portrait of a particular scene, that of the modern photographer is to produce a picture."

Personal Expression

In these two statements we may find a key to understanding the question of personal expression in the photographic medium. The world was astonished by the ability of this new invention to record reality, so much so that when fraudulent spirit photographs were introduced in 1861 they were accepted as truth solely on the basis of their being photographic.

The photograph was an impersonal and impartial document; the

photographer stood by as objects drew their own pictures. The topographic intent, or an attention to the depiction of object, place, or event as opposed to the pictorial intent, an attention to interpretive values of personal expression, is of the utmost importance in tracing the evolution of the landscape in photography.

Today we may respond more favorably to the work of greater or lesser known photographers who documented a landscape primarily for its significance as to place than to the art-consciously conceived work of the same period. This should not be looked upon as being paradoxical. Much of the work done in the name of the pictorial was highly imitative, structured by rules of composition, and expressing doctrinal ideas.

Looking at many topographic photographs of the past we may be impressed by the direct quality of their statement. We may look upon them nostalgically or become fascinated by the almost surreal quality that some possess. A number of arresting photographs were taken and demand our attention both for their antiquarian as well as esthetic qualities.

When one spoke of art and photography in the 1860s, certain distinctions were made. While addressing the South London Photographic Society on December 20, 1868, C. Jabez Hughes suggested the following categories for consideration: Mechanical-Photography (topographic and later to be termed scientific), Art-Photography, and High-Art-Photography.

Mechanical-Photography included all photographs "which aim at simple representation of the objects to which the camera is pointed. . . . Let it be understood that I do not mean the term *mechanical* to be understood deprecatingly. On the contrary, I mean that everything that is to be depicted exactly as it is, and where all the parts are to be equally sharp and perfect, is to be included under this head. I might have used the term *literal* photography, but think the former better. This branch, for obvious reasons, will always be the most practiced; and where the literal unchallengeable truth is required, is the only one allowable."

Art-Photography embraced all photographs "where the artist, not content with taking things as they may naturally occur, determines to infuse his mind into them by arranging, modifying, or otherwise disposing them, so that they may appear in a more appropriate or beautiful manner than they would have been without such interference."

The term High-Art-Photography, Mr. Hughes felt, might appear to be somewhat presumptuous, but he felt the necessity of including it, in light of the allegorical and genre work being done by photographers led by Mr. O. J. Rejlander and Mr. H. P. Robinson. The term also included the "composite" or "composition" photograph, brought to public attention by O. J. Rejlander in 1857 with "The Two Ways of Life," an allegorical photograph (a combination of thirty separate negatives) of the roads to virtue and vice. High-Art-Photography was directed toward "higher purposes than the majority of art photographs. . . . " Its aim was "not to amuse, but to instruct, purify, and ennoble" and was brought into play "when deep and earnest minds seek to express their ideal of moral and religious beauty. . . ."

The Pictorial Tradition

The presence of pictorial considerations in photography can be traced to 1844. Then William Henry Fox Talbot, in *The Pencil of Nature*, suggested the "beginnings of a new art" when he included in this discussion of the practical uses of photography the photograph entitled "The Open Door," presented solely for its "picturesque" quality. In 1845 J. E. Mayall illustrated the Lord's Prayer in a series of ten daguerreotypes. Later he composed a series of six daguerreotypes in the manner of Campbell's "Soldier's Dream."

This allegorical tradition is further represented in the work of Gabriel Harrison and Lake Price. By the mid 1860s an established pictorial tradition is evident, championed by Rejlander and Robinson. Stemming from the allegorical tradition, the figure in the landscape is again of increasing importance. Much of the work is contrived, and repeats many of the ideas of composition and seeing developed from Burnet's *A Treatise on Painting*, a popular instructional work written for painters and adopted by photographers.

How labored these rules could become can be seen in "Finger Posts for Landscape Photographers" by W. H. Davies, published in *The British Journal Photographic Almanac* and *Photographers Daily Companion* for the year 1866: "The first object of importance in a picture is that the foreground be so chosen as to lead the eye towards the centre of the view or of the subject which is generally near the centre of interest, but which is not necessarily the centre of the plane of delineation. The centre of the subject (otherwise called the van-

ishing point, or point of distance) should always be placed on one side or the other of the medial line, and preferably at one third to two fifths of the entire length of the base line, and the same distance from the top or bottom of the picture, according as it may or may not have a high or a low horizon. The horizon should never be exactly intermediate between the top and bottom of the picture, but be from one third to two fifths from the top or bottom edge."

Naturalistic Photography

The traditional considerations of geometric perspective and composition were later attacked openly and repeatedly by P. H. Emerson, the leader of the Naturalistic School of Photography. Concerning Burnet's treatise, Emerson felt that: "In short, the whole work is illogical, unscientific, and inartistic, and has not a leg to stand on. It is specious to say that all compositions are made according to geometrical forms; nothing can be easier than to take arbitrary points in a picture and draw geometrical figures adjoining them. The pyramid is a favorite geometric form of composition. Now take any picture, and take any three points you like, and join them, and you will have a pyramid, as does every composition contain a pyramid, as does a donkey's ear."

Emerson felt that pictorial work should become more naturalistic and that the allegorical and doctrinal did not "lie within the scope of art." Naturalistic photography, to Emerson was "an *impersonal* method of expression, a more or less correct *reflection* of nature, wherein 1) truth of sentiment, 2) illusion of truth of appearance (so far as is possible) and 3) decoration are of first and supreme importance."

A basic contradiction appears to exist in Emerson's thesis. He felt that the photograph was a "mechanically recorded reflection of Nature" and therefore could not be a work of art, but he also stated that "there is no *absolute* truth to Nature from the visual standpoint, for as each man's sight is different, the only absolute truth to Nature for each man is his own view of her (though certain broad features remain true to all)." It is difficult to understand why Emerson acknowledged the existence of a personal point of view and yet limited its significance because it was expressed by an "impersonal method." Personal vision was acknowledged and yet denied by Emerson.

Ground was giving way to a psychological standpoint based in vision, but photography's significance was not yet clearly understood. Emerson resolved this problem of personal vision in this naturalistic context when he stated that naturalism "must be true in fundamentals to the point of *illusion*. Thus a man's boots must not be twice as big as his head, and so on with everything."

This movement away from traditionally prescribed methods of seeing was made evident in an interesting article published in the English newspaper *The Morning Leader*, March 25, 1898. The concept of a "point of view" was dramatically explored by a presentation of engravings from photographs showing radical views looking up at buildings. The point was made that the photographs indicate what one actually sees from a certain point of view.

Personal Interpretation

The concept of the visual significance of a freely expressed, individual way of seeing on the basis of personal observation, as opposed to making the photograph conform to a set system of values, was confirmed by the photographer Alvin Langdon Coburn in 1912. This extension of vision through photography became firmly established during the years to follow, but not until a pictorial flirtation with Impressionism took place.

Emerson's naturalistic considerations began to be acknowledged by many photographers. George Davidson, an exponent of the Naturalistic school, however, found recognition for his "pinhole" technique. This in effect produced a counter movement which absorbed many of Emerson's ideas.

In a review of the Photographic Society's Exhibition at Pall Mall in *The Photographic Art Journal* for November 1, 1890, Davidson's approach is applauded—an approach which strongly reflects some of the physical characteristics of the Impressionistic movement in painting. The *Journal* reports, however, that in Davidson's landscapes "the exhibitor has made a bold, decisive step, from which he would find it difficult to retreat, and the advancement of a new school is strongly indicated."

Emerson issued a pamphlet in the same year entitled, "The Death of Naturalistic Photography." In it he restates his previous stand on the question of art and photography and bitterly attacks Davidson

for presenting a paper to the Society of Arts in which many of his ideas "were freely and impudently handled about" without due credit.

Davidson was quick to acknowledge Emerson's contribution and stated: "The application to photography of the principles and views adopted by those painters known as impressionists marks an important period in the evolution of artistic photography. This application was due, in the first instance, to the writings and action of Dr. Emerson."

Emerson, however, denied any association with the "fuzzy school." "Fuzziness, to us, means *destruction of structure*. We do advocate broad suggestions of organic structure, and artistic focus of relative planes, which is a very different thing from destruction. . . ." He further stated: "The pinhole picture is inadmissible, because the smallness of the aperture falsifies modeling and perspective. The general diffusion or softness falsifies tone, and there is no power of differentiating."

Impressionism

The question of how the photographic statement is made, rather than what statement is being made, was and still is the dominant preoccupation of our literature. The categorical acceptance of concepts expressed in the work of the truly creative, when formulated into shools of thought to be made readily intelligible, can do much to destroy the original conception of the artist.

In an article in *Camera Notes* for January 1901, the art critic Charles H. Caffin cautioned against such conceptualizing when he stated: "The vagueness of impressionism is mainly in the use of the term itself, as applied to a small group of painters, who against their will and with no reference to their distinguishing tenets have been dubbed impressionists. The term is far too inclusive and fails entirely to characterize their particular aims." He goes on to state: "In the simplest and broadest meaning, every artist is an impressionist. He strives to reproduce the object or scene as it impresses him, that is to say, as he sees it; and the way in which he sees it depends upon what he is looking for, upon his peculiar temperament, and upon the complex associations stored up in his individual artistic memory."

Attention to true purposes is expressed when Caffin reminds photographers that "effects" alone do not produce significant work. He further states: "I can well believe that a future for photography lies along the lines of impressionism. Through it the artist escapes the deadly mediocrity of the mechanical photograph, which sees and records everything with such relentless impartiality. Any child can touch the button; the artist desires to get away from this commonplace facility into personal, individual expression."

It is evident that the vast majority of photographers did not heed Caffin's warning. Handwork on negative and print to produce photographs which looked like art became the dominant preoccupation. The continuous presence of the topographic tradition and the efforts of a few working within the pictorial tradition caused the formation of two divergent groups. Many pictorial societies were established and continued art-consciously to express a pictorialism ranging from values and rules inherited from H. P. Robinson to this false concept of photoimpressionism.

Through what at times appeared to be the sole efforts of Alfred Stieglitz, attention was also directed towards the abilities of the medium to make a statement photographically. In 1903 Stieglitz conveyed the essential need for change which eventually was to place him apart from many of his co-workers in the Photo Secession who later chose to ally themselves with the precepts of Pictorialism. Stieglitz emphatically believed that: "The progress of the ages has been rhythmic and not continuous, although always forward. In all phases of human activity the tendency of the masses has been invariably towards ultraconservatism.

"Progress has been accomplished only by reason of the fanatical enthusiasm of the revolutionist, whose extreme teaching has saved the mass from utter inertia. What is today accepted as conservative was yesterday denounced as revolutionary. It follows, then, that it is to the extremist that mankind largely owes its progression. In this country, photography has followed this law, and whatever have been the achievements which have won it exceptional distinction, they have been attained by the efforts of the enthusiastic so-called extremists. True, however, only through bitter strife, until those most deeply interested in the advancement of photography along the lines of art have been compelled to register their protest against the reactionary spirit of the masses. This protest, this secession from the spirit of the doctrinaire. . . ."

This revolution was felt and experienced in all art forms. Anticipating well in advance the spirit and the ideas of what was later called the New Vision or the New Objectivity, Alvin Langdon Coburn was one of the first to sense this need for an evolution of a visual consciousness in photography. He had affirmed this new vision as early as 1912 in a series of photographs entitled "New York From Its Pinnacles," a pictorial assessment of the significance of a "point of view." The photographs were taken looking down from tall buildings and Coburn felt that they were "almost as fantastic in . . . perspective as a Cubist fantasy; but why should not the camera artist break away from the worn-out conventions, that even in its comparatively short existence have begun to cramp and restrict his medium, and claim the freedom of expression which any art must have to be alive?"

Coburn also stated in *Photograms of the Year 1916:* "Yes, if we are alive to the spirit of our time, it is these moderns who interest us. They are striving, reaching out towards the future, analysing the mossy structure of the past, and building afresh, in colour and sound and grammatical construction, the scintillating vision of their minds; and being interested particularly in photography, it has occurred to me, why should not the camera also throw off the shackles of conventional representation and attempt something fresh and untried? Why should not its subtle rapidity be utilised to study movement? Why not repeated successive exposures of an object in motion on the same plate? Why should not perspective be studied from angles hitherto neglected or unobserved? Why, I ask you earnestly, need we go on making commonplace little exposures of subjects that may be sorted into groups of landscapes, portraits, and figure studies? Think of the joy of doing something which it would be impossible to classify, or to tell which was the top and which the bottom!"

Visual Experimentation

Pictorialism became inbred in the photographic societies; as a reactionary force it waged war against the active production of the "moderns." In 1929, however, a major exhibition held in Stuttgart, Germany, entitled "Film und Foto"—the work of leading photographers throughout the world—explored the scope and vitality of antipictorialism. Two main areas seemed evident: one, the direct use of camera and materials to express the concerns of a personal

vision; the other, employing photographic materials or portions of photographs to construct a statement (photogram and photomontage). The driving force of one of the exhibition's leading participants, L. Moholy-Nagy, has done much to sustain the important concept of visual experimentation.

Edward Weston's work was also represented in the exhibition—a work associated with the concept of Straight Photography, but which more significantly expressed a highly individual way of seeing. Writing in *Experimental Cinema* in 1931, Weston expresses the central motivating force of his work: "Life is a coherent whole: rocks, clouds, trees, shells, torsos, smokestacks, peppers are interrelated, interdependent parts of the whole. Rhythms from one become symbols of all. The creative force in man feels and records these rhythms, these forms with the medium most suitable to him—the individual—sensing the cause, the life within, the quintessence revealed directly without the subterfuge of impressionism, beyond the range of human consciousness, apart from the psychologically tangible.

"Not the mystery of fog nor the vagueness from smoked glasses, but the greater wonder of revealment—seeing more clearly than the eyes see, so that a tree becomes more than an obvious tree.

"Not fanciful interpretation—the noting of superficial phase or transitory mood: but direct presentation of *things in themselves.*" You may recall that seventy-five years earlier the landscape photographer James Mudd expressed a similar concern for "beauty in the object itself." But even today this significance in relation to photography is scarcely understood.

Many of the old precepts remain. The extension of expression—to challenge our feelings rather than satiate them—demands an understanding of the significance of vision and the value of personal expression. Devoid of categorical assessments, the confining and self-limiting question of subject matter, landscape, with or without people, recognizable or unrecognizable, would emphasize the need for visual literacy. To understand the significance of a visually imaginative commitment, one has only to explore the history of art. He will be assured that its very existence speaks of many points of view, but collectively they represent a penetrating understanding of the world. Possibly what is yet to be considered is that in a world composed of images, a photographer, aware of the significance of vision as a sense of selective observation, can isolate inner realities found to be in correspondence with the physical world.

3

Foreword to Photography 63

Nathan Lyons

The New York State Exposition and the George Eastman House of Photography have co-sponsored this exhibition to acknowledge and encourage the work being done by a younger generation of photographers. The exhibition is primarily based upon the recommendations of the Nominating Committee. In a very real sense this is their exhibition; our function has been to bring all phases of the project together. Of the 148 photographers participating in the exhibition only 22 were selected from the open section. Photographers were asked to send three photographs. Nominated photographers submitted their work with the understanding that at least one photograph would be exhibited. Photographers were informed that their work would be selected by the Director of the Exhibition.

In accepting the responsibility of carrying out the Nominating Committee's recommendations, it was felt that in most instances a minimum of two photographs should be exhibited by each photographer. By following this procedure it was felt that a truer picture of the general nature of the photographer's work could be presented.

Reprinted by permission from *Photography 1963* (Rochester, N.Y.: International Museum of Photography at George Eastman House, 1963).

Comparing the two photographs by a photographer is important for an understanding of each photograph. In doing so we must put aside the argument that the photographer is the best judge of his own work. This is not the question here, at all. The intent is not only to recognize and encourage, but to understand—to understand the inclinations of the photographer as a statement maker, and to study the nature of the statement being made. To truly understand the abilities of the photographer his work must be experienced as an individual synthesis, each photograph seen in the context of other photographs he has taken. The exhibition and the catalogue are designed as a graphic index of photography as practiced by a younger generation of photographers.

On what basis, therefore, might we begin to assess the work in this exhibition beyond obvious technical or stylistic considerations? When we look at the work of a photographer can we sense the unity within his own work? It may be well to say that man seeks to find form for the expression of his ideas and feelings, but to what degree are we willing to share or understand what it is he is attempting to say? The extension of expression, to challenge our feelings rather than satiate them, demands an understanding of the significance of vision and the value of personal expression.

If a reasonable distinction can be made between a familiar view of nature and an unfamiliar view of nature, then it could be said that through the former we may understand events which confirm or remind us of known experiences, while through the latter we become involved with experiences which extend or challenge that which we know. The camera has been used primarily to record a familiar view, too often in the sense of the reprographic (document copying for scientific, cultural, industrial, or administrative purposes) or topographic. In contrast to these applications of the medium, events isolated from the physical world are not selected at random by a machine, but arise as the result of its use as an extension of the complex response mechanisms of a man. It is, therefore, on the question of the relationship of photography to perception that emphasis must be placed.

Photography is primarily a means of retaining the impressions that an individual deems significant. This, we may say then, is his point of view. When we speak of statement making in relation to a point of view, the emphasis is not placed on the photographic image, but on the image photographed. The photographer extracts, selective-

ly, a rectangle from the complex structures and events of the world. It represents the removal of a part from its original context. The nature of the statement will be a reflection of the view of nature the individual is capable of responding to. The photographer, therefore, must be able to perceive, articulate, and extend his own capabilities as a statement maker. If he understands creative expression to be a generative process, his attention must be directed towards perceptions which extend or challenge that which he knows.

Sensory activity in relation to the response situation may be evaluated further on the basis of the literal and non-literal aspects of visual statement making. The literal functions on the basis of known and accepted representations or symbols. In other words, they are directly associative. The non-literal is not as directly associative as the literal, primarily because it functions along completely different lines. Here the photographer becomes involved with the pictographic representation of unknowns or unknown symbols. It is through use and in the greater context of an art tradition that their meaning can be understood.

4

Meditations Around Paul Strand

Hollis Frampton

They say that we Photographers are a blind race at best; that we learn to
look at even the prettiest faces as so much light and shade; that we seldom
admire, and never love. This is a delusion I long to break through. . . .
 —Lewis Carroll, 1860

Is still photography fated to wrestle forever with its immemorial trou-
bles?

A year ago, a student of mine explained, with great agitation, why
she was giving it all up: there was *"no history of thought"* in pho-
tography, but only a *"history of things."* During 130 years of copi-
ous activity, photographers had produced no *tradition*, that is, no
body of work that deliberately extends its perceptual resonance
beyond the boundaries of individual sensibility. Instead there was a
series of monuments, mutually isolated accumulations of "precious
objects," personal styles more or less indistinctly differentiated from
the general mass of photographic images generated "by our culture,
not by artists," from motives merely illustrative or journalistic.

Furthermore, every single photographer had somehow, for him-

self, to exorcise the twin devils of painting and the graphic arts: there was, seemingly, no way for photography to cleanse its house. Master and journeyman alike had to face down, in a kind of frozen Gethsemane, the specter of the plastic arts. She had wearied of it.

Twelve years before, less than certain of an alternative, I had wearied too. So I baited her, and listened. What would she do? Why not embrace the monster, and paint? "Good God, no," she answered, "that would be even worse!"

There was only one thing to do: she would make films. And then: "What I mean is, films are made for the mind; photographs seem to be only for the eye."

And again: "Anyway, all photographs are beginning to look alike to me, like pages of prose in a book." Did I know what she meant?

She meant that they all "looked as if they had been made by the same person."

If twentieth-century American photography has given us as many as three grandmasters, undisputed by virtue of their energy, seniority, and bulk of coherent oeuvre, then their names must be Alfred Stieglitz, Paul Strand, and Edward Weston. The first and last are gone; Strand alone, Homerically, survives.

Stieglitz, an evidently volcanic figure whose precise mass has never been rigorously assayed, was born in Hoboken, New Jersey, in 1864; he was Paul Strand's mentor (so says Strand) and died in 1946. The transplanted Californian, Weston, was confirmed in his true vocation during a 1920 visit to New York, in the heyday of *Camera Work* and "291," where he saw photographs by Stieglitz and Strand, and met them both. Weston died on New Year's Day, 1958.

It is scarcely necessary to point out that exhaustive examination is decades overdue for all three of these men.

Mercifully, we are given, for the first time since his 1945 retrospective at the Museum of Modern Art, just such a view of the whole work of Paul Strand, in a really massive exhibition originating at the Philadelphia Museum of Art. (During the next three years, the photographs will travel to five other museums in the United States.) There are nearly 500 prints, together with the films[1] for which Strand must bear crucial esthetic responsibility.

The show is accompanied by the publication of *Paul Strand/A Retrospective Monograph/The Years 1915–68*. This is not the usual small souvenir catalogue, but a large quarto volume of nearly 400 pages which contains, along with biographical and bibliographical

material, and a systematic nuggeting of texts by and about Strand, impeccably acceptable reproductions of more than half of the photographs in the show.

Paul Strand himself supervised in detail the installation of the show and the design of the book. The results of both efforts vary from ordinary expectation in ways that illuminate Strand's convictions on the nature and cultural meaning of photographic images.

So I shall have to examine their suggestions at some length, and also take up, along the way, some fundamental problems implied by photographs at large.

To begin with: the word "retrospective" is sufficiently misleading, in this case, to suggest important dissociations. Nearly all the prints in the show are *new*, made and matched especially for the occasion. (Consider, for a moment, the unimaginable parallel case in painting!)

What Strand has actually made, during fifty-three years, is a large number of *negatives*.

The negative has somewhat the same relation to the photographic print as the block has to the woodcut, with the important difference that the curatorial notion of "states" does not apply to photographs. That is, the graphic artist's plate suffers gradual attrition during the pulling process, whereas a virtually infinite number of prints may be generated from the information stabilized in a single negative.

But the photographic result is no more fixed or automatic than the graphic. In the hands of a gifted and able printer (and Strand is supremely both) a single negative may be made to yield prints of the most extraordinary variety. I would compare the process to that of deciphering the figured basses in baroque keyboard works: given a sufficiently wide rhetorical field to work in, there must finally obtain the possibility of shifting a whole work from one to another mutually contradictory emotional *locus* by the variation of a single element.

I seem to be speaking, of course, of what has been derogated as *nuance;* and there is a strain in the temper of modern art that has, quite rightly I think, found suspect any tendency to locate the qualities of art works outside the *direct conceptual* responsibility of the artist, in "performance" or "interpretive" values. But for Strand (himself the craftsman-performer of his stock of negatives) such concerns amount, as we shall see, to very much of his art.

Nuance is a superficial matter. But photographs are, in the pre-

cise sense, perfectly superficial: they have as yet no insides, it would seem, either in themselves or inside us, for we are accustomed to deny them, in their exfoliation of illusion, the very richness of implication that for the accultured intellect is the *only way at all* we have left us to understand (for instance) paintings.

To put it quite simply, a painting which may be, after all, "nothing but some paint splashed on canvas," is comprehended within an enormity which includes not only all the paintings that have ever been made, but also all that has ever been attributed to the painterly act, seen as abundant metaphor for one sort of relationship between the making intelligence and its sensed exterior reality. The "art of painting" seems larger than any of its subgestures ("paintings"), protecting, justifying, and itself protected and justified as a grand gesture within the humane category "making."

Contrariwise, photography seems to begin and end with its every photograph. The image and its pretext (the "portrait" and the "face," which bear to one another the relationship called "likeness") are ontologically manacled together. Every discrete phenomenon has its corresponding photograph, every photograph its peculiar "subject"; and after little more than a century, the whole visible cosmos seems about to transform itself into a gigantic whirling rebus within which all things cast off scores of approximate apparitions, which turn again to devour and, finally, replace them.

We are so accustomed to the dialectics of twentieth-century painting and sculpture, that we are led to suppose this condition is a sorrow from which photographers hope for surcease. But this simply is not true, on balance; and most certainly not in Strand's case. Rather, a stratagem by no means peculiar to Strand, but detectable in the work and published remarks of photographers in every generation since Stieglitz, has consisted in insisting (with considerable passion) upon the primacy of photography's illusions and, simultaneously, upon the autonomy of the photographic artifact itself.

The larger esthetic thrust of photography has concentrated, not upon annihilating this contradiction, as painting seems always to verge upon doing, but instead upon *containing* it; since the West is still largely populated by closet Aristotelians, we are far from inheriting all the wealth that may be born to the mind in entertaining, equidistant from a plane of contemplative fusion, two such evidently antagonistic propositions. However, in photography the paradox lies at the very core of the art, refusing to be purged.

For Paul Strand, both theses interlace and are succinctly bracketed in a single notion: Craft. For it is by craft that illusion reaches its most intense conviction, and by craft also that the photograph is disintricated from other visible made things, through regard for the inherent qualities of photographic materials and processes. Craft is, moreover, a complex gesture, which begins with a formal conception and precipitates in the print.

So we return to the exhibition: hundreds of such precipitate.

Yet I should like to pursue this matter of photographic prints into still further distinctions, since they are, after all, the only evidence we have.

Let us suppose, for a moment, that every work of art consists of two parts: a *deliberative structure*, and an *axiomatic substructure*. The structure is what is apparent, that is, the denumerable field of elements and operations that constitute the permanent artifact of record. Barring corruption by moth and rust, it is immutable—and of course it is here that art, curiously, used to spend so much of its energy, in consolidating physical stability.

The substructure consists of everything the artist considered too obvious to bother himself about—or, often enough, did not consider at all, but had handed him by his culture or tradition. Axioms are eternal verities—subject, as we have begun to see, to change on very short notice.

There was a time, when art concerned itself with its structure merely: what art itself was seemed clear enough. That every single work of art assumes an entire cosmology and implies an entire epistemology (I take it this is the Goldbach's Theorem of analytic criticism) had occurred to no one. And they called it the Golden Age.

We are accustomed to examine the axiomatic assumptions of any work of art (or of anything else)—to examine its substructure, in short, in stereoscopic focus with its structure. The tendency to do so is what make us (for serious lack of a better term) "modern." The utter concentration of attention upon what is "assumed," upon the root necessity of an art, is called radicalism.

Photography came in 1839 into an axiomatic climate of utmost certainty. What art was, and what it was for, were known. The photograph simply inherited the current axioms of painting. It became a quick and easy method for meeting most of the conditions prescribed for the art object: it "imitated," according to the strangu-

lated contemporary understanding of that verb. By the 1890s, painting had begun to examine its own assumptions and bequeath those it discarded to the photograph, which had long since bifurcated: there was the photographic "record," and then there was photographic Art. The former went its own way; the latter imitated currently fashionable (*not* radical) painting.

Enter Stieglitz, who came, in time, to sense that the photograph merited at least a generic substructure of its own—whose reflex sympathies (he had been trained as a photoengraver) moved him eventually too choose the alternate pathway, the photograph that, if it had not repudiated the assumptions of art, was at least indifferent to them. At this remove, many of Stieglitz's prints still look suspiciously like art, but his *Steerage* remains a talisman as acute as any in photography. He was an able polemicist, and "291" was a sure and defensible critical act—but he was not a particularly nimble or fervid theorist.

Enter Paul Strand, a man very much younger, of drastically different temper. It must be admitted that some of *his* earliest work also looks like art, and moreover like modern art. But it is quite clear from his photographs and from his early writing[2] that he saw, instantly:

1. photography must separate itself immediately from painting and the graphic arts;

2. the separation must be based upon sensible axiomatic differences directly related to *illusion;*

3. photography must insist upon the special materiality of its own process.

It is easy enough to assent to all this, although the arguments were certainly fresher in those days, and their paragraphs more open to the mysterious options of self-cancellation. But *then*—indistinctly (and three generations later, they still are not wholly focussed)— come intimations of a novel insight.

If I read Strand correctly, his reasoning (in my own terms) runs thus:

A. The structure of the photographic image is wedded absolutely to illusion. As photographers, we are committed to the utmost fidelty of spatial and tactile illusion.

B. *Mais d'abord, il faut être poète.* No two men, however perfect their illusionary craft, make commensurable photographs from the same pretext.

C. These differences *must* somehow be accounted for. So they must lie within the substructure of the work, that is, among its cosmological and epistemological assumptions.

D. Therefore, every parameter of the photographic process (". . . form, texture, line, and even print color . . .") *directly* implies, and defines, a view of reality and of knowledge.

In so conceiving the *structure* of a work as entirely "given," and locating all control in its axiomatic substructure, Strand originates an inversion of (Romantic) values that is still in the process of assimilation. To the sensibility oriented towards painting, quite extreme parametric variations on a single photographic image must seem no more than pointlessly variant "treatments" of an icon. But to any mind committed to the paradoxical illusions of the photographic image, the *least* discernible modification (from a conventionalized norm) of contrast or tonality must be violently charged with significance, *for it implies a changed view of the universe, and a suitably adjusted theory of knowledge.*

In cleaving thus to sensory *données,* the photographer suggests a drastically altered view of the artist's *role.* The received postures of Spirit Medium and Maker nearly disappear. On the deliberative level, the artist becomes a researcher, a gatherer of facts, like Confucius' ancients, who, desiring Wisdom, "sought first to extend their knowledge of particularities to the uttermost." And on the axiomatic level, where the real work is now to be done, the artist is an epistemologist.

The quest for nominally perfect fidelity to spatial and tactile illusion excludes the very concept of *style* as irrelevant; and "development," within the lifework of one man, yields to increasingly exhaustive rigor of Archimedean approximation. (In portraiture, for example, expression is to be avoided, for it must necessarily interfere with the study of physiognomy.) Ideally, the fully disciplined artist should be able to visit the same site on two occasions decades apart and return with identical images.

Carried to its logical outcome, the ambition of this activity can amount to nothing less than the systematic recording of the whole visible world, with a view to its entire comprehension. And that is a sober enterprise indeed.

Thus the importance for Strand of what he calls "craftsmanship," and thus also the importance of the print. In reprinting nearly every

photograph for the present exhibition, Strand is conforming the *investigations* of a lifetime to his current (presumably mature and perfected) view of the world. So that this retrospective view of his work is not for us, the "visitors," alone; it is not even primarily ours, for we have never seen the prints he made in 1916 from the negatives of that year. Nevertheless, *he* holds them in his own mind; this retrospective is for Strand himself.

All the photographs are hung, in single or double rows, at about eye level. They are presented with the most severe uniformity, in wide white mattes, behind glass, in narrow white frames. The gallery walls are white. There are no captions or dates, but only the most unobtrusive small *numbers,* and these do not run serially. The prints are not arranged chronologically. The treatment is reminiscent of microscope slides—somewhat disordered cross sections from the tesseract of Strand's sensibility—or criminological photographs from old Bertillon files.

Most of the prints fall within the bounds of 8 by 10 inch paper, although a very few go to 11 by 14 and a few more are smaller. Strand seems indifferent, but hardly insensible, to classic prohibitions against cropping. A small number of prints are toned: I assume these are the oldest in the show. Occasional prints are extremely grainy: that the superimposed syntax of grain is "admissible" is surprising.

With a single exception, Strand appears to accept the standard painterly categories of portrait, landscape, still life, abstraction (the latter remains strictly referential, and is achieved through extreme close-up and adroit cropping, a familiar device of which Strand is co-originator). Each category is dealt with from a few carefully standardized points of view. Landscapes, seldom peopled, are of two sorts: a wide panorama, on the one hand, and on the other—where there are man-made structures—a near middle distance characterized by flattened, geometric frontality and extremely delicate attention to the boundaries of the image-rectangle. Portraits are mostly frontal, posed. They are Roman busts. (But there are a few full-lengths, and an extensive subset of heads.) There are few interior architectural spaces but a relative abundance of exterior architectural detail, very often carved wood or stonework related to Christian iconography. Images of animals are rare, and then most often parenthetical: friends who have spent time (and have themselves photographed) in Mexico, Mediterranean Europe, and Africa, have commented upon this with amazement.

Finally, there is one category entirely missing: the nude. There simply are not any images of the nude human figure at all. And then, as if to underscore deliberately the omission, one is obliged to reckon with the presence, on loan from Strand's private collection, of a quarter-scale bronze sculptured nude by Gaston Lachaise, long a close personal friend of the photographer. I am constrained to consider what Strand has in fact *done*—and not what he has omitted or avoided doing—but I cannot help but record my absolute astonishment at this; it is a lacuna which contradicts much that I had divined of Strand's esthetic, for there is nothing elsewhere, in either his work or his writing, which suggests that anything under the sun might be exempt from the scrutiny of his lens.

I have said that the ordering of photographs, in both the show and its strictly parallel monograph, pointedly avoids both chronology and titling. Nonetheless, there *is* a principle of organization.

The small numbers on the mattes refer us to placards, posted occasionally throughout the exhibition space, which describe each image by title (when there is one)—and *always* by date and locale. And it is by *locale*, in fact, that the prints are sorted. Strand has returned often to his accustomed sites, and two adjacent photographs from Vermont, for example, may be dated thirty or forty years apart. (Predictably, they differ from one another no more than they might if made on consecutive days.) The photographer, if he could go on working for a few more millennia, might photograph the whole terrain of the world; the local human fauna seem almost excrescences, albeit absorbing ones, of the landscape and local architecture.

The barest attempt to reconstruct a diachrony meets with the photographer's implicit reproof: information is never withheld, but it is made effectively inaccessible, since its pursuit necessitates endless trips from photograph to identifying legend and back again. The meaning is quite clear. Still photography has, through one and another stratagem, learned to suspend or encode all but one of our incessant intuitions: I refer to what we call *time*. Paul Strand seems consciously intent, in his presentation of his work as in the work itself, on *refuting* time. It seems distinctly forbidden that the problem shall ever arise.

Paul Strand's work has been praised by everyone who has ever written about it, and I will not presume to praise it further. It has been called everything. Stieglitz called it "pure," and thereby per-

haps founded our abuse of that adjective; others have called it "brutal" and "elegant" (though it is curious that no one person has thought it both). But I should like to say something about the residue of feeling I am left with, at the brief remove of three weeks: the entire exhibition rhymes perfectly twice with every photograph in it: once, in its almost unbearably sumptuous appearance—and again, in the exquisite chastity of its assumptions.

Through the years, a man peoples a space with images of provinces, kingdoms, mountains, bays, ships, islands, fishes, rooms, tools, stars, horses, and people. Shortly before his death, he discovers that the patient labyrinth of lines traces the image of his own face.

—Jorge Luis Borges

Notes

1. Strand has been a professional cameraman for a large part of his adult life, and so has probably shot scores of films. I refer only to: *Manahatta*, 1921 (with Charles Sheeler); *Redes*, 1933; *The Plow That Broke the Plains*, 1935 (directed by Paré Lorentz); *Native Land*, 1942.

2. Three early essays contain, as it were, the Analects of Paul Strand; later items in his bibliography do not modify appreciably the views expressed in: "Photography," *Seven Arts*, August, 1917, pp. 524–26. "Photography and the New God," *Broom*, Vol. 3, No. 4, 1922, pp. 252–58. "The Art Motive in Photography," *The British Journal of Photography*, Vol. 20, 1923, pp. 612–15.

5

The New West

Foreword

John Szarkowski

As Americans we are scarred by the dream of innocence. In our hearts we still believe that the only truly beautiful landscape is an unpeopled one. Unhappily, much in the record of our tenancy of this continent serves to confirm this view. So to wash our eyes of the depressing evidence we have raced deeper and deeper into the wilderness, past the last stage-coach stop and the last motel, to see and claim a section of God's own garden before our fellows arrive to spoil it.

Now however we are beginning to realize that there is no wilderness left. The fact itself is without doubt sad, but the recognition of it is perhaps salutary. As this recognition takes a firmer hold on our consciousness, it may become clear that a generous and accepting attitude toward nature requires that we learn to share the earth not only with ice, dust, mosquitoes, starlings, coyotes, and chicken hawks, but even with other people.

There is considerable evidence to support the view that man is a unique and foreign mutation, an exception, in the otherwise natu-

Reprinted by permission from *The New West: Landscapes Along the Colorado Front Range* (Boulder: Colorado Associated University Press, 1974).

ral and symbiotic life of the planet. Granted, this evidence has been collected and interpreted by men, which suggests that the conclusion might be a perverse sort of bragging. Nevertheless, this view has provided grist for the mills of many of America's most distinguished artists. The most important of these in terms of recent influence is perhaps Thoreau, whose elegantly expressed dyspepsia has convinced many otherwise intransigent rationalists that man is not in fact a part of nature.

Whatever his failings as a naturalist and a philosopher, Thoreau was a very great artist. And, as is well known, the gifts of artists are not really free. Even the gifts of very minor artists are not free. Consider this ad from a photographic trade paper:

NEW BLUE SKIES

If for some reason the sky in your transparency is unsuitable, we can, in most instances, substitute a new blue sky and at the same time remove wires, telephone poles and other objectionable objects appearing in the sky. Charge for this is $20.00.

Not free, but a bargain surely, and a proposition that contains a very imaginative concept: a system for renewing the landscape at the retoucher's table, costing no inconvenient displacement of the world's serious work.

If this is the best we can manage, we should not scorn it, for our best deserves better than easy jokes. On the other hand it is possible that we *might* do better—that we might achieve a landscape that we would find not only good to look at in pictures, but good to fly over, drive past, walk through, and even live in—one that might offer the rewards of recognition and remembrance. Such a place would be a natural landscape with people in it.

This we have considered a contradiction in terms. Since we have understood men to be dangerous at best, and tolerable in the countryside only at very low densities, we have given little serious thought to the proposition that a landscape might be simultaneously beautiful, natural, and populated by human beings. We have instead explored the plausible alternatives.

The most useful of these alternatives has been the idea of segregating the esthetic and the practical functions of the land. This con-

cept has been pursued in the United States with vigor, intelligence, and considerable success since the administration of U. S. Grant. The concept says in essence that certain especially splendid parts of the natural landscape should be fenced around, in order to keep the citizenry out, or to allow them in as transient visitors, under adequate precautionary controls. This idea has achieved great victories, especially in the case of lands which lie on the tops of mountains, or in the basins of deserts, or on the rocky spines of the northern spruce belt, to which areas relatively few of the citizenry have, until now, demanded permanent access.

For the great past and future gifts of the traditional conservation concept we should all be profoundly grateful. We should also be vigilant, for the fences are erected by men, who are equally capable of removing them, after exercise of their best judgment.

Nevertheless it is probably true that the exemplary value of the great parks will obtain only as long as there is some recognizable relationship between the landscape inside the fence and that outside. When this relationship is no longer visible, or remembered, honest men will storm the parks and collect its specimens as exotic souvenirs, as we do the cult objects of forgotten religions.

Thus even to preserve our natural parks we must learn to use naturally the land that lies outside their boundaries. It is not likely that we will manage this as long as we consider ourselves nature's natural enemies. As a step in the right direction, we might try to think of ourselves not as rapists of the landscape, but as its clumsy and naive lovers.

In this self-conciliatory spirit, what, if anything, can be said in defense of the sprawling non-towns that suddenly cover so much of what was recently our beautiful countryside? It is well known that these recent settlements do not compare favorably, by any known esthetic standard, with Positano, for example, or Stockbridge, Mass., or for that matter with any ordinary American farm town before World War II. Nevertheless a man of objectivity, intelligence, and good will might conceivably find even in this chaff the seeds of new virtues, as yet unlabeled. Or, alternatively, to the degree that the alleged objectivity might really be a traditional Yankee contrariness—the other side of the perverse Thoreauvian coin—such a man might actually prefer to discover a suggestion of hope right in the middle of God's Own Junkyard than in the places where he has been

told to look. We should also keep in mind the artist's close affinity to the magician, and the pleasure he takes in making silk purses out of sows' ears.

But whether out of a sense of fairness, a taste for argument, or a love of magic, Robert Adams has in this book done a strange and unsettling thing. He has, without actually lying, discovered in these dumb and artless agglomerations of boring buildings the suggestion of redeeming virtue. He has made them look not beautiful but important, as the relics of an ancient civilization look important. He has even made them look, in an unsparing way, natural.

Adams' pictures describe with precision and fastidious justice some of the mortal and venial sins that we have committed against our land in recent decades. The gaggle of plywood ranch houses at the foot of the mountain, fenced in by the trailer parks, acid neon, and extruded plastic of the highway, is an affront even to our modest expectations. But his pictures also show us that these settlements express human aspirations, and that they are therefore not uninteresting. It is clear also that these places are very casually built, and will therefore acquire character soon enough. Amateur carpenters, willful repairmen, and the fearful climate will add a sort of architectural variety. And as Adams says, the sun shines on these works also, even if not quite so brightly as it did.

Adams' pictures are so civilized, temperate, and exact, eschewing hyperbole, theatrical gestures, moral postures, and *expressivo* effects generally, that some viewers might find them dull. There is probably nothing that can be done about this. It is not even certain that anything should be done about it, since the measured Attic view of things is not intrinsically better than the romantic. But other viewers, for whom the shrill rodomontade of conventional conservation dialectics has lost is persuasive power, may find in these pictures nourishment, surprise, instruction, clarification, challenge, and perhaps hope.

Though Robert Adams' book assumes no moral postures, it does have a moral. Its moral is that the landscape is, for us, the place we live. If we have used it badly, we cannot therefore scorn it, without scorning ourselves. If we have abused it, broken its health, and erected upon it memorials to our ignorance, it is still our place, and before we can proceed we must learn to love it. As Job perhaps began again by learning to love his ash pit.

Introduction

Robert Adams

The first uplift of the Rocky Mountains, the Front Range, revealed to nineteenth-century pioneers the grandeur of the American West, and established the problem of how to respond to it. Nearly everyone thought the geography amazing; Pike described it in 1806 as "sublime," and Kathryn Lee Bates eventually wrote "America the Beautiful" from the top of the peak he discovered. Nonetheless, as a practical matter most people hoped to alter and exploit the region.

The mountains still synopsize the frontier, though our expectations have matured and the significance of the land has therefore changed— we want to live with it harmoniously. This may seem a tame goal when compared to that of our forebears, but in fact the struggle is desperate because it is also to live with ourselves, against our own creation, the city, and the disgust and nihilism it breeds.

Many have asked, pointing incredulously toward a sweep of tract homes and billboards, why picture *that?* The question sounds simple, but it implies a difficult issue—why open our eyes anywhere but in undamaged places like national parks?

One reason is, of course, that we do not live in parks, that we need to improve things at home, and that to do it we have to see the facts without blinking. We need to watch, for example, as an old woman, alone, is forced to carry her groceries in August heat over a fifty-acre parking lot; then we know, safe from the comforting lies of profiteers, that we must begin again. Arthur Dove, the painter, was right:

> We have not yet made shoes that fit
> like sand
> Nor clothes that fit like water
> Nor thoughts that fit like air
> There is much to be done. . . .

Paradoxically, however, we also need to see the whole geography, natural and man-made, to experience a peace; all land, no matter what has happened to it, has over it a grace, an absolutely persistent beauty.

The subject of these pictures is, in this sense, not tract homes or

freeways but the source of all Form, light. The Front Range is astonishing because it is overspread with light of such richness that banality is impossible. Even subdivisions, which we hate for the obscenity of the speculator's greed, are at certain times of day transformed to a dry, cold brilliance.

Towns, many now suggest, are intrusions on sacred landscapes, and who can deny it, looking at the squalor we have laid across America? But even as we see the harm of our work and determine to correct it, we also see that nothing *can*, in the last analysis, intrude. Nothing permanently diminishes the affirmation of the sun. Pictures remind us of this, so that we are able to say with the poet Theodore Roethke, "Be with me, Whitman, maker of catalogues: For the world invades me again."

6

Introduction to The New Topographics

William Jenkins

. . . I should try to tell, in a straightforward way, plain stories, so that I will try to get away from mazes, from mirrors, from daggers, from tigers, because all of those things now grow a bit of a bore to me. So that I will try to write a book, a book so good that nobody will think I have written it. I would write a book—I won't say in somebody else's style—but in the style of *anybody* else.[1]

—Jorge Luis Borges

There is little doubt that the problem at the center of this exhibition is one of style. It should therefore be stated at the outset that while this introduction will concern itself with the exhibition as a stylistic event, the actual photographs are far richer in meaning and scope than the simple making of an esthetic point. Sr. Borges has stated his ambitions in terms of stylistic anonymity, but such an intention merely provides a framework within which he will continue to write, perhaps not about tigers and daggers, but about something other than the work itself.

This point is made first because the stylistic context within which

Reprinted by permission from *The New Topographics* (Rochester, N.Y.: International Museum of Photography at George Eastman House, 1975).

51

all of the work in the exhibition has been made is so coherent and so apparent that it appears to be the most significant aspect of the photographs. It would seem logical to regard these pictures as the current manifestations of a picture-making attitude that began in the early nineteen sixties with Edward Ruscha. His books of photographs (*Twentysix Gasoline Stations* [1962], *Some Los Angeles Apartments* [1965], and others) possessed at once the qualities of rigorous purity, deadpan humor, and a casual disregard for the importance of the images which even permitted the use of photographs not made by Ruscha himself. The pictures were stripped of any artistic frills and reduced to an essentially topographic state, conveying substantial amounts of visual information but eschewing entirely the aspects of beauty, emotion, and opinion. Regardless of the subject matter the appearance of neutrality was strictly maintained. Ruscha made his point with such clarity and renown that his importance as an antecedent to the work under discussion should be obvious. Yet the issue suggested by this relationship is a very difficult and critical one.

There is an obvious visual link between Ruscha's work and the pictures shown here. Both function with a minimum of inflection in the sense that the photographers' influence on the look of the subject is minimal. Frank Gohlke feels that much of this sense of neutrality lies in the way the edges of the picture function and that the work in the show (including his own) maintains an essentially *passive* frame. That is, rather than the picture having been created by the frame, there is a sense of the frame having been laid on an existing scene without interpreting it very much. The exhibitors also share subject matter with Ruscha, picturing, almost without exception, man-made structures within larger contexts such as landscapes.

Yet there remains an essential and significant difference between Ruscha's *Twentysix Gasoline Stations* and, as an example, John Schott's undetermined number of motels along Route 66. The nature of this difference is found in an understanding of the difference between what a picture is *of* and what it is *about*. Ruscha's pictures of gasoline stations are not about gasoline stations but about a set of esthetic issues. John Schott summarized the position neatly: " . . . they [Ruscha's pictures] are not statements about the world through art, they are statements about art through the world."

I have deliberately chosen to belabor the Ruscha issue because that distinction, though elusive, is fundamental to photography. The two distinct and often separate entities of actual, physical subject

matter and conceptual or referential subject matter can be made to coincide. It is this coincidence—the making of a photograph which is primarily *about* that which is in front of the lens—that is the central factor in the making of a document.

The world is infintely more interesting than any of my opinions concerning it. This is not a description of a style or an artistic posture, but my profound conviction. The fictional properties of even the most utilitarian photograph suggest the difficulty of coming to a genuine understanding of the medium's paradoxes, let alone its power. As it is somewhere on a cloudy continuum between the literary and the painterly, so likewise does it hover between fact and point of view. I love the contradictions of photography. Each successful photograph balances content with form and truth with aspect, using a solution unique to itself. While describing something that matters with clarity, economy, and force seems to be photography's perennial esthetic, how this comes about remains for most a private and, for the most part, intuitive matter. The best photographs are transparent, sensual, intelligent, fulfilled, freshly arrived, enduring and, in the deepest sense, are of the world.[2]

<div style="text-align: right">

—Nicholas Nixon
June 3, 1975

</div>

The word *topography* is in general use today in connection with the making of maps or with land as described by maps and it does not unduly stretch the imagination to see all photographs as maps of a sort. But for the sake of clarity a return to the orginal meaning may be helpful: "The detailed and accurate description of a particular place, city, town, district, state, parish or tract of land."[3] The important word is *description* for although photography is thought to do many things to and for its subjects, what it does first and best is describe them.

Unfortunately, the simple descriptive function of the photographic image is linked to other, more complex issues. The last exhibition of current photography presented at the International Museum of Photography ("The Extended Document," February–May 1975) dealt with artists who were actively, through their work, questioning the photograph's veracity. Such concerns stemmed from a recognition that it is precisely photography's pretense of truthfulness, its assertion of accuracy that gives it the ability to mislead so effectively. The issue was not that photographs are inherently untruthful, but that the relationship between a subject and a picture of that subject is extremely fragile. The simple task of describing something photographically requires that this delicate coherence be preserved.

There is something paradoxical in the way that documentary photographs interact with our notions of reality. To function as documents at all they must first persuade us that they describe their subject accurately and objectively; in fact, their initial task is to convince their audience that they are truly documents, that the photographer has fully exercised his powers of observation and description and has set aside his imaginings and prejudices. The ideal photographic document would appear to be without author or art. Yet of course photographs, despite their verisimilitude, are abstractions; their information is selective and incomplete.[4]

—Lewis Baltz

If then, as Lewis Baltz suggests, the photograph needs to appear without author in order to function well and maintain veracity, what has become of style? Is it possible to negate style, to make a photograph that is style-less? When Timothy O'Sullivan photographed the American West he was working without precedent. Many of his subjects had never been photographed and he was working in a medium which had virtually no past. It would therefore be possible to conclude that O'Sullivan and other photographers of the early and mid-nineteenth century neither embraced nor rejected any existing photographic style or esthetic: that they had no style. (Even this is questionable since they were subject to varying degrees of visual prescription from painting.) It is, however, impossible to imagine the photographers in this exhibition working in a critical and historical vacuum. To recognize one's antecedents (as Robert Adams has done) and to elect to make pictures that look a certain way is a stylistic decision, even if the effort is to subdue the intrusion of style in the picture.

In making these photographs I attempted to make a series of images in which one image is equal in weight or appearance to another. Many of the conscious decisions made while the series was evolving had to do with denying the uniqueness in subject matter or in one exposure as opposed to another in the belief that the most extraordinary images might be the most prosaic, with a minimum of interference (i.e. personal preference, moral judgment) by the photographer. An early decision was that a formal undifferentiated approach be used "as a plate on which to serve up the subject matter," so as to minimize the formal decisions which recur every time an exposure is made. The approach chosen accommodated my desire for less personal intrusion and greater uniformity. 1) By being at a greater distance from my subject matter it became difficult to significantly alter the angle of view or organization of the image by a step or two in any direction; 2) the point of view and distance from the subject allowed an acceptance by the lens of a greater amount of contextual information without allowing too great

a dominance of one object over another. The elimination of the vagaries of sky and horizon is partly an attempt to fill the frame and create a self-contained, undifferentiated space, and is also the elimination of a familiar clue to scale and orientation, and to that extent indicates the degree of ground-directedness of these photographs. Beyond that they are pure subject matter.

—Joe Deal
June 1975

Pictures should look like they were easily taken. Otherwise beauty in the world is made to seem elusive and rare, which it is not.

I admire the work of many photographers, but none more than that of O'Sullivan and Lange.

By Interstate 70: a dog skeleton, a vacuum cleaner, TV dinners, a doll, a pie, rolls of carpet. . . . Later, next to the South Platte River: algae, broken concrete, jet contrails, the smell of crude oil. . . . What I hope to document, though not at the expense of surface detail, is the Form that underlies this apparent chaos.

—Robert Adams
June 1, 1975

It must be made clear that "New Topographics" is not an attempt to validate one category of pictures to the exclusion of others. As individuals the photographers take great pains to prevent the slightest trace of judgment or opinion from entering their work. The pictures may occasionally become analytical as in the case of the Bechers' recent work from Pennsylvania. The *Typology of Coal Breakers* is a form of historical analysis and the *House Near Kutztown, Pennsylvania* a kind of formal analysis. But this process does not culminate in conclusion or judgment. The Bechers are content with observation. This viewpoint, which extends throughout the exhibition, is anthropological rather than critical, scientific rather than artistic. The exhibition, as an entity separate from the photographers, will hopefully carry the same non-judgmental connotation as the pictures which comprise it. If "New Topographics" has a central purpose it is simply to postulate, at least for the time being, what it means to make a documentary photograph.

Notes

1. Jorge Luis Borges, "A Post-Lecture Discussion of His Own Writing," *Critical Inquiry*, Vol. 1, No. 4, (June 1975), p. 710.

2. In May, 1975 all of the participating photographers were asked to submit, for

use in this catalogue, a statement about either their own work or the exhibition in general. Some, for excellent reasons, chose not to write. Others responded at length. Except where indicated otherwise, the quotations used in the introduction have been taken from this material.

3. *Webster's New Twentieth Century Dictionary, Unabridged,* Second Edition, s.v. "topography."

4. Lewis Baltz, review of *The New West,* by Robert Adams, in *Art in America,* Vol. 63, No. 2 (March–April 1975), p. 41.

7

Review of *The New West*

Lewis Baltz

There is something paradoxical in the way that documentary photographs interact with our notions of reality. To function as documents at all they must first persuade us that they describe their subject accurately and objectively; in fact, their initial task is to convince their audience that they are truly documents, that the photographer has fully exercised his powers of observation and description and has set aside his imaginings and prejudices. The ideal photographic document would appear to be without author or art. Yet of course photographs, despite their verisimilitude, are abstractions; their information is selective and incomplete. The power of the documentary photograph is linked to its capacity to inform as well as to reflect our perception of the external world. In view of this it becomes possible, for example, to marvel at the striking resemblance the rural South still bears to Walker Evans' '30s photos.

Few photographers have demonstrated as sophisticated an understanding of this as Robert Adams, whose recent book, *The New West*, is a model of excellence in documentary photography. His subject

is the suburban-strip development that has proliferated along the eastern slope of the Colorado Rocky Mountains, all the way from Wyoming to New Mexico, in the past twenty years. Adams has infused his vision of Colorado—the relation of its inhabited parts to its prairies and mountains—with the authority of absolute fact, yet his somewhat reductive style of picture making provides as well a complex moral understanding of the subject. Adams' antecedents might be the pioneer photographers Timothy O'Sullivan and William Henry Jackson, who worked in the same region a century earlier. Recent photography offers few parallels to Adams' work, although the use of photographic documentation in certain works of Conceptual art, such as Ed Ruscha's earlier books or the industrial typologies of Bernhard and Hilla Becher, suggests a similar belief in the primacy of the photographic information.

What distinguishes Adams from most of his photographer contemporaries is the distance, both emotional and intellectual, that he maintains from his subjects. This distance is essential to Adams' work, for he is presenting a record of man's attempts to live on—and occasionally with—the land, a debased theme generally left to the dubious mercies of sentimentalists and homespun metaphysicians. It is a subject requiring not only distance but honesty as well—also present in Adams' book to an extraordinary degree. These qualities permit him to direct our attention to the most meretricious examples of exploitative "development" without infecting his photographs with their vulgarity. More important, Adams' rigorous detachment, while restraining the temptation to moralize, allows him, nevertheless, to take a humane stance.

The new suburban areas of America pose an array of novel problems for society. Conceived in expedience for the sole purpose of maximum profit, pathetically dependent on the automobile, these new cities have disposed themselves formlessly along the frontage roads of every interstate highway. Posing an ecological threat which we are only now beginning to grasp, this new human sprawl is also ultimately as alien to urbanism as it is to the land it consumes. Adams' awareness of this contributes to the sense of ambivalence in many of his photographs. For as much as the landscape is altered and diminished by the growth of suburbs, the traditional virtues of city living, with its diversity and community, are dissipated as habitation is spread too thinly across the prairie. Adams shows us how ephemeral man-made structures look on the high plains of Colorado;

the scattered mobile-home parks and tract houses offer no bulwark against the arid and inhospitable lands they occupy so uneasily. It is difficult to think of them as homes or even as shelters; they resemble the test structures built at ground zero.

The sheer pervasiveness of this type of land use has engaged architects, planners, environmentalists, social critics of all persuasions, and, of course, photographers. Each has emphasized a different aspect of suburbia's virtues or shortcomings. Recent publications on the subject would form a small library, with Robert Venturi's iconoclastic celebration of Las Vegas at one end of the shelf and Bill Owens' *Suburbia*, a grim little indictment of middle America, at the other. *The New West* is a unique and valuable contribution to this library; no other book has demonstrated so clearly the mutuality of intrusion between the landscape and its inhabitants. Adams' understanding transcends partisanship; his introduction to *The New West* echoes the complex understanding of his eye: ". . . why open our eyes anywhere but in undamaged places like national parks? . . . we also need to see the whole geography, natural and man-made. . . ."

More enduring than man's structures is light; in Adams' Colorado, it is always too bright and glaring, offering little shade. Adams shows this light in its full measure: the relentless light of perpetual noon, which magnifies every flaw of the desiccated landscape. Lévi-Strauss observed that the cities of the Americas suffered from "a chronic illness . . . a high temperature . . . which prevents them, for all their everlasting youthfulness, from ever being entirely well." Citizens of our new cities sense this and arrange their lives to provide themselves the maximum possible insulation from the public areas of the city and from each other. Aware of this, Adams views the city more as a collection of artifacts than of personalities. His subjects are the fences, the one-way windows, the vacant lots, and all the rest behind which we stand. His style emphasizes how little moves when we insulate ourselves in this way. Adams is rare among landscape photographers in his reliance on a square format. This, together with his tendency toward a centralized image within the frame, results in unusually static pictures, appropriate to an urbanized geography in which little is animate.

People are usually conspicuous by their absence in the book. When he does include them, they are engaged in activities so banal as to dispel any tendency on our part to particularize any individu-

al. Clearly, the few persons populating *The New West* are conceived as representatives of a larger category of equally anonymous individuals. The tasks they perform—shopping, driving, hanging out the wash—are so routine as to suggest that the photograph could be made, or remade, at any time. Thus Adams exchanges one of photography's most dramatic attributes, the power to isolate highly specific fragments from the flux of time, for the less theatrical but no less powerful attribute of scientific experiment—i.e., repeatability and verifiability.

Adams' insistence on the ordinary and the typical, as well as on the verifiable function of picture taking, is a prophylactic strategy against our culture's increasing suspicion that photography, if not an outright lie, is at best a willful distortion of the world. By confining his attentions to the most commonplace objects and events, and by using his camera in the most direct and uninflected manner, Adams builds a series of points of correspondence between the viewer's experience of the world and his own. Through this means he prepares the viewer for the one aspect of his work which falls outside the bounds of logical language: the strange and glacial beauty that, in spite of everything, still resides in the land.

8

Photography, Vision, and Representation

Joel Snyder and Neil Walsh Allen

I

Is there anything peculiarly "photographic" about photography—
something which sets it apart from all other ways of making pictures?
If there is, how important is it to our understanding of photographs?
Are photographs so unlike other sorts of pictures as to require unique
methods of interpretation and standards of evaluation? These ques-
tions may sound artificial, made up especially for the purpose of theo-
rizing. But they have in fact been asked and answered not only by
critics and photographers but by laymen. Furthermore, for most of
this century the majority of critics and laymen alike have tended to
answer these questions in the same way: that photographs and paint-
ings differ in an important way and require different methods in in-
terpretation precisely *because* photographs and paintings come into
being in different ways. These answers are interesting because, even
within the rather restricted classes of critics, photographers, and
theorists, they are held in common by a wide variety of people who

Reprinted from *Critical Inquiry*, Autumn 1975, by permission of the University of
Chicago Press. Copyright © 1975 by The University of Chicago.

otherwise disagree strongly with each other—by people who think that photographs are inferior to paintings and people who think they are (in some ways, at least) superior; by people who believe that photographs ought to be "objective" and those who believe they should be "subjective"; by those who believe that it is impossible for photographers to "create" anything and by those who believe that they should at least try.

Our purpose here is not to show that these answers are always, in every case, wrong, or that there is never anything to be gained by differentiating between photography and other visual arts, or that questions about how photographs come into being are never appropriate to any investigation. But we do want to suggest that they are a very small part of the story and that they have been supported by definitions of the "nature" of photography and the way it works which are misleading at the very least, and are more often quite simply wrong. But to appreciate just what it is that modern critics and laymen believe about photography, it might be instructive to go back a step and take a look at a different notion of what photography is all about.

In 1889, Peter Henry Emerson, a physician and one of the finest photographers of his time, set down his prescriptions for photographers in a pamphlet entitled *Naturalistic Photography for Students of the Art*.[1] Emerson assumes that photographs are first and foremost *pictures,* and that like other pictures they may serve to provide information (the "scientific division") or to provide esthetic pleasure (the "art division"). The aim of the artistic photographer is not different from the aim of the artist in other media such as oil painting or charcoal; for Emerson, this aim is "naturalistic" representation. By naturalism, Emerson meant the representation of a scene in such a way as to be, as much as possible, identical with the visual impression an observer would get at the actual spot from which the photograph was made. Thus, much of his argument is devoted to a discussion of the characteristics of human vision, based on the research of Von Helmholtz, and the application of this knowledge to the selection and use of a lens so that its "drawing power" would render a scene with "natural" perspective and with the correct amount of detail, suitably distributed throughout the various planes of the scene. The "students of the art" are warned against an excess amount of definition, which is both untrue to our senses and "artistically false" even though it may be "scientifically true." In addition, one must expose, develop, and print photographs so as to have a

"natural" relation among the tones—the student is cautioned to avoid the commercially successful heresy of "pluckiness" or "snap" (contrast), the enemy of artistic truth. These strictures on practice are useless unless the photographer is familiar with the principles of naturalistic art; therefore, Emerson includes a sort of walking tour of the British Museum in one chapter, telling students which exhibits are to be admired and why.

Although Emerson's program of "naturalism" was not universally accepted, the basic notion that photographs were representations, and should be understood and judged as were other kinds of representations, was quite widespread. Thus, in 1907, the critic Charles Caffin writes, "This group of 'advanced photographers' is striving to secure in their prints the same qualities that contribute to the beauty of a picture in any other medium, and ask that their work be judged by the same standard."[2]

But critical opinion was shifting even as Caffin wrote. The consensus of modern critics is that photographs differ from other sorts of representations in a fundamental way and that special theoretical principles and critical standards are necessary to account for them. The philosopher Stanley Cavell expresses this difference in the following way: "So far as photography satisfied a wish, it satisfied a wish not confined to painters, but the human wish, intensifying since the Reformation, to escape subjectivity and metaphysical isolation—a wish for the power to reach this world, having for so long tried, at last hopelessly, to manifest fidelity to another. . . . Photography overcame subjectivity in a way undreamed of by painting, one which does not so much defeat the act of painting as escape it altogether: by *automatism*, by removing the human agent from the act of reproduction."[3] Photographs are not simply different from other kinds of pictorial representation in certain detailed respects; on the contrary, photographs are not really representations at all. They are the practical realization of the general artistic ideals of objectivity and detachment. The use of a machine to lay down lines and the reliance on the natural laws of refraction and chemical change to create pictures are viewed as the decisive differences leading the critic André Bazin to proclaim, ". . . the essential factor in the transition from the baroque to photography is not the perfecting of a physical process . . . rather does it lie in a psychological fact, to wit, in completely satisfying our appetite for illusion by a mechanical reproduction in the making of which man plays no part. The solution is not to be found in the result achieved but in the way of achieving it."[4] Stated

in the most general terms, the modern position is that in photography there are certain necessary connections between a photograph and its "real life" original which simply do not (and perhaps cannot) exist in the "traditional" arts. But just what are these guarantees, and how important are they for our understanding of photographs?

We will examine the way one modern theorist, Rudolf Arnheim, has recently formulated answers to these questions. Arnheim's exposition is interesting for two reasons: First, it is more complete and covers more ground than many other treatments of the subject; second, it is to some extent a recantation of his earlier work, *Film as Art*.[5] This book contained a lengthy discussion of how photography could escape from being "a mere mechanical copy of nature" and thus, in Arnheim's view, claim the stature of a true art:

The strategy was therefore to describe the differences between the images we obtain when we look at the physical world and the images perceived on the motion picture screen. These differences could then be shown to be a source of artistic expression. In a sense it was a negative approach because it defended the new medium by measuring it according to the standards of the traditional ones. . . . Only secondarily was I concerned with the positive virtues that photography derives precisely from the mechanical quality of its images.[6]

In his recent article, Arnheim bases his argument squarely on the "mechanical" origin of photographic images. "All I have said derives ultimately from the fundamental peculiarity of the photographic medium: the physical objects themselves print their image by means of the optical and chemical action of light" (p. 155). Because of this fundmental peculiarity, photographs have "an authenticity from which painting is barred by birth" (p. 154). In looking at photographs, "we are on vacation from artifice" (p. 157). We expect to find a certain "documentary" value in photographs, and toward this end we ask certain "documentary questions": "Is it authentic?" "Is it correct?" and "Is it true?" (p. 157).

Certain ethical and stylistic consequences follow from the close connection between photography and "physical reality" or "the facts of the moment." The picture taker is on slippery ethical ground since "the photographer is part of the situation he depicts" and his picture, like the photon in atomic physics "upsets the facts on which it reports" (pp. 152, 151).

Old-time photographers benefited from the slowness of the early

photographic processes since they could portray people with an "enviable timelessness" that "transcended the momentary presence of the portrayed objects" (pp. 150, 154).

More modern processes are capable of preserving "the spontaneity of action," although they may exhibit "the incompleteness of the fraction of a second lifted from the context of time" (p. 151). To portray the anxiety of man "in need of a *persona*, concerned with his image," all that the modern documentarian needs is "persons acknowledging the presence of the photographer" (p. 155). Finally, should a photographer develop a hankering for surrealistic effects, he need only pose some naked people in a forest, a living room, or an abandoned cottage: "Here was indubitably real human flesh, but since appearances of nude figures were known only from the visions of painters, the reality of the scene was transfigured into a dream" (p. 154).

Of course, compared with painting, photographs suffer from the same deficiencies that "physical reality" or "the world" itself does. They lack the "formal precision" and "expressive freedom" which the "private visions" of the painter possess. Photographs are tied to the world which is "irrational" and "incompletely defined." By its very nature, photography "limits the creations of the mind by powerful material constraints" (p. 160). But regrettable as these constraints may be "from the point of view of the painter, the composer, or the poet," they are "an enviable privilege" when we consider photography's "function in human society" (p. 160).

Arnheim shies away from what he takes to be the most extreme modern doctrine that the "photographic image is nothing but a faithful copy of the object." He insists that the process of photography injects its own "visual peculiarities" into the final picture, and that the picture must somehow "acquire form at its primary level" in order to communicate "its message" (pp. 155–56). But, oddly enough, the "visual peculiarities" of photographs serve as a sort of rhetorical reassurance; they make their audience aware that it is indeed a photograph they are looking at and not some sort of *trompe l'oeil* painting. In regard to form, a photograph is a compromise between nature and the "formative power" of man, a "compromise" or "coproduction" (pp. 156, 157, 159–60). Just as in Arnheim's theory, human visual perception "organizes and structures the shapes offered by the optical projections in the eye . . . in a photograph, the shapes are selected, partially transformed, and treated by the picture taker

and his optical and chemical equipment" (p. 159). Unlike other kinds of pictures, photographs are not entirely "made and controlled by man" but are "mechanical deposits of light" which reflect, as no other kind of imagery can, the "visual accidents of a world that has not been created for the convenience of the photographer" (p. 158). The very shortcoming of photography—its inability to attain the formal perfection of the other visual arts—is simply the obverse of photography's cardinal virtue—its ability to embody "the manifest presence of authentic physical reality" (p. 159).

Before examining these doctrines closely, it should be emphasized that Arnheim is not advancing anything very new or different here. Siegfried Kracauer and André Bazin, two critics whom Arnheim cites with approval, have advanced rather similar positions, and writers as diverse as Etienne Gilson, R. G. Collingwood, Stanley Cavell, William Ivins, and E. H. Gombrich[7] have all used photography as a benchmark of "pictorial fact" against which to measure more traditional pictorial media.[8] Nor are Arnheim's views confined to a small circle of specialists. Most people, if asked, would no doubt say that, whereas the painter can paint whatever he wants, the photographer must depict "what is there." The painter creates, the photographer "finds" or "captures" or "selects" or "organizes" or "records" his pictures. Needless to say, many photographers would agree with Arnheim as well. Of course, some people think that an intimate connection with physical reality is a very fine thing indeed, and others do not; some believe that photographers should accentuate "visual peculiarities" such as film grain and wide-angle lens distortion, while others are more conservative; some believe that photographers should try to "interpret" the world, and others believe that any "interpretation" is heretical. But these disagreements are minor when one considers the broad areas of agreement within which they arise. For example, even when the director of the Department of Photography at the Museum of Modern Art attempts to show that photographers can produce the kind of "private visions" that Arnheim assigns to the traditional artist, he insists that photography is a "different kind of art," unrelated to traditional types but closely related to perception.[9]

Arnheim describes himself as a "media analyst," not a critic, but despite this disclaimer, we must point out that he makes criticism of photographs difficult if not impossible. And since his views are held by critics and their audience as well, it is not surprising that there is very little intelligent criticism of photography. We are told

that when we look at a photograph we are on "a vacation from arti-
fice"—but *should* we be on vacation? We are told that a photograph
is a "coproduction of nature and man"—but is this coproduction
along the lines of Michelangelo and a piece of marble, or a geneti-
cist and breeds of corn, or some other sort of coproduction altogeth-
er? We are told that it is wrong to look at a photograph as though it
were "made and controlled by man"—but what might we discover if
we did look at photographs in just that way? In addition, we might
ask whether Arnheim's "acknowledged fact" that "the physical ob-
jects themselves print their image" is really a fact at all, and whether
the photographic process itself really guarantees much of anything
about the relation between image and imaged.

It is odd that modern critics who believe that the photographic
process should be the starting point for criticism have had very little
to say about what the process is, how it works, and what it does and
doesn't guarantee. Aside from the simple notion of automatism, two
models of how photography works have been used, or at least as-
sumed. One of these, which we will call the "visual" model, stresses
the supposed similarity between camera and the eye as optical sys-
tems, and posits that a photograph shows us (or ought to show us)
"what we would have seen if we had been there ourselves." The other
version of how photography works we will call the "mechanical"
model. It stresses the necessary and mechanical connections which
exist between what we see in a photograph and what was in front of
the camera. According to this model, a photograph may not show us
a scene as we ourselves would have seen it, but it is a reliable index
of what *was*. Writers on photography have often treated these mod-
els as though they were identical, or as though one were contained
within the other, but this is not the case, and such assumptions gloss
over the basic challenge to any theory which attempts to find the
meaning of photographic images by referring to their origins—the
challenge of extracting pictorial meaning from the operation of nat-
ural laws.

II

The photographic process consists of the more-or-less permanent
recording of an image made by a camera. The use of cameras with
lenses for making pictures was first described by Giovanni Battista
della Porta in the second edition of his book *Magica Naturalis*, pub-

lished in 1589. Cameras were used by draughtsmen and painters, including Canaletto and probably Vermeer, as an aid in rendering perspective and detail. By the time Niepce, Daguerre, and Fox Talbot began to try to fix the camera image, cameras had been used by artists for more than 200 years, and the requirements of "traditional" art had already influenced their design; whereas a round lens "naturally" creates a circular image (fig. 1) which shades off into obscurity around its circumference, the portable *camera obscura* of

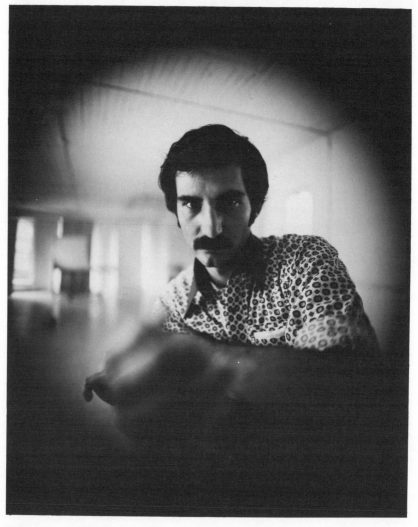

Figure 1. Complete image area of photographic lens.

the early nineteenth century was fitted with a square or rectangular ground glass which showed only the central part of the image made by the lens.

A camera image, especially one seen on the ground glass of a large-format camera, is almost magically lifelike: colors seem "natural" yet intense and every motion in front of the camera is seen in the image as well. It is difficult to find a term describing the relation between what was in front of the camera and the image which does not predetermine the results of any investigation into that relation. We will use the words "characterization" and "characterize" to describe both individual steps and aspects of the photographic process (a given lens characterizes things in greater or lesser detail than another lens) and also the end result of the process (a photograph is a characterization of something). A characterization may be accurate or inaccurate, may refer to something real or that is conjured up; it may be valuable because it refers to something else or have value as a thing in itself; and, finally, certain kinds of characterizations, such as maps, may be valuable for the most part in only one way, for their accuracy, whereas other kinds of characterizations, such as drawings may be valuable in many different ways—for their factual content, or as souvenirs, or as art.

A photographer—even a Sunday snapshooter—makes a number of characterizations by his choice of equipment and how he uses it. He may not consider each one in detail on every occasion, and in a simple snapshot camera (and subsequently, in drug-store processing) these characterizations are "built in"—but they are still there. Some of these characterizations determine the amount of detail that will appear in the picture. A lens may be able to resolve very fine detail, or it may be inherently "soft." The lens must be focused on a single plane in front of the camera. Sharp focus will extend behind and in front of this plane to varying degrees, depending on the focal length of the lens, the size of the image area and extent of enlargement in printing, and the size of the lens opening—a phenomenon called "depth of field." The camera must also be placed in a definite position, which will establish a point of view for the image.

The position of the camera effects further characterizations; once again, this holds true whether the position of the camera is carefully planned by the photographer, or whether the camera goes off by accident when dropped, or whether the camera is built into a booth and goes off automatically when people feed coins into a slot.

The camera position will determine whether one of two objects within the camera's field of view will be to the right or the left, in front of or behind, another object. Together with the choice of lens, the camera position will determine the size and location of individual objects both in relation to the total image area and to each other. Thus, given a man standing in a room, the photographer can characterize the scene so that the man appears to dominate his environment or to be dominated by it.

With these kinds of characterizations in mind, Arnheim's notion that "the physical objects themselves print their image" seems more like a fanciful metaphor than an "acknowledged fact." It is the light reflected by the objects and refracted by the lens which is the agent in the process, not "the physical objects themselves." These "physical objects" do not have a single "image"—"their image"—but, rather, the camera can manipulate the reflected light to create an infinite number of images. An image is simply not a property which things naturally possess in addition to possessing size and weight. The image is a crafted, not a natural, thing. It is created out of natural material (light), and it is crafted in accordance with, or at least not in contravention of, "natural" laws. This is not surprising. Nor is it surprising that something in the camera's field will be represented in the image; but how it will be represented is neither natural nor necessary.

What we have called the "visual" model of the photographic process is another way of trying to flesh out the bare bones of photography's alleged "intimate involvement" with "physical reality." No doubt this model originated in, and retains its plausibility because of, the supposed resemblance of the human eye with its lens and retina to the camera with its lens and film. But once this resemblance has been stated, the model fails to establish anything further. The notion that a photograph shows us "what we would have seen had we been there ourselves" has to be qualified to the point of absurdity. A photograph shows us "what we would have seen" at a certain moment in time, *from* a certain vantage point *if* we kept our head immobile *and* closed one eye *and if* we saw with the equivalent of a 150-mm or 24-mm lens *and if* we saw things in Agfacolor or in Tri-X developed in D-76 and printed on Kodabromide #3 paper. By the time all the conditions are added up, the original position has been reversed: instead of saying that the camera shows us what our eyes would see, we are now positing the rather unilluminating proposi-

tion that, if our vision worked like photography, then we would see things the way a camera does.

The camera-eye analogy is no more helpful for people investigating human vision than it is for the investigator of photographs. The more the supposed analogy is investigated, the more convincing becomes the conclusion that we do not possess, receive, or even "make" *an image* of things when we see—that there is nothing corresponding to a photographic image formed in one place which is then inspected or interpreted. Images are indeed formed on the retina of the eye, but they do not answer functionally to the image at the film plane of a camera. In the living, active eye, there is nothing that can be identified as *the* retinal image, meaning by that a persisting image that is resolved on one definite topographical portion of the retina. Rather, the image is kept in constant involuntary motion: the eyeball moves, the image drifts away from the fovea and is "flicked" back, while the drifting movement itself vibrates at up to 150 cycles per second.[10] Amidst all this motion, is there one privileged image to set beside a photograph for comparison? At the material level (the level at which arguments about photography are usually pitched), the two processes are simply incommensurate. We might, of course, identify the end result of vision—"what we see"—as *the* image. But unless the camera-eye analogy works at some simpler level, why should we call what we see an "image" at all?[11]

For these reasons, there are great difficulties, not only with theories which equate photography with vision, but also those which equate it with half-digested vision.[12] Similarly, there is little choice between theories which find the artistic merit or value of photographs in their closeness to human perception[13] or in their departure from it.[14] The problem is that all such theories presuppose some standard or baseline of retinal correctness from which "artistic" or "good" photography either ought or ought not to depart—but that standard or baseline does not exist.

If anything, Emerson's conscientious attempt to duplicate characteristics of human vision strikes us today as "impressionistic" or even "arty" rather than as "natural" in any definitive sense of that word (figs. 2, 3). We are just as likely or even more likely to accept as "natural" a photograph that renders much more detail throughout than Emerson's procedure allows. This variety of standards of optical "truth" is not unique to photography; neither is the difficulty of guaranteeing "natural" relationships between the picture and its

Figure 2. "Gathering Water Lilies" by P. H. Emerson. Courtesy of Art Institute of Chicago.

Figure 3. Actual size detail of "Gathering Water Lilies."

real-life original. E. H. Gombrich has dealt with the problems at length.[15] He states that illusionistic images are not those *derived* from nature but, instead, are those which have been so made that under certain conditions they will confirm certain hypotheses which one would formulate, and find confirmed, when looking at the original scene. Thus, given our immobile, one-eyed viewer, it may be possible to construct some sort of representation (by photography, painting, or tracing on a pane of glass) which will show him some of the same shapes, or the same relative brightness values or relative color values that he would perceive "directly" from nature, without representation. But representations suggest to us fewer hypotheses capable of confirmation or refutation. The celebrated rabbit-duck figure always remains ambiguous. There are no additional hypotheses to formulate and test (as we might do when confronted by ambiguous-looking things in real life). We do not, as we might in "real-life" cases, say at the end of careful scrutiny: "Aha—it really is a duck after all, though I can see why I thought at first that it might be a rabbit." Furthermore, representations can be made so as to confirm certain hypotheses (about meaning, relationships, and so on) which we would never think of formulating about their real-life counterparts. Perhaps all this is what Arnheim means when he says that in photography, unlike vision, "the shapes have been selected, partially transformed and treated . . ."[16]—but it's hard to find anything specifically "photographic" about that interpretation.

The visual model of the photographic process is of only limited value as a way of describing how we react to photographs (as opposed to "traditional" works of art) as well. Julia Margaret Cameron's photograph of Alice Liddell (fig. 4) was made by placing the camera considerably below Miss Liddell's eye level. In looking at the photograph, do we really duplicate the camera position in our imagination—do we believe that we are shorter than Miss Liddell, or that we are stooping down or squatting in front of her? Only in a vague and metaphorical sense. The experience is much more like looking at a painting in many respects. When we look at a painting of a figure that dominates the canvas, depicted from the point of view that Mrs. Cameron used, we do not mentally reconstruct the actual scene in the artist's studio and the peculiarities of the artist's cornea, retina, and optic nerve which allowed him, or forced him, to depict the figure as he did. Instead, our immediate reaction is that we are looking at a proud, haughty person, and on analysis we conclude that

Figure 4. "Pomona" (Alice Liddell) by Julia Margaret Cameron. Courtesy of the Permanent Collection of Photography, Exchange National Bank of Chicago.

the artist used a certain manner of depiction in order to give us that impression. It seems silly not to make the same assumption about Mrs. Cameron.

The problems of photographing "what we see" are substantial, and the solutions only partial, when "what we see" consists of stationary dry goods. When we turn to the problems of photographing things that move or even might move, the visual model breaks down completely. Let's consider how we might photograph horses running a race. We can keep the camera stationary and use a slow shutter speed: the horses will appear as blurs against a stationary background. We can "pan" the camera with the horses and use a somewhat faster shutter speed: the horses will be somewhat sharper and the background blurred. We can use an extremely fast shutter speed and "freeze" the horses against a stationary background. All these methods are commonly used and accepted ways of photographing moving things. But we don't see motion in any of these ways; we see things move. When Eadweard Muybridge succeeded in "freezing" rapid motion—to settle a bet as to how horses galloped—his results were met with dismay by artists, photographers, and the general public alike as being "unnatural" and "untrue." This was not an expression of doubt in the veracity of Muybridge's results but, instead, a perception that the results lay outside of common visual experience, and outside of the conventions of representation that obtained at the time. People believed that horses might indeed gallop as Muybridge had photographed them, but the proposition could only be confirmed by other photographs, not by direct observation.

If photographic characterizations of motion display a unique character trait of the medium, as Arnheim says,[17] then this trait is that a photograph is a still picture. It is a peculiarity shared with other, traditional media, but not with normal vision. Like other media, photography must resort to conventions to represent motion. Since conventions are multiple, it is no surprise that there are several different ways of representing motion with photography, or that photographers have developed conventions of representation that depart from the prephotographic norms. And these conventions do not necessarily operate in total isolation from our practical, day-to-day experience with things. It is our practical knowledge which helps us interpret a fuzzy patch in a photograph as representing motion, rather than something rendered out-of-focus or even something "naturally" fuzzy (such as fog or lint) rendered in sharp focus. If a photographer wishes to capture (or avoid) the "incompleteness of a

fraction of a second," he must do more than use (or eschew) a fast shutter speed. He must also analyze his subject and be aware of the expectations of his audience. Conversely, the slowness of early photographic materials was insufficient by itself to produce an "enviable timelessness"or to depict "the abiding nature of motion." All too often early photographs showed instead the restless nature of enforced immobility, and "natural"-looking portraits were attributed to the photographer's artistry, technical virtuosity, or sometimes to his hypnotic powers over his subjects.

It can be asserted, of course, that while photographs do not always show us a scene as we would have seen it, they are, because of their mechanical origin, an accurate record of the scene as it actually was. Thus, although we did not see blurred horses or a blurred background or horses frozen in midstride as we watched the horse-race, there is a causal explanation for all of these—they are the inevitable outcome of the facts of the situation. The horses actually did assume a certain posture at a certain time; the motion of the horses or the camera or both bear a causal relation to the blurs we see in the photograph. This sort of approach would certainly allow us to say that certain photographs are "natural" or "objective" even though it was obvious that they showed things which we never had seen and never were likely to see.

To the extent that the mechanical model holds that a camera is a certain sort of extension or expansion of our normal visual experience along certain lines, it seems quite plausible. For instance, when we see a horse "frozen" in mid-gallop in a photograph, we have no reason to doubt that, at a certain moment, the horse "really"assumed that posture. Here we are simply extending and modifying the notion that the camera is an eye. We are assuming that, if we could see a horse in full detail in a thousandth of a second, he would look like this. But the blurred horse we see in a time exposure is another matter. Here we do not assume that the galloping horse ever "really" became a blur at all. We assume, instead, that the horse "really" galloped and that this galloping plus perhaps the movement of the camera and the peculiarities of the film resulted in the horse being characterized as an equine blur. Thus the photograph is not a substitute for vision, not even a modified or extended form of vision, but simply the inevitable outcome of a certain series of events. No doubt it is this sense of inevitability, this feeling that a photograph is the end result of a series of cause-and-effect operations performed

upon "physical reality," that inclines us to impute a special sort of veracity to photographs—an "authenticity from which painting is barred by birth," to use Arnheim's phrase. After all, a photograph can be used to settle matters of fact and establish scientific truth. No matter how great the photographer's range of controls, no matter how labyrinthine the path from scene to image, one can always find mechanical connections between the two. The question is whether these mechanical connections are really important to us when we look at and try to understand the final picture.

Let us consider another equestrian example, one which is universally agreed to be an impartial record of the finish of a horserace (fig. 5). As the horses near the finish line, the operator of the photofinish camera flicks a switch which starts a motor. The motor pulls film smoothly past a razor-thin vertical slit in a metal plate near the film plane of the camera. No shutter interrupts the light on its way to the film while the camera is running, so the final result will be a single still picture. As long as nothing moves past the finish line, all that is recorded on the moving streak is a vertically patterned blur. But as the nose of the winning horse crosses the finish line, it is recorded, and the process continues as the horse's neck and legs cross, and as all the other horses cross.

This single picture shows the exact order of finish of all the horses in the race. It would be impossible to show this in a conventional, "instantaneous" photograph, since although it might be clear which horse got to the finish line first, the photograph would not show which of two close contenders actually finished second or third. With the photofinish camera, it's all very easy: whatever horse is seen to be to the right of another horse was recorded on the film first and therefore reached the finish line before the other horse. Of course in making the prints to be shown to the crowd, the camera operator has to put in an artificial "finish line" on the nose of whatever horse is in contention, but there is no great deception here, since every point in the photograph is the finish line. Futhermore, the speed with which the film moves past the slit is usually set to correspond roughly with the speed with which the images of the horses will move past the slit: otherwise, the horses might appear greatly elongated or greatly compressed in the final print. Neither compression nor elongation would make much difference in determining which horse finished when, but it might upset the crowd.

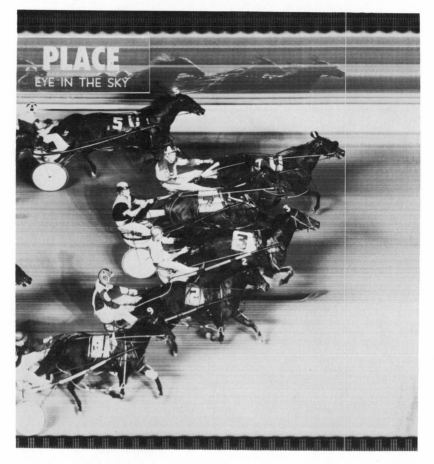

Figure 5. Photofinish. Courtesy of Sportsman's Park and Eye-in-the-Sky.

Of course, once we know how a photofinish picture is made, it upsets *us*. We are accustomed, when we see five horses occupying five different positions in a photograph to think that we are looking at a picture of five horses that were all in different places at the same time. In a photofinish, we see five horses that were at the same place at different times. When we look at the nose and tail of a single horse in the picture, we are still looking at things which were recorded as they occupied the same place at different times. As we move from left to right across the picture, we are not looking at distance, but at time. We do not know how far the winning horse was ahead of the place horse at the time he crossed the finish line—all we know is

that it took a certain amount of time for the place horse to cross the finish line after the winner.

There is no doubt that the photofinish is an accurate characterization of the finishing order of horses in a race and no doubt that this accuracy derives from the mechanisms of the camera, laws of optics and chemistry, and so on. But the way in which the picture is made has little to do with the way we normally interpret it. The photofinish looks like a snapshot taken at the end of a race, and no amount of knowledge about photofinish cameras can supplant this interpretation with another one. The picture seems "realistic" or "natural" or to display "the manifest presence of authentic physical reality" in spite of the way in which it was made, in spite of the fact that what the photograph actually manifests is far from what we normally take "physical reality" to be. The mechanical relations which guarantee the validity of the photograph as an index of a certain kind of truth have been almost completely severed from the creation of visual likeness.

It might be objected that the photofinish is a special case, or a "trick" photograph. This invites the question why people who bet on horseraces should consent to have their bets settled by trickery. Nor is the photofinish a special case; many kinds of "scientific" photographs display a similar divorce of pictorial content and "the facts of the moment." In infra-red and ultra-violet color photography, visible colors are arbitrarily assigned to invisible bands of the spectrum. In color Schlieren photography used to analyze motions in gases and liquids, colors are arbitrarily assigned to directions, and no surgeon expects to find anything resembling an X-ray when he opens up a body. In all these cases, the picture is valuable as an index of truth only to the extent that the process by which it was made is stated explicitly, and the pictures can be interpreted accurately only by people who have learned how to interpret them. To the uninstructed viewer, red and purple potato plants look equally bizarre; only the expert interpreter, who knows how color infra-red film works, who knows what filter was placed over the lens, and who knows something about potato plants can confidently equate red with health and purple with disease. Even when a scientist uses "conventional" kinds of photography, he is likely to rely on the inclusion of stopwatches or yardsticks or reference patches in the image, rather than on the photographic process pure and simple, to produce pictures which are a reliable guide to the truth.[18] Needless to say, the

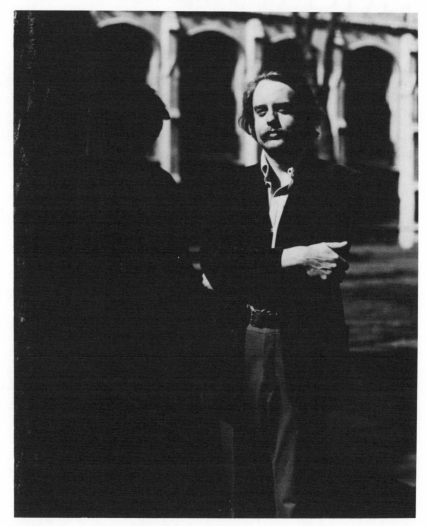

Figure 6. Correct exposure for sunlit face.

explicitness that provides guarantees to the scientist is rarely de-
manded of most photographs we see, and if demanded couldn't be
provided, and if provided wouldn't explain much anyway.[19]

Let's consider, for example, two photographs taken with a "nor-
mal" lens, given "normal" development, and so on (figs. 6, 7). They
differ only in that one (fig. 6) was given the "normal" exposure for
the figure in sunlight, the other the "normal" exposure for the fig-
ure in shade. As indexes of "what was there," they are equally in-

Figure 7. Correct exposure for shaded face.

formative; as "mechanical deposits of light," one is as good as the other. Indeed, as "mechanical deposits of light," overexposure and underexposure so extreme as to be utterly featureless would be just as acceptable as the exposures used here. The mechanical model, by explaining everything, ends up explaining nothing. In practice, the mechanical workings of the photographic process must constantly be regulated by a set of rules for making "acceptable" pictures, and simple mechanical procedures must be augmented by additional

processes to produce a number of different degrees and kinds of acceptability. By following the rule of thumb "better underexposure than over,"[20] a photographer would produce figure 6 rather than figure 7, and by employing any one or a combination of techniques (most of them "nonmanipulative"), a photographer could greatly compress the "natural" brightness range of the scene into acceptable, or even pleasing, limits.

III

If "automatism" and both the visual and mechanical models of photography explain so little of how photography works, why are they advanced? At least one reason seems to be that they are not intended as serious descriptions of the photographic process in the first place and are only put forward as "negative" definitions in order to establish what is peculiarly photographic about photography by way of contrast with what is peculiarly "artistic" about art. Thus what is truly significant about a photograph of a horse is not really that the horse himself printed his image, or that the photograph shows us the horse as we ourselves would (or wouldn't) have seen him, or that it establishes something in the way of scientific truth about this horse. What is significant (it seems to be alleged) is that *this* horse wasn't invented by some artist: this is a picture of a *real* horse. This sort of thing is usually more hinted at than stated explicity, and it seems to encompass a number of different beliefs, some about photography and some about art, some mainly ontological and some mainly esthetic.

At a simple, literal level, the ontological distinction seems rather unpromising. Certainly Holbein *might* have painted the portrait of some imaginary being and called the result "Erasmus"—but we are fairly sure that Erasmus was not a phantasm of Holbein's imagination. Certainly "imaginary" scenes can be created by traditional art, but this does not mean that every painting, or even every good painting, is by definition totally divorced from "physical reality." Nor is it a fact that every photograph is inextricably mired in "the facts of the moment." At the literal level once again, one must first exclude by fiat all sorts of photographic practices in order to make the distinction begin to work. There must be no retouching, no staging, no

distortion, no combining of negatives in a single print. "Photography" must be understood to exclude such (purely "photographic") printing methods as gum-bichromate (which allowed the addition of brush strokes to the emulsion) and bromoil (a classic book on this method includes an illustration with the caption "excess sheep removed").

Of course once a theorist has defined photography as being non-manipulative, non-imaginative, and non-inventive (in a literal sense), and has defined "art" as being manipulative, inventive, and imaginative, the distinction between the two becomes relatively clear.

As far as principles of esthetics go, John Szarkowski has gone further than many other writers by stating explicitly the theory of art that separates photography from "handmade" representations: "most of the literature of art history is based on the assumption that the subject exists independent of, and prior to, the picture. This notion suggests that the artist begins with his subject and then does something to it—deforms it somehow, according to some personal sense of style"[21] In the very next sentence, Szarkowski adds that this theory probably doesn't account for the work of any artist in any medium, which makes his assertion that "it is especially irrelevant in the case of photography" somewhat less than definitive. Now it is certainly true that many artists have drawn or painted Crucifixions, Last Suppers, and Horatios and Bridges, and that it is instructive to see how representations of these set subjects have varied from era to era, and among different artists of the same era. It is, however, equally instructive to compare the ways that William Henry Jackson and Ansel Adams photographed Old Faithful, or the ways Edward Steichen and Walker Evans photographed the Brooklyn Bridge. Of course these are not "pre-existent" subjects in quite the way Szarkowski means. But neither were the subjects of Constable's *Wivenhoe Park* or Turner's *Burial at Sea,* or Seurat's *Sunday Afternoon on Grande Jatte Island.* Furthermore, when one does compare two "traditional" renditions of ostensibly the same subject, one is often forced to the same conclusion that Szarkowski takes to be unique to photography: that much of the creative task of the artist lies in defining just what the subject *is.* When Szarkowski says of a photograph by Harry Callahan that the subject "is not the figure, or the room, or the shape and graphic weight of the light window against the dark ground, but every element within the frame, and their pre-

cisely just relationship,"[22] he is hardly revolutionizing the esthetics of the visual arts.

Now it would be quite correct to point out, à la Gombrich, that there is nothing in photography that corresponds exactly with the schemata used by many artists of other eras as aids in making representations of individual objects. The photographer who knows how to make acceptable pictures of horses might be thrown for a loop if a rhinoceros, instead of Old Dobbin, were to come trotting out of the barn, but it would not be for lack of means of representing rhinos as opposed to horses. However, formulas and standardized procedures of representation are certainly not lacking in photography, especially in those kinds of photography often thought to be simple, straightforward "documents." The passport photograph and the police "mug shot" are each produced by formulas regulating choice of lens, framing, and lighting. The Kodak manual *Clinical Photography*[23] contains 118 pages describing a wide variety of methods of photographing the human body, each method appropriate for the characterization of a separate set of conditions or symptoms. Similar manuals exist to instruct commercial photographers in the methods appropriate for architecture, family groups, silverware, and glassware. In addition, there are the "built-in" formulas of the snapshot camera, designed for "typical" snapshot subjects and to compensate for the amateur's problems with focus, exposure, framing, and holding still. Some methods of photography and some pieces of photographic equipment are more versatile than others, but there is no single method that will produce acceptable results every time—because the standard of what is "acceptable" varies with the subject to be represented and the audience and purpose for which it is to be represented.

Even in the realm of serious and inventive photography there is no clear-cut break with older traditions of representation. Genres such as portraiture and landscape have been appropriated, expanded, and redefined, and new genres and subgenres have been created. Furthermore, photographers have relied upon conventions and habits of pictorial interpretation (both by confirming conventional expectations and by deliberately frustrating them), have created new conventions of their own, and have borrowed other conventions from the nonvisual arts. Thus to formulate a set of critical principles for photography based on what is purely or uniquely or essentially photographic is as absurd and unprofitable as would be the adoption in

its place of standards taken from a mummified canon of nineteenth-century painting.

"Traditional" analyses of photographs may not be theoretically impossible, but are they worthwhile and workable? We will attempt to show that they might be by performing a rather stodgy analysis of a photograph made by a living photographer with a 35-mm camera, first published in *Life* magazine. The picture (fig. 8) is by Dennis Stock and shows James Dean at the grave of Cal Dean. We will not try to show that this is a great or even a very good photograph, much less to establish that it is better than, or at least as good as, some comparable painting or drawing. But we will try to show that it is capable of being analyzed as a picture "made and controlled by man." In addition, we will attempt to determine how the fact that James Dean really existed, and really stood next to Cal's grave, is important to our understanding of the picture. Finally, we will attempt to show that this photograph, and other photographs, lend themselves to a wide *variety* of critical approaches.

Clearly our interest in this picture does not lie strictly in the objects that it portrays but in the relation between those objects which

Figure 8. "James Dean at the grave of Cal Dean" by Dennis Stock. Courtesy of Art Institute of Chicago.

have been characterized by the photographer's choice of lens and point of view. These relations are complex. The two people are carefully balanced in opposition to the tombstone. Dean's younger brother is looking at the tombstone; Dean himself is glancing away. The surroundings are extremely simple, and help to concentrate our attention on the two figures and the grave. Dean himself seems to be a study in ambiguities: he is both consoling his younger brother and being comforted by him; he cannot "face up" to death, yet sees it all around him. We feel that Dean has ceased to view death as an incomprehensible tragedy which happens to other people and sees it instead as a constant threat to himself. Although the scene was recorded instantaneously, there doesn't seem to be anything "fragmentary" about it: it seems quite typical of the contrasting attitudes of a boy and a sensitive young man toward death.

We could reconstruct the "actual" scene that took place—the visit to the grave, the five or ten minutes that Dean and his brother spent there—and we can easily see that thousands of photographs *might* have been taken which would not affect us as this one does. For example, instead of this photograph, Stock might have made an exposure at the same moment from a similar point of view which showed much more of the cemetery. This alternate view would present substantially the same "facts" but would considerably weaken the contrasts between Dean and his younger brother. Dean's action at Cal Dean's grave would no longer seem to be a more mature yet also more self-centered reaction than that of his younger brother: he might appear to be more philosophical in relating his great-grandfather's death to the general lot of humanity, or he might simply appear to be a person who gets edgy in graveyards.

There is no doubt that Stock made a number of choices in the course of producing this photograph, but it is difficult to imagine that he calmly evaluated every possible photograph that *might* have been taken and chose this one as the best. Nor is it likely that he hopped about the cemetery, viewfinder glued to his eye, until he "found" this picture and pressed the shutter release, nor even that he was standing around in the cemetery when suddenly James Dean started looking odd and Stock, with lightning reflexes, vaulted onto the tombstone and "captured" the scene. It seems much more likely to suppose that Stock began with a notion that he would like to photograph Dean in a way which expressed what Stock believed to be Dean's attitude toward death and that he proceeded to set up a sit-

uation and choose a point of view and a lens that would create the photograph.

More to the point, we should notice that the kind of visual experience we have when looking at Stock's photograph is never (or very rarely) available to us as we walk about. The reason it is unavailable is not that we rarely happen upon sensitive young men standing in family plots. (This is the complaint of many would-be photographers.) Rather, the sort of experience we have in looking at the photograph is available only through representations, not directly from nature. In other words, if we were to state that Stock's work in making this picture consisted of selecting—of including and excluding—that selection does not operate directly on the scene in front of him. Instead, the principles of inclusion and exclusion are to be found in the final print that Stock has already decided upon as his goal.

Of course Stock did not create his notion of the final print out of thin air, or intuit it from some other-worldly realm. He knew James Dean and knew what sort of objects one was likely to find in cemeteries. He knew what kind of picture he was after: one that would show something of Dean's character from his reaction to his surroundings. He knew how his audience might react to various arrangements of figures with one another, with other objects, and within the space of the overall picture. He also knew what his camera, lens, and film would do under all sorts of circumstances. To this must be added Stock's own sensibility, his ideas of what sorts of pictures were worth making. Considerations of this sort are available to every photographer, although how they are employed in creating photographs seems to vary greatly. Some photographers "previsualize" every detail of the negative and print before tripping the shutter. Others may have a number of nebulous possibilities in mind which take on more specific form as they shoot a number of exposures, and their expectations may take on final form only when they "discover" their picture on a contact sheet.

Perhaps it is this sort of procedure that prompts critics to talk of photography as an "encounter with physical reality" or as a "compromise" or "coproduction." But certainly there is nothing new here: artists have long sought out favorite bits of countryside, hired favorite models, returned time and again to congenial themes, or restricted themselves to one or two genres. The limitations on visual artists, including photographers, are usually self-imposed or imposed by a lack of invention or a lack of representational schemes and pro-

grams for translating ideas into pictures. So if we find some fault with Stock's picture, we needn't let him off the hook by saying that Nature hasn't done *her* share, or trying to see things as mechanical deposits of light, or reminding ourselves that, after all, it's only a photograph. We are fully justified in saying that the work itself is flawed, or poorly made, or trivial. If we do find such faults, we might try to show how Stock could have done better, or, if this was the best he could do, we might suggest that he file this picture away with his other unsuccessful efforts.

Does this picture have any special status by virtue of the fact that it was made by a camera rather than by hand? One is tempted to say that it does, that it establishes certain facts about James Dean— that, at the very least, he once stood next to the grave of Cal Dean. But even this minimal statement is not incorrigible. We might be challenged to prove that it was indeed James Dean, not a look-alike, or that this is a real grave, not a stage set, or that Cal and James Dean were related. If we were to establish that everyone and everything is what it seems from external evidence, what *new* facts does the photograph establish? It would seem then to establish the same things about James Dean that would be established about the subject of this picture even if he *weren't* James Dean, or in fact had never existed at all. Of course our knowledge about the real James Dean—that he died young or that he played a character named Cal in *East of Eden*—may add a good deal of poignancy to this photograph. This sort of thing happens all the time, regardless of medium and even regardless of "the facts." Our recognition that it is Christ on the cross, or Marat in the bathtub adds to, or may even transform, our appreciation of pictures and of their subjects—even when we suspect or know that the death scenes in question "didn't really look like that."

The method of analysis we have sketched out here is by no means the only one that might be applied to this picture. We might instead have tried to assign Stock's picture to a genre—say a certain sort of portraiture which we might call "environmental portraiture," that differs both from simple portraiture and from simple depiction of people engaged in daily activities. Or, having noted that some of the effect produced by Stock's picture is due to an interplay between human figures and their environment, we might ask how another photographer, Henri Cartier-Bresson, handles these two elements in ostensibly similar pictures. Here we might conclude that whereas

in Cartier-Bresson's work the relation of people to their environment is usually incongruous or in the broad sense humorous, in Stock's photograph the environment serves as an appropriate setting and occasion for human action. In this respect, Stock's photograph seems to be akin to certain kinds of motion pictures in which similar arrangements of people within an environment are found. We might ask why this picture was published in a mass-circulation periodical, how that possible use might have influenced Stock in creating this picture, and what the picture might reveal about the readership of *Life* magazine.

In sum, we may consider the photograph either as something in itself or in its relationship to other things—to its subject matter, or the formal qualities it shares with other pictures, or to the psychological make-up of its creator, or to the conventional expectations of its audience. We may ask specifically photographic questions of it (pertaining, for example, to the use of wide-angle lenses) or we may ask questions that are extremely broad (pertaining, for example, to the representation of "serious" action by agents who are neither better nor worse than average). The ability to investigate this photograph and others in these various ways does not, in and of itself, establish that this is a great or significant photograph or that photography is "as good as" easel painting. Instead, the variety of critical approaches (of which we may think some to be valuable and others to be wrongheaded) provides us with a variety of ways to assess the merit or lack of merit of this and other photographs. Just as important, this variety provides us with a number of ways of defining just what this photograph is, both in itself, and as the cause of a variety of effects and as the effect of a variety of causes.

Even if we are interested in photographs as "documents" rather than as "art," the naive belief that photography lies outside the sphere of other representations can lead to a basic misunderstanding of the "documentary" questions we ought to ask. The documentary value of a photograph is not determined solely by Arnheim's questions of "authenticity," "correctness," and "truth." We can also ask what it means, who made it, for whom it was made, and why it was made in the way it was made. These questions are asked of other "documents," ranging from Minoan warehouse receipts to great works of art. They should be asked of "documentary" photographs and photographs-considered-as-documents as well.

The poverty of photographic criticism is well known. It stands out

against the richness of photographic production and invention, the widespread use and enjoyment of photographs, and even the popularity of photography as a hobby. To end this poverty we do not need more philosophizing about photographs and reality, or yet another (this time *definitive*) definition of "photographic seeing," or yet another distillation of photography's essence or nature. The tools for making sense of photographs lie at hand, and we can invent more if and when we really need them.

Notes

1. Peter Henry Emerson, *Naturalistic Photography for Students of the Art* (London, 1889; facsimile ed. of 1890 ed., New York, 1972).

2. Charles H. Caffin, *Photography as a Fine Art* (New York, 1901; facsimile ed., Hastings-on-Hudson, N.Y., 1971), p. vii.

3. Stanley Cavell, *The World Viewed* (New York, 1971), pp. 21, 23.

4. André Bazin, *What Is Cinema?* (Los Angeles and Berkeley, 1967), p. 12.

5. Rudolf Arnheim, *Film als Kunst* (Berlin, 1932); *Film as Art* (Los Angeles and Berkeley, 1957).

6. Rudolf Arnheim, "On the Nature of Photography," *Critical Inquiry* 1 (September 1974): 155. Hereafter, page numbers in the text refer to this article.

7. Etienne Gilson, *Painting and Reality* (London, 1957), pp. 242-46; R. G. Collingwood, *The Principles of Art* (New York, 1958), pp. 53-55; Cavell, pp. 16-25; William M. Ivins, Jr., *Prints and Visual Communication* (Cambridge, Mass., 1973), pp. 121-22, 177-78; E. H. Gombrich, *Art and Illusion* (New York, 1960; 2d ed. Princeton, N.J., 1969), pp. 67–73.

8. However, Gilson's opposition is between "picturing" and painting; Collingwood says that by using "tricks" the photographer can escape from "literal representation"; Ivins is more concerned with reproducing pictures than with making originals. But only Gombrich entertains real doubts about the usual reference to photography to settle questions of pictorial fact (pp. 34, 36).

9. John Szarkowski, "Photography—a Different Kind of Art," *New York Times Magazine* (April 12, 1975).

10. Roy M. Pritchard, "Stabilized Images on the Retina," *Scientific American* (June 1961); reprinted in *Perception: Mechanisms and Models,* ed. Richard Held and Whitman Richards (San Francisco, 1972).

11. "Images" may be thought necessary to explain the difference between what I see and what my cat sees. But is such a noun absolutely necessary even in this case? I hear differently from my cat; I also eat differently and walk differently. Must there be entities in these cases also, which take no human or feline form, or are endowed with human or feline properties?

12. Arnheim, "On the Nature of Photography," p. 159.

13. Emerson, p. 114.

14. Arnheim, *Film as Art,* p. 127; Szarkowski, p. 65.

15. Gombrich, pp. 33–62, 87–90.

16. Arnheim, "On the Nature of Photography," p. 159.

17. Ibid., p. 151.

18. Similarly, professional photographers include the standard Kodak Colorguide in their pictures to aid printers in reproducing color. In the absence of such a referent, photofinishers printing amateur color negatives program their printing machines on the assumption that every picture will "average out" to about 18 percent grey. When the assumption is wrong and the results go awry, photofinishers refer to it as "subject failure."

19. Even in criminal proceedings, the police photographer is not questioned about optics or chemistry. He is asked instead whether his photographs give an accurate indication of what the scene looked like—a question that could be asked, and answered, of many "handmade" pictures as well. See also Eastman Kodak Company, *Basic Police Photography* (Rochester, N.Y., 1974).

20. This is a simple modern rule for color reversal film. A more complex modern rule for black and white would be to expose for highlights and develop for shadows. The opposites of these rules have prevailed in other areas.

21. Szarkowski, p. 65.

22. Ibid.

23. Eastman Kodak Company, *Clinical Photography* (Rochester, N.Y., 1974).

9

A Box of Jewish Giants, Russian Midgets, and Banal Suburban Couples

Sanford Schwartz

Susan Sontag's *On Photography* must be one of the bleakest views of its subject on record—a truer title for it would be *On the Limitations of Photography*. Sontag is far from the first to look at the dilemmas and built-in problems in photography, but few writers have ever made such a grand tour of those dilemmas. Her approach is an inseparable blend of the political, moral, esthetic, and sociological. She looks at photography and judges it as a hobby, a "compulsion," a business, an art, a form of "knowing," and in each case she sees unattractive, unsatisfying ironies. She begins and ends on the same note. We're living in a world, she says, that gets its information chiefly from "photographed images," and she wants to warn us that those images are not to be trusted. They distort reality, confuse our sense of the past, and make us emotionally detached from experience.

Presented in a nutshell, *On Photography* sounds as if it's a diatribe, but it doesn't read that way. Sontag doesn't set out to deliberately attack the photographic way of seeing—she writes to find out why photography disturbs her. With its semi-polemical, semi-in-

trospective manner, her book has the weight of an eighteenth-century essay which speculates on the nature of a certain kind of education or science, and tries to pin down its qualities. *On Photography* is made up of six articles that orginally appeared, in a somewhat different and shorter form, from 1973 through 1977, in the *New York Review of Books*. (A seventh, which also appeared in the *Review*, on Leni Riefenstahl's *The Last of the Nuba* and on Riefenstahl's career in movies, has not been included.) The pretexts for Sontag's articles, except for the first and last of them, were specific books to be reviewed, and she wrote during a period when plums were dropping. Among those she picked up were the Aperture monographs on Diane Arbus and Paul Strand, the Museum of Modern Art's Walker Evans catalogue, August Sander's *Men Without Masks*, John Szarkowski's *Looking at Photographs*, and Edward Weston's reissued *Daybooks*.

Using these books as touchstones for the ideas she wants to work out, she gives a reasonable account of photography's major themes and personalities. Even if you don't agree with all of her conclusions, you admire her fairness, even courteousness, toward those with whom she disagrees theoretically. In a decade when we've been swamped with people finding ways to say Yes to photography, it's almost a relief to have someone saying No, and Sontag has the right tone of sincerity for the job. One never questions her sense of un-easiness, and much of what she says is grounded in mixed feelings we have all had about photographs. Yet she doesn't analyze those feelings in ways that seem freshly her own. Her perceptions and intuitions are always meshing (rather too neatly) with one or two large, overriding ideas—that photography is the ideal expression of capitalist cultures, or that a photograph cannot tell the "truth." She has every right to look at photography from what seems to be roughly a Marxist and/or roughly a platonic point of view; but she uses these views in a manner that smothers issues more than it clarifies them. Even though important questions are raised in *On Photography*, you don't feel that they are resolved—you feel that they have been re-placed by a set of literary and political metaphors, and it's the met-aphors that are resolved.

Sontag doesn't put it in these terms, but the key to her many over-lapping arguments is that, unlike a painting or a novel, a photograph can never fully be a work of the imagination. The photographer "cap-tures" a slice of reality, but that reality will never be entirely his;

every photograph, be it the masterwork by Atget or the dullest, most banal snapshot, is a collaboration between a human being with a machine and the real world, and the real world is an unpredictable partner. No matter what the photographer's intentions, whether commercial, documentary, or artistic, the extra, uncontrollable life in a photograph—the nugget of reality—will subvert, if only in a sly, subtle way, those original intentions. A good example of what Sontag means is what happens with a Lewis Hine photograph of children working in a factory. What for one generation was a picture of social injustice and human suffering eventually becomes, whether we want it to happen or not, an image that has less to do with suffering than with the poignancy of time past.

She's right to say that all photographs, regardless of their subject or who took them, or what they were meant to express, eventually take on this quality. She's also right when she says that, regardless of whether one chooses to call photographs works of art, most photographic images eventually become "interesting" or "esthetic" or "touching" to us. She admits that there is something magical and fascinating about this transformation; but, in her mind, it's fascinating the way a cobra is. Photographs are untrustworthy to her because, in time, she sees them coating all experiences—the extraordinary and the trivial, scenes of wartime horror and records of family outings—with the same kind of indiscriminate, valueless fascination. They "turn the past into an object of tender regard, scrambling moral distinctions and disarming historical judgments."

This is her trump card in almost every case: that photographs can't be responsible to "history," "morality," "ethical and political knowledge." The underlying assumption is that true works of the imagination—paintings, poems, novels, operas, etc.—are responsible to those values. "Strictly speaking," she tells us in a typically doom-laden and all-encompassing declaration, "one never understands anything from a photograph," the reason being, presumably, that a photograph means different things to different people at different times. Whereas she implies that, in what she calls the "traditional arts of historical consciousness," the meanings stand fast. These arts of "historical consciousness" are, therefore, politically responsible and ethically constructive. Unlike photography, they "attempt to put the past in order, distinguishing the innovative from the retrograde, the central from the marginal, the relevant from the irrelevant or merely interesting."

No one questions that a photograph produces a different effect than a novel, a painting, or an opera. Anyone will grant that a photograph has a more mechanical and anonymous nature, and demands to be judged on more than esthetic merits alone. The question is, do we always judge novels, paintings, and operas on esthetic merits alone? The way Sontag argues, it's as if every time we encounter a painting we know we're in the realm of moral, political, and historical truth—but it's more complicated than that. She never deals with the fact that cagey, dishonest feelings can be buried within the "traditional arts of historical consciousness" too, though they may be buried differently from the way they are in photographs. She seems to be forgetting that, on some rough, instinctive level, the same process of testing a work, to see how much of it is emotionally and intellectually fake, and how much true, goes on with whatever we look at or read or listen to. Don't we expect that most conscious, complex works of art will have a shifty, uncertain relation to the ethical and political values of their time? Doesn't the same thing hold true for the many works that aren't necessarily intended to be art but give us some of the feelings we get from art? And don't we expect that all these works will change in value over many generations?

Of course photography fails to give us "ethical and political knowledge." Judged by such moralistic, platonic criteria, everything else fails too. She could hand down the same verdicts about paintings, newspapers, television, movies—anything. When she tells us that "only that which narrates can make us understand," we know what she's driving at, and can agree with her; but certainly we also "understand" something from paintings and sculptures, which, like photographs, are unnarrative. Sontag would agree to that. But she doesn't face the logical discrepancy.

With her belief that no photograph can be taken at face value, she's either skeptical about the achievements of the well-known photographers, or else approves of them in guarded ways. Sometimes this pays off. She's good on why Weston is a distant figure for us now, and she's even better on why Arbus' pictures, for many people, seem shallow and coy, even false. Sontag writes differently on Arbus than on anyone else; her prose has more punch and speed. She argues more directly from her feelings. Arbus' work angers her, and, in trying to explain that anger, she gets into Arbus' skin. Even though she dislikes the photographs, she makes what Arbus was doing psychologically and poetically real—more real than any other critic has.

Sontag writes almost to rid herself of Arbus, and you can see why: there is something of Diane Arbus in Sontag's approach. As a photographer, Arbus says to her subjects—her "Jewish giant," her "Russian midgets," her banal suburban couples, her nudists and transvestites—"You know, you are horrible in our eyes." But then, lingering with them, she goes beyond her fear and hostility; she says, "If I can creep into your embarrassing life, if I can contain all that is wormiest about you, I'll have a moment of relief. Photographing you, I'll lay a fear to rest." Arbus' photographs may be forms of exploitation; but they also look as if they provided her with solace—that's why many have the radiance of visionary things. For Sontag, photography is a box of Jewish giants, Russian midgets, and banal suburban couples. She's drawn to the medium because, you feel, it gives her a chance to describe processes that may have been in her mind before she thought about photography—processes whereby the trivial is magnified, the beautiful is shrunken, and whatever is left is deadened.

No other photographer infuriates or engages Sontag as much. No other one contains, for her, the same ambivalent depths that she wants to dive to. Walker Evans, Sander, Strand, Atget, and the many others she mentions in varying detail are all, in comparison, ghosts to her. She sees them only as illustrations of moments in intellectual history; nineteenth-century idealism, Surrealism, modern "optimism" and "heroism." That she wants to see nearly every photographer as a dated, paltry, misguided, or naive exponent of these ideas isn't the problem. The problem is that photographs for her have very little life apart from ideas. Sontag sets out to take on photography in all of its aspects; but it is a visual medium, and she doesn't treat it visually. When she refers to the specifically visual, or even the story-telling qualities of a photograph, it's as if she's supplying a footnoted reference.

Atget is one of the few she admires, yet she can only give herself to him after she's converted him into a class-conscious, socially subversive figure. To do it, she has him follow in the "footsteps of the ragpicker, who was one of Baudelaire's favorite figures for the modern poet." Atget is sent on his anti-bourgeois way, picking up "marginal beauties of jerry-built wheeled vehicles, gaudy or fantastic window displays, the raffish art of shop signs and carousels," etc. Sontag's point would be valid if we knew that Atget was attracted to the shop signs because they were "raffish," but from what we know

of him, we have no idea that that was his motive. And since she wants him to be concerned only with "marginal beauties," she leaves out of her list of his subjects over half the things he did: the pools and walks at Versailles, the Austrian embassy, the Luxembourg gardens, the court at Fontainebleau, scenes of the Marne and the Seine, modest and neat middle-class interiors, and so on. Atget, who made his photographs for their possible use by professional historians, and who was documenting an old culture beginning to look frayed, could be called a "ragpicker" of sorts. Except that, in their range and feeling, his pictures seem to say that those rags were precious and grave to him. Making him into a collector of kitsch, which is what Sontag means by rags, misuses his spirit.

Walker Evans is misused too. Without fully explaining why, she calls him the "greatest photographer of America." Then she casts a shadow over that estimation by implying that the social and moral climate of his work is dated. Quoting his phrase about wanting to make his photography "literate, authoritative, transcendent," she announces that, the "moral universe of the 1930s being no longer ours, these adjectives are barely creditable today. Nobody demands that photography be literate. Nobody can imagine how it could be authoritative. Nobody understands how anything, least of all a photograph, could be transcendent." It doesn't occur to Sontag to compare Evans' photographs with his phrase, to see if they match. Nor does it occur to her that there may be something rhetorical about that phrase. She has to make Evans and the "moral universe" of his pictures a dead issue because it squares with her idea that we live in a demoralized, devaluated culture.

But there is a catch here. We're told repeatedly that photographs cannot contain "moral distinctions" and "historical judgments" because apolitical, sentimental feelings always creep in, softening the original point. How, then, can she explain the idea that, when we look at Evans' photographs, we find the "moral universe" of the '30s perfectly intact? By her own logic, shouldn't that "moral universe" have evaporated? And there is a second catch: Since Evans' work preserves the history and politics of its era so well, isn't that a way of putting the "past in order"? Isn't this the art of "historical consciousness" that she herself asks for?

On Photography ends with "A Brief Anthology of Quotations," a chapter-length collection subtitled "Homage to W. B."—for Walter Benjamin, the German essayist Sontag calls "photography's most

original and important critic." The quotes she has assembled include remarks on photography—pro, con, and mixed—by figures such as Schopenhauer, Baudelaire, Wittgenstein, and Kierkegaard; a long excerpt from an Agatha Christie novel, in which people talk about why they keep photographs; Minolta and Polaroid ads; statements from many photographers on their work; and reports from *The New York Times* that mention photography, such as one on present-day Auschwitz which refers to the fact that postcards of the gas chambers are sold there to tourists.

10

The Harp and the Camera

Owen Barfield

The harp has long been employed as the symbol of music in general, and of heavenly music in particular; just as music itself has been employed as the symbol of heaven on earth. As the English poet Walter de la Mare put it:

> When music sounds, all that I was I am
> Ere to this haunt of brooding dust I came—

In Ireland the harp is the national symbol. It is even on their postage stamps. I remember, when I was young, a popular song that began: "Just a little bit of heaven fell from out the sky one day / And dropped into the ocean not so many miles away." Years later I came to suspect a grain of substance underlying the sentimental drivel. If you travel to Scotland and then go on to Ireland, you see first the Scottish mountains and then the Irish mountains; and they are very much alike in many ways. In both places it is probably raining, or will be in a minute or two; yet there is a subtle difference between

Reprinted by permission from *The Rediscovery of Meaning, and Other Essays* (Middletown, Conn.: Wesleyan University Press, 1977).

them, the kind of subtlety that really needs a combination of Ruskin and Henry James to put it into words. Perhaps you could put it crudely like this. In the Scottish mountains you feel the mountains are somehow being drawn up into the sky. The earth seems to have been raised up to the sky and to have mingled with it; whereas in Ireland it is the other way round. It is almost as if the mountains were actually a part of the sky that had come down and was mingling with the earth.

There is one kind of harp which most of us never have seen. I have never seen one myself. And that is the aeolian harp or, as I shall call it for short, the wind-harp, since Aeolus was the Greek god of the winds. It sounds a delightful instrument, and I have always meant, but have somehow never managed, to make one. It is simply a series of strings in a box, which you fix up somewhere where the wind will blow through the strings and the strings will sound. A good place is an open window; and that might perhaps remind us that the earliest windows were not the kind we have today with glass in them. They were designed not for letting in the light and keeping out the air, but for letting in both of them together. In fact the word "window" is a corruption of "wind-eye."

The wind-harp has been much more written about than it has been seen or heard. It had a very special fascination for the Romantics. The German poet Eduard Mörike speaks of *"einer luftgeborene Muse geheimnissvolles Saitenspiel"* "the secret string-melody of an air-born muse" (today perhaps it would be safer to say "wind-born"), and describes how, when the wind grows more violent, the harp gives out a kind of human cry. The wind makes a sound of its own, but in the harp's strings it echoes or imitates itself, with a would-be personal sound that reproduces the cosmic, impersonal sound of the wind itself. William Wordsworth begins his long poem, *The Prelude*, by speaking of "aeolian visitations"; and in a later passage of the poem, where he is describing the crossing of the Alps, although the wind-harp is not mentioned, he probably has it in mind when he speaks of

> a stream
> That flowed into a kindred stream; a gale
> Confederate with the current of the soul

Many of the great Romantics were as much interested in the theory of poetry as they were in writing poetry. So Wordsworth's "confederate gales" represented to him not just a flight of fancy, but really

an avowed part of his theory of the nature of poetry, or rather of his whole esthetic theory, that is, his whole theory of the relation between man and nature in perception considered especially in the realm of art. Now you find in reading the Romantics that sometimes their theory of poetry is embodied in the poetry itself. That is the case with Coleridge's poem *The Aeolian Harp,* where you find these often quoted lines:

> And what if all of animated nature
> Be but organic Harps diversely framed,
> That tremble into thought, as o'er them sweeps
> Plastic and vast, one intellectual breeze,
> At once the Soul of each, and God of all?

But more often perhaps the theory is kept apart from the practice and is expressed in prose. There is Shelley, for instance. The wind-harp, as you might expect, made a very strong appeal to his imagination. You find in his early essay "On Christianity" this passage: "There is a Power by which we are surrounded, like the atmosphere in which some motionless lyre is suspended, which visits with its breath our silent chords at will." He is depicting the genesis of poetry. But if poetry is merely the wind that agitates the wind-harp, what is a poet? Well, Shelley has his answer in the same early essay, and you remember that it was an attack on Christianity. He tells us that poets are "the passive slaves of some higher and more omnipotent Power. This Power is God." Did he really think that? If we conceive of the genesis of poetry in terms of something like "inspiration," as perhaps we must, we are at once faced with a difficult question. What is the part in it played by the poet himself? That always has been a difficult question and remains one now. Whether we speak, as Shelley does, of the "breath of universal being," or of the unconscious, or the id within the unconscious, or whatever terminology we choose to adopt, we still have an extremely difficult question. And so a few years later, when Shelley came to write his "Defence of Poetry," he felt he had to make his wind-harp a little more complicated. He now put it this way:

Man is an instrument over which a series of external and internal impressions are driven, like the alternations of an ever-changing wind over an aeolian lyre, which move it by their motion to ever-changing melody. But there is a principle within the human being, and perhaps within all sentient beings, which acts otherwise than in the lyre, and produces not melody alone, but harmony, by an internal adjustment of the sounds of motions thus excited to the impressions which excite them.

103

So we have now a "principle" which acts otherwise than in the lyre. And one feels he has changed the symbol to something more than an ordinary lyre or harp, something more even than a wind-harp, something more like a kind of magic harp that somehow plays itself by being played on. But then again, does it play itself? Later in the same essay we have him saying it is "those poets who have been harmonized by their own will" who give forth divinest melody, when the breath of universal being sweeps over their frame. That is rather different from the "passive slave" we heard of before. You might think it is rather a queer sort of a passive slave who has to have a will of his own. My idea of a slave—and I am pretty sure it was shared by the author of *Prometheus Unbound*—is someone who is just not allowed to have a will of his own.

The title of this lecture is "The Harp and the Camera"; and while I have been talking about harps, you may have been privately wondering when I am going to come to cameras, and what on earth the two have to do with each other. I must first tell you how they became linked together in my mind. The trick was done for me by one very remarkable man. He was a German Jesuit called Athanasius Kircher, and he lived some three hundred years ago. Kircher was a "polymath" if ever there was one. He studied a variety of subjects including—and these are not the only ones—music, Egyptology, Sinology, botany, magnetism. In the course of his life he had himself let down into the crater of Vesuvius and he is claimed as the founder of geology. But besides his book on music he also wrote one on optics, which is called *Ars Magna Lucis et Umbrae*. I must mention here that I am indebted for my acquaintance with Kircher, and therewith for the germ of this lecture, to M. H. Abrams, the author of that truly admirable book *The Mirror and the Lamp*, in which the notes are almost as excellent as the text. Now Kircher is the first writer to have described the wind-harp. Whether he actually invented it is disputed, and indeed there is an old tradition that it was invented by St. Dunstan. St. Dunstan is also the patron saint of the blind, and whether there is any significance in *that* I shall leave you to ask yourselves at the end of the lecture. Anyway it was during the hundred or so years after Kircher's death that the aeolian harp became a popular tenant's fixture. Quite a lot of people had one as a normal addition to the amenities of the house. Then, towards the end of the eighteenth century, it seems to have died away as a toy and begun a second life as a symbol. It was adopted, as I have said, as a favorite symbol by the Romantics.

But there is another quite different invention, in the development of which the same man, Athanasius Kircher, seems to have taken a leading part; and that is the camera obscura. Moreover it is agreed, I think, that he *was* the actual inventor of yet a third device, and one which occupies a very important place in what I shall later on be calling the "camera sequence." But let us begin with the camera obscura, which Kircher both described and improved, though he probably did not invent it. It is, as I expect you know, something like a box with one single very, very small aperture. One could perhaps think of the aperture as a tiny window. It is either so small as scarcely to deserve the name—just a pin-prick, in fact—or else, though not quite so small as a pin-prick, it is still very small and is filled with a particular sort of glass which we now call a lens. Inside the box you fix a mirror, disposed I think at an angle of forty-five degrees; and the result is that, by looking through a larger aperture in the top of the box, you receive a picture in miniature of all that the focused light brings with it through the tiny one.

Reflecting on those two very different ploys of Athanasius Kircher it struck me that, if the wind-harp can be seen as a kind of emblem of the Romantic Movement, or the Romantic Period if you like, the camera obscura is no less an emblem of the Renaissance. Only in this case it is a good deal more than an emblem; and it is an emblem of a good deal more than the Renaissance. It points us to something that underlay the Renaissance and came to expression not only in the Revival of Learning but also in such other historical movements as on the one hand the Protestant Reformation and on the other the birth of modern science. In other words it is an emblem of that species of Copernican Revolution in the human psyche which was quite as much the cause as it was the consequence of the Copernican Revolution in astronomy. I mean the revolution, formulated rather than initiated by Immanuel Kant, whereby the human mind more or less reversed its conception of its own relation to its environment. It is more than an emblem, because the camera obscura (considered as the original source of the whole camera sequence) was also *instrumental* in actually bringing about the change of which I have spoken. We may better call it a symbol, since the camera sequence as a whole was part of the change which it betokens or symbolizes. You know it has been said that the proper definition of a symbol is that it both represents something other than itself and is also a part of it. Coleridge defined a symbol as "part of the reality it represents." For that reason he held that a historical event may be a symbol of

the historical process of which it is a part. It is precisely in that sense that I am claiming the invention of the camera as a symbol of post-Renaissance man.

Let us now have a look at this "camera sequence." In the world in which the camera obscura was invented, in the sixteenth and seventeenth centuries, there was as yet no such thing as photography. There could not have been, since the camera obscura was itself the photographic camera in embryo. Besides therefore being an amusing toy, the camera obscura quickly came to be used for practical purposes, for the production of reduced-size sketches of larger objects or assemblies of objects, and particularly in the business of sketching landscapes. There on the screen you had the complex three-dimensional real world, in which we walk about on legs, conveniently reduced to a little two-dimensional image which the pencil had only to trace. In other words, this convenient device effected, almost of its own accord, a result which many great painters had been trying very hard for a large number of years to learn how to bring about, and in which they were just beginning to succeed. There you had given to you a picture drawn very accurately *in perspective*. Now if it is true that the painters had been trying for a number of years to bring about the use of perspective—to discover what it was—it is also true that, in terms of the whole history of the art of painting, that number is really a very small one. In fact, the gradual and very late discovery of the secret of perspective seems to me to be a truly remarkable phenomenon. I ask you to consider, in support of that contention, the following five facts. There had been for centuries past many great and skillful painters passionately interested in the technique of their art. Secondly, geometry was a study highly advanced among the Greeks. Thirdly, the Greeks were perfectly well able to apply their discoveries in geometry to the practice of art—to architecture for instance—for if you read about the principles on which the building of the Parthenon was conducted you will find most elaborate geometrical principles embodied in it. Fourthly, Euclid himself actually wrote a work on optics. Euclid, the founder of geometry, wrote a work on optics, although that work is lost. And lastly, the Greek theory of art, whether of sculpture or poetry or painting, was a theory of *imitation*, imitation of nature. Now, keeping all that in mind, recall that nevertheless European painters only began to interest themselves in the comparatively simple rules of perspective in perhaps the fourteenth or fifteenth cen-

tury A.D.; in perspective, which is the kingpin, one could say, of the whole craft of representing three dimensions in two! When it did happen, not only were they interested but they were wildly excited. There is a story somewhere, I believe it is in Vasari, of an Italian painter who walked about the streets, and I believe also woke up his wife at night, constantly repeating, *"Che dolce cosa é questa perspettiva!"*; "What a lovely thing this perspective is!" Leonardo's reflections led him to the conclusion that you should make your picture look like a natural scene reflected in a large mirror. And naturally, when the camera obscura came and he heard of it, he soon went on to it.

It seems so obvious; and yet apparently something had to happen, something quite out of the experience of the Greeks, and of the Egyptians, who were also no mean geometricians, to make it appear even possible, let alone obvious, to imitate nature by that simple trick. And now when it did come at last after all those years, here was a simple mechanical device that brought the fruit of years of technical study and experiment by great painters within the reach of every Tom, Dick, and Harry. All he needed was a pencil and a hand steady enough to trace accurately. The art of imitating had been reduced to the technique of copying. The next step in the camera sequence was to do away with even the pencil and the steady hand. For the camera obscura led to the invention of the daguerreotype and so to that of the photograph. And then the advent of the photograph did something which could hardly have been anticipated by those who had invented it, though it may well be that it would not have worried them if it had. It all took a little time, but one thing that the photograph did was to kill stone dead (well not quite stone dead, for the wound has only proved mortal in our own time) just that leading principle of esthetic theory, that principle of art, which had held sway at least from the time of Aristotle down to the eighteenth century, the theory that the function of the artist is to imitate nature. The imitation of nature, now that it was being done by applying the sweet rules of perspective, had become altogether too easy; so easy that you could make a little gimmick that would do it all for you.

The camera sequence is not altogether simple to narrate. It betrays a certain leapfrogging element. Long before photography was invented, while it was still in embryo as the camera obscura, the next step, which properly *succeeds* photography, had already been

taken. It had been taken in fact by Athanasius Kircher himself. For it is generally agreed that Kircher *was* the inventor of what used to be called the "magic lantern." Perhaps it still is. That particular toy does not receive pictures into itself but, with the help of artificial light inside it, it projects (repeat, *projects*) them back onto the world outside itself, normally onto a blank screen, or a blank wall, or some kind of *tabula rasa*. But even if the wall is not blank, provided the artificial light is bright enough, the picture will be projected and it will either mix with or obliterate for the spectator whatever is actually on the wall. Hastening now to a conclusion, the next step was of course to run a lot of these projected pictures together; it was the step from still to motion, from the magic lantern to the movie. And the last step of all followed quickly; from the movie to television. Only here at last do we reach the toy in which Marshall McLuhan's Herr Gutenberg and his successors probably *have* had as big a hand as Kircher himself and his successors. Only in the technique of television does the art of printing enter the long camera sequence that began with Kircher's camera obscura and his magic lantern.

Let us contemplate for a moment the enormous contrast between the camera and the wind-harp, taken as typifying the process of perception. The process of perception is the means by which what is there outside of us—what is going on "out there"—becomes our own experience. The harp's medium is air, on which of course sound is borne to us, and air is something that is itself both inside and outside of us. Apart from its use in perception, it is entering and leaving us all day and all night from the day we are born until the moment we cease to breathe. In order that we may perceive by means of it, it has to enter quite a long way into the body before, within the labyrinth of the ear, it is converted into sensations of sound. The word "inspiration," as doctors use it, means taking physical air—oxygen—into our lungs. But the same word in common parlance always suggests taking something else in along with the oxygen. The sounding harp in fact may be taken as the emblem of *inspiration*. By contrast the camera's medium is light. And light does not enter into the body at all. It is stopped short at the surface of the eye; and you know how often the eye has been compared to a mirror. From that point on, what happens is so to speak our own affair. But as to what actually *does* happen, to give us the experience of seeing, whether there are produced replicas, or internal reproductions, or what you will, of the world outside us—that is something that has

been argued about almost since argument began. It is very much easier to shut our eyes than it is to shut our ears. What exactly *is* it that is there when our eyes are open but is no longer there when they are shut? With the different attempts at answering that question you could fill a line or two of a dictionary; you would need as much simply for the different names that have been given to what *is* there. *Forms, phantoms, idols, simulacra, effigies, films* are some of them. In Lucretius alone you find a whole mine of different synonyms for this mysterious panorama that the eye delivers to us. But they all mean something like, or some part of, what the word *image* means. And *image* is perhaps the word most commonly employed. The camera then can fairly be seen as an emblem, or perhaps this time one should rather say caricature, of *imagination*.

The Italian word *camera* means a room or chamber; and the camera is of course, a hollow box or little dark room. Unlike the camera the harp has no inside, it does not first of all receive into itself stimuli from without and then respond to them. The wind-harp becomes what it is by itself becoming an "inside" for the environing air, by becoming a modulated voice for it to speak with. If the eyes are shut and there is no other guide, it is very difficult to tell where any particular sound comes from, presumably because the air and its contents are all around us. Well, light and its contents are also all around us. But our eyes are so made that they leave us in no doubt where those contents are placed, and how they are disposed. The two sorts of arrangement are very different and that difference is really all we mean by the word "perspective." Light comes to us impartially from all directions and you might think that our point of view out into it would diverge from the eye in lines going out in all directions into space, at least in all directions open to it. Actually the opposite occurs. If we see in perspective, as we normally do, we have to make those lines converge to one particular point, which is usually called the "vanishing point." The farther off from us and from each other things are in space, the nearer they must be in our picture to the vanishing point and therefore to each other. Now that is not the way we *think* about space; it is the way we see it. We vaguely fancy there is a difference between "view" and "point of view"; but in fact there is none. The eye, seeing in perspective, is *projecting* its own point of view, its punctiliar nothingness as I would like to call it, into what geometricians call the plane at infinity but the ordinary man has to imagine as something like the inside of a vast hollow shell. By doing

so, the eye converts that hollow sphere into a tableau that reduces depth to surface and flattens three dimensions into only two. That is the *immediate* experience so faithfully recorded by the camera. If there were no such immediate experience, photographs would not be "lifelike." That is also why the camera is a *caricature* of imagination, although it is a true emblem of perspective. Imagination is living, perspective only "lifelike." It used to be said that the camera cannot lie. But in fact it always does lie. Just because it looks only in that immediate way, the camera looks always *at* and never *into* what it sees. I suspect that Medusa did very much the same.

Well, then along come the magic lantern and the movie, and they project all over again that very projection of punctiliar nothingness, that very "film" which the camera itself produced by projection in the first place. Perhaps it is not surprising that "project" and "projection" have become such very loaded words. What a history they have behind them! A student of the history of words and their meanings is apt to acquire a rather profound scepticism concerning the shared mental horizon of his contemporaries. He notices that when poets use metaphors, they at least know they are doing so. But nobody else seems to know it, although they are not only speaking but also thinking in metaphors all the time. I recall very well, when I was writing my early book, *History in English Words*, being astonished at the ubiquitous appearance of the *clock* as a metaphor shortly after it had been invented. It turned up everywhere where anybody was trying to describe the way things work in nature. Then the clocks stopped—but the metaphor went on. The student of words and their meanings and the history of them asks himself uneasily: This Newton-Kant-Laplace universe, in which the nineteenth century found itself so much at home, was it after all much more than metaphorical clockwork? But unfortunately he cannot stop there. Coming a little nearer to our own time he finds the psychology of the unconscious, in which the first half of the twentieth century felt so much at home. Strange how squarely it seems to be based on an image of "repression," which is much the same as *com*pression! Was it after all just the steam-engine in disguise? We no longer live in the age of the steam-engine. We live in the age of $E = mc^2$, the atomic age. We have discovered, or have told ourselves, that matter does not produce energy but that matter is energy; and we bestow our eager attention on the smallest possible detached unit of matter, expecting to find there the ultimate, still source of all energy. Yes, and we also live in the age of existentialism.

So it is that, in the age of the movie, the student of words who is unfashionable enough to examine their history as well as their current use is not perhaps so impressed as some others are by the universal practice of projection not only in movie houses and on the television screen, but also, as a concealed metaphor, in the ingenious fancies of men. Is projection itself being projected? He finds, for instance, scientists and philosophers joining hands to assure us that the familiar world around us is a projection of our own mental apparatus onto a kind of wall of imperceptible realities, not perhaps a blank wall, but it might just as well be blank for all the resemblance it bears to anything we do actually see or hear. Or again, when he turns to the psychologists, he finds projections (or perhaps they might almost be called projectiles) in the form of neuroses, fantasies, mother-images, father-fixations, feelings of guilt, and various parts of the body including its secreta and excreta, flying to and fro among them so thick and fast that he has to duck to avoid them. Or again, when the psychologists join hands with the anthropologists, he sees a whole cloud of these projectiles flying off in the same direction and landing on the same target—namely, the mind of that luckless repository, primitive man. One thing at least is made very clear from what all these informative people are fond of telling us about primitive man and that is that, whatever else he was doing, he was always projecting his insides onto something or other. It was his principal occupation. He must presumably have had one or two other things to do as well, but that was what he majored in. The eighteenth century, you know, used to talk of a "ruling passion"; but there is also the ruling metaphor. Perhaps for reading the signs of the times, it is a good deal more important. Let us assume for a moment that it is, and ask ourselves how much of all this stuff would ever have been heard of if Kircher had never invented his magic lantern? Was he, while inventing it, engaged at the same time in inventing for example the anthropological theory of animism? We might even go on to ask (except that the question is one that is never raised in humane academic circles) how much of it all is true?

After all, it is we who actually have *got* the magic lantern and the camera; it is we who have *got* perspective, both in pictures and in photographs, together with the habit of vision which they have raised and fostered. Could it be ourselves who are doing the projecting, when we talk of primitive man in that confident way? *Was* he a magic lantern? Was he even a camera obscura? Are we so sure that he even *had* any inside to speak of? The punctiliar sort that *projects*? Now I

personally am quite sure that he had not. Moreover I am firmly persuaded that we shall never get anywhere with our anthropological attempts at reconstructing the mind of primitive man until we make up our minds to throw away all this projection business. If we *must* think in metaphor (and we must), why not try beginning again on the assumption that primitive man was not a camera obscura but an aeolian harp? Surely it is only by this route that we can hope to understand the origin of myths and of thinking at all. Leslie Fiedler, writing on the myth, noted a distinction between two elements we can detect in it. He called them respectively "archetype" and "signature," the signature being that part of a narrative myth which has been contributed by an individual mind or minds. That is a useful distinction, but its usefulness in the long run will depend upon what we are prepared to mean by the word "archetype." It will depend on our accepting the central truth which no one who writes today on the subject does appear to accept, though I should have thought it had been made clear enough more than a half a century ago by Rudolf Steiner; the truth that it was not man who made the myths but the myths, or the archetypal substance they reveal, which made man. We shall have to come, I am sure, to think of the archetypal element in myth in terms of the wind that breathed through the harp-strings of individual brains and nerves and fluids, rather as the blood still today pervades and sustains them. Then, when we have started off on the right foot instead of the wrong one, we may come fruitfully on to the problem Shelley had to deal with from a rather different point of view, the problem of the wind-harp that is nevertheless played on by a performer. Then we shall come properly equipped to the problem of that "principle within the human being," as Shelley called it, which acts otherwise than in the lyre and produces not melody alone but harmony. We shall approach in the right way the problem of beings (to quote Shelley again) "harmonized by their own will."

Did that enthusiasm of the Romantics for the wind-harp signify that they had come to see the history of the Western mind as a kind of war between the harp and the camera—that they foresaw the camera civilization that was coming upon us? If so, they were true prophets, because it certainly has come. The camera up to date has won that war. We live in a camera civilization. Our entertainment is camera entertainment. Our holidays are camera holidays. We make them so by paying more attention to the camera we brought with us than to the waterfall we are pointing it at. Our science is almost entirely

a camera science. One thinks of the photographs of electrons on screens and in cloud-chambers and so forth. Our philosophers—it is no longer possible even to argue with most of them, because you cannot argue about an axiom, and it is already becoming self-evident to camera man that only camera words have any meaning. Even our poetry has become, for the most part, camera poetry. So much of it consists of those pointedly paradoxical *surface* contrasts between words and between random thoughts and feelings, arranged in the complicated perspective of the poet's own often rather meager personality. Where, one asks, has the music gone? Where has the wind gone that sweeps the music into being, the *hagion pneuma*, the *ruach elohim*? It really does feel as though the camera had won hands down and smashed the harp to pieces.

Perhaps it is just this defeat which the guitar-loving hippies have somehow got wind of. But I do not myself believe that the way out of defeat lies in substituting the harp for the camera except of course as an aid to historical imagination. For I do not believe that the root from which the camera sequence originally sprang is an unmitigated evil. I even believe it was a necessity. But then neither do I believe that the existence of separate, autonomous human spirits is an unmitigated evil. I traced the camera sequence from a beginning only about as far back as the seventeenth century. But its root is much older than that. It began, I would say, as soon as signature was added to and interwoven with archetype in the structure and substance of myth. That is the same as saying that it began as soon as poetry began to exist within myth—at first within, and then alongside of it. And that again is to say it is something that lies within our destiny. Is not this a truth which the most penetrating minds among the Romantics themselves came to realize? It is interesting to note that, whereas in Shelley we found only that rather perplexed transition from the wind-harp to a harpist's harp, Coleridge—who lived so much longer and had more time to think out a full theory of poetry— does not omit the camera obscura from the imagery he chooses. In the *Biographia Literaria*, by way of comment on Milton's wonderful description of the banyan tree in *Paradise Lost*, he writes:

This is creation rather than painting, or if painting, yet such and with such co-presence of the whole picture flashed at once upon the eye, as the sun paints in a camera obscura.

Coleridge, you see, converts it from a caricature into a true emblem of imagination. How? By placing the sun, instead of the punctiliar

nothingness, at that vanishing point which, as he well knew, was really the point of projection from within the eye of the beholder. After all, however it may have been for primitive man, we cannot in our time get away from projection altogether. "The mind of man is not an aeolian harp." That is another sentence from *Biographica Literaria*, reneging rather sharply, it would seem, from the point of view expressed in the author's youthful poem I quoted to begin with. The mind is at least not wholly an aeolian harp. For us there must be projection, and the question for the twentieth century is whether it is to be projection of nothingness or a projection of the sun-spirit, the spirit of light. Is not this why, in the same book, we find Coleridge quoting that sentence from Plotinus: "The eye could never have beheld the sun if it were not itself of the same nature as the sun"; the sentence which also meant so much to Goethe, and which he rephrased in the form: "If the eye were not of the same nature as light, it could never behold the light."

If then the story of the harp and the camera is to continue instead of ending with a whimper, it will have to be by way of a true marriage between the one and the other. Is it fanciful, I wonder, to think of a sort of mini-harp stretched across the window of the eye—an Apollo's harp if you will—as perhaps not a bad image for the joy of looking with imagination? That "joy," as will be well-known here, was precisely the thing which C. S. Lewis spent most of his life discovering more about, discovering in particular that it is by no means the same thing as pleasure or happiness or contentment. In a literary climate, which has already become all camera and no harp, all signature and no archetype, we ought not to forget that little group, if group is the right word, which has sometimes been referred to as "Oxford Christians," and sometimes as "Romantic theologicans," and with which this college has, thanks to the devotion and energy of Dr. Kilby, established a very special connection. For they may perhaps have contributed their mite to the continuation of the story. The German poet and thinker Novalis, you know, specifically compared with an aeolian harp the *Märchen* or adult fairy tale that modern variant of the myth, in which signature may mingle fruitfully with archetype, but without swamping it altogether. The passage where he does so was selected by George MacDonald as the motto to his own *Märchen, Phantastes*, which played (as he has told us) such a crucial part in the literary and spiritual development of C. S. Lewis. Besides giving us *Märchen* of their own, both Lewis and Tol-

kien, and their comrade in arms Charles Williams, thought deeply and wrote well on the place of myth and *Märchen* in our modern consciousness. One way or another, they were all three concerned with the problem of imagination; and there is perhaps no piece of writing that deals more gently and genially with the place of imagi- nation in the literature of the future than Tolkien's essay "On Fairy- Stories" in the volume *Essays Presented to Charles Williams*. At least that is so, if I am right in suggesting (as I have been trying to sug- gest by my own rather devious route) that the ultimate question, to which imagination holds the key, is the question of how we can learn to sign our own names to what we create, whether as myth or in other ways, but so nevertheless that what we sign as our own will also be the name of Another—the name I would venture to say, with- out venturing to pronounce it, of the Author and the Lord of the archetypes themselves.

11

Tracing Nadar

Rosalind Krauss

Though it was written toward the end of his life, Nadar's memoir, *My Life as a Photographer,* was undertaken at a point when its author's activity in the medium had far from ceased. That is why the title's insistence on pastness (in French it is *Quand j'étais photographe*), its declaration of a chapter's having closed, seems somewhat curious. But Nadar's past tense has less to do with his personal fortunes and the trajectory of his own career through time, than with his status as witness. The man born Gaspard-Félix Tournachon, who called himself Nadar, was aware that he had been present at an extraordinary event, and, like the survivor of some natural cataclysm, he felt duty-bound to report on what it had been like, or even more than that, to conjure for his listener the full intensity—emotional, physical, psychological—of that experience. Nadar writes his memoir with the urgency of the eyewitness and the conscience of a historian. Every passage of the text reverberates with this sense of responsibility.

Which is why the book is so peculiar. For it is structured like a set of old wives' tales, as though a community had entrusted its ar-

chives to the local gossip. Of its thirteen chapters, only one, "The Primitives of Photography," really settles down to producing anything like a historical account. And although this is the longest chapter in the book, it comes nearly at the end, after an almost maddening array of peculiarly personal reminiscences, some of which bear a relationship to the presumed subject that is tangential at best.

Perhaps it is this quality of rambling anecdote, of arbitrary elaboration of what seem like irrelevant details, of a constant wandering away from what would seem to be the point that accounts for the book's relative obscurity. Published in 1900, it was never reprinted, and at this date its surviving copies are both very battered and very scarce.

The memoir on photography was hardly Nadar's only publication. The author of eleven other books, he was a frequent writer of short stories and a prolific essayist. His relation to the world of letters extended beyond the friendships he maintained with the most important writers of his day; it included an intimate connection to the craft of writing, to the patient and careful construction of meaning. If Nadar undertakes the writing of history in the guise of a novelist, that is because the set of facts he hopes to preserve against time are primarily psychological. "People were stunned," he begins, "when they heard that two inventors had perfected a process that could capture an image on a silver plate. It is impossible for us to imagine today the universal confusion that greeted this invention, so accustomed have we become to the fact of photography and so inured are we by now to its vulgarization.

The immensity of the discovery is what Nadar wishes to communicate, not who did what and when. After listing the incredible stream of inventions that changed the course of nineteenth-century life—the steam engine, the electric light, the telephone, the phonograph, the radio, bacteriology, anesthesiology, psychophysiology—Nadar insists on giving pride of place, in terms of its *peculiarity*, to the photograph. "But do not all these miracles pale," he demands, "when compared to the most astonishing and disturbing one of all, that one which seems finally to endow man himself with the divine power of creation: the power to give physical form to the insubstantial image that vanishes as soon as it is perceived, leaving no shadow in the mirror, no ripple on the surface of the water?"

What Nadar saw, from the vantage of 1900, was the conversion of

this mystery to commonplace. And so a chapter was, literally, over, even though his own activity remained unchanged. If this was Nadar's historical message at the turn of the century, it repays our attention, especially now. For at this point, in our turn, we are realizing the immense impact of photography, the way it has shaped our sensibilities without our quite knowing it, the way, for example, the whole of the visual arts is now engaged in strategies that are deeply structured by the photographic.[1] The symptoms of a cultural awakening to this fact are everywhere: in the recent flurry of exhibitions; in the surge of collecting; in the rise of scholarly activity; and in a growing sense of critical frustration about just what photography *is*. It is like the man who, finally accepting his doctor's diagnosis, turns around and demands to know the precise nature of his illness. Cultural patients, we insist on something like an ontology of photography so that we can deal with it. But Nadar's point is that among other things photography is a historical phenomenon, and therefore what it *is* is inseparable from what it *was* at specific points in time, from a succession of responses which were not uniform. In his memoir Nadar treats himself like an analytic patient, fixing on details and elaborating them, in order to recover a past that will be resonant with its own meaning.

The opening three chapters of the memoir exemplify this method. The first is occasioned by an object in Nadar's possession: the only known Daguerreotype of Balzac, which he had purchased from the caricaturist Gavarni. The second, triggered by the reality of long-distance transmission systems like telegraphy and radio, is the tale of a confidence trick played on him in the 1870s. The third is a seeming piece of trivia called forth by the certain success of aeronautical technology, which Nadar had always championed over aerostatistics, or ballooning. Entirely different in scope, and increasingly peripheral to the history of photography proper, the disparateness of these accounts, their appearance of moving into a subject only by backing away from it, make of these chapters a very odd sort of beginning. Yet there is a connection between them, an underlying theme that Nadar wishes to dramatize.

The story about Balzac revolves around the novelist's superstitious reaction to photography, a reaction that was issued somewhat pretentiously in the form of a theory. Describing Balzac's Theory of Specters, Nadar writes:

119

According to Balzac's theory, all physical bodies are made up entirely of layers of ghostlike images, an infinite number of leaflike skins laid one on top of the other. Since Balzac believed man was incapable of making something material from an apparition, from something impalpable—that is, creating something from nothing—he concluded that every time someone had his photograph taken, one of the spectral layers was removed from the body and transferred to the photograph. Repeated exposures entailed the unavoidable loss of subsequent ghostly layers, that is, the very essence of life.[2]

Throughout the rest of this account Nadar's tone is affectionately mocking. Théophile Gautier and Gérard de Nerval had rushed to Balzac's side to become "converts" to his Theory, and Nadar focuses more sharply on the affectations of their discipleship than on any suspicions of Balzac's own insincerity. The man of science, Nadar is magnanimous as he indulges the self-consciously assumed primitivist fantasies of his literary friends.

But the second chapter of the memoir is a replay of this fantasy, with its terms somewhat changed. "Gazebon Avenged" begins with a letter sent to Nadar in the 1850s from a provincial named M. Gazebon requesting a photographic portrait of himself. Nothing is unusual about this except that, on the assurances of a "friend" of Nadar's, Gazebon expects the photograph to be taken in Paris while he himself remains in Pau. Deciding that he will not dignify this joke with an answer, Nadar forgets the whole business until twenty years later when a young man presents himself in Nadar's studio claiming to have perfected the means for executing Gazebon's demand: long-range photography (*photographie à distance*). While Nadar's companion, convinced by the technological jargon with which the young man supports his claim, gets more and more excited by the prospect of carrying out the experiment, Nadar himself waits for "the touch" to come. When it does, Nadar pays out the money, knowing that he has been defrauded and that he will never see the young "inventor" again. No explicit connection is made between this story and the Theory of Specters, but the psychological point of the story—Nadar's own, deep certainty that "remote-photography" is an impossibility—is a variation on the Theory, from the point of view of Science. Photography can only operate with the directness of a physical graft; photography turns on the activity of direct impression as surely as the footprint that is left on sand.

It is this knowledge of the physical immediacy of photography that

is given an emotional resonance in the story of "The Blind Princess," to which Nadar then turns. In the 1870s a blind woman is brought by her grown children to the studio to sit for her portrait. Because she is a member of the royal family of Hanover, Nadar takes the occasion to inquire after the young nobleman who had looked after him when Nadar was confined in Hanover two years previously, due to a rather grotesque ballooning accident. Nadar's interest in the other man had developed from their shared contempt for balloons and their joint conviction in the possibility of flight in craft that was heavier than air. Having heard that the nobleman had been exiled from Hanover because he had killed someone in a duel, Nadar asks one of the Princess's children if this is true. The drama of this question, which fortunately the Princess doesn't hear, turns on the fact that the victim of the duel was the sitter's eldest son, and though his death has been successfully hidden from the mother, Nadar's question could have revealed it to her. Remembering his own distress, Nadar closes the story with a series of reflections on the psychological consequences, and thus the potential power, of the circumstances of making a photograph: to the point where a life could be affected by the chance remark transmitted through "a visit to a photographer's studio, in a strange city. . . ."

The focus of this ending is clearly on the kinds of changes that industrialization brings to every corner of society—collapsing distances, imploding separations of class—so that a French balloonist could be blown into the care of a German royal household, and a princess would engage in the new, social transaction of the photographic portrait-sitting. In thus dramatizing the intimacy of the photographic situation, Nadar fixes again on the physical proximity that is its absolute requirement, on the fact that no matter how any other system of information transfer might work, photography depends on an act of passage between two bodies in the same space.

In these three chapters, then, Nadar circles around what seems for him to be the central fact of photography: that its operation is that of the imprint, the register, the trace. As semiologists we would say that Nadar is giving an account of the photographic sign as an index, a signifying mark that bears a connection to the thing it represents by having been caused, physically, by its referent. And we would go on to describe the limited field of significance available to that type of sign.[3] But Nadar was not a semiologist, and sure as he was of the indexical nature of the photograph, of its condition as a

trace, the inferences he seems to have drawn from this were peculiar to his century rather than our own.

For the early nineteenth century, the trace was not simply an effigy, a fetish, a layer that had been magically peeled off a material object and deposited elsewhere. It was that material object become *intelligible*. The activity of the trace was understood as the manifest presence of meaning. Standing rather peculiarly at the crossroads between science and spiritualism, the trace seemed to share equally in the positivist's absolutism of matter and the metaphysician's order of pure intelligibility, itself resistant to a materialist analysis. And no one seemed more conscious of this than Balzac, author of the Theory of Specters.

When Barbey d'Aurevilly sneered that Balzac had made description "a skin disease of the realists," he was complaining about the very technique in which Balzac took the greatest pride and which allowed him to boast that he had foreshadowed the Daguerreotype. If written description was intended to skim the surface off a subject and transfer it to the novel's page, this was because of Balzac's belief that this surface was itself articulate, the utterly faithful representation of inner man. "The external life," Balzac wrote, "is a kind of organized system which represents a man as exactly as the colors by which the snail reproduces itself on its shell."[4] The endless reworking of this metaphor produces the kind of character in the *Comédie Humaine* about which one could write that "his clothes suit his habits and vices so well, express his life so faithfully, that he seems to have been born dressed."[5] Therefore, as eccentric and fanciful as the Theory of Specters might at first strike us, the notion of man as a series of exfolliating, self-depicting images, is only a more whimsical version of the model of the snail. And this model, with its intentional connections to biological study, was meant to carry the authority of Science.

As Balzac never tired of explaining, the physical description through which he was confident that he could trap the vagaries of character had been tested in the laboratories of physiognomy.[6] Whatever the relative obscurity of Johann Caspar Lavater now, *The Art of Knowing Man by Means of Physiognomy* (1783) had enormous prestige in the nineteenth century.[7] As the title implies, physiognomy involved the decoding of a man's moral and psychological being from those physiological features which were thought to register them. In this reading, for example, thin lips are the index of avarice. Balzac made it

no secret that his own characters were built as much from raids on the ten volumes of Lavater's work as on recourse to his own observation.

Lavater himself had paved the way for Balzac's extension of physiognomy to a system of indexical signs, or physical traces, that encompassed far more than the shape of a man's skull or the character revealing conformation of his mouth. The *Analytic Essays* from 1830, like "The Study of Habits by Means of Gloves," or "The Physiology of the Cigar," are elaborate Balzacian glosses on the kind of thing Lavater had in mind when he wrote:

It is true that man is acted upon by everything around him; but conversely, he too acts upon his environment, and while modified by his surroundings, he in turn modifies them. It is on this basis that one can gauge the character of a man by his dress, his house, his furniture. Set within this vast universe, man contrives a smaller, separate world which he fortifies, entrenches, and arranges in his own fashion and in which we discover his images.[8]

In this view, character is like a generator of images, which are projected onto the world as the multiple cast shadows of the bearer. That Lavater's attention should have included the extremely minor art of silhouette making is not surprising insofar as these profile portraits were the literalization of the cast shadow. The very name of the "physionotrace," a type of silhouette produced in 1809 by quasi-mechanical means and included in most histories of photography as a forerunner of the aspirations (if not the actual process) that made the photograph inevitable, bears the mark of Lavater.

But the check that Lavater wrote for the systematic study of physiognomic traces could be cashed in other banks besides that of positivism. Balzac points to this when he speaks of the two sides of his interest, the one indebted to Lavater, the other focused on Swedenborg. And indeed, in *Mimesis*, when Erich Auerbach analyzes Balzac's technique he selects a passage in which both aspects present themselves. For behind the details of dress and bearing through which Balzac renders the *petit-bourgeois* avarice and cunning of Père Goriot's landlady, there gather a set of images drawn from an entirely different register of study, images that create "the impression of something repulsively spectral." These images, Auerbach writes, form "a sort of second significance which, though different from that which reason can comprehend, is far more essential—a significance which can best be defined by the adjective demonic." And he adds, "What confronts us, then, is the unity of a particular

milieu, felt as a total concept of a demonic-organic nature and presented entirely by suggestive and sensory means."[9]

For the Theory of Specters to have issued from Balzac's pen, there needs only one ingredient to be added to the Lavater system of physiognomic traces, one element that will transform the physical manifestations of character into the idea of a man as a set of spectral images, or ghosts. That ingredient is light. Light was the means by which the seemingly magic transfer of the photograph was effected, the way in which one could, in Nadar's words, "create *something* from *nothing*." And light, the keystone in the Swedenborgian system, was the conduit between the world of sense impression and the world of spirit. It was in terms of a luminous image that the departed chose to put in their spectral appearances at the nineteenth-century séance. And after 1839 it required only a baby step in logic to conceive of recording these apparitions photographically. "Spirit photography" is described by Huysmans in *Là-Bas*, and in 1882 Georgiana Houghton quite seriously published a work entitled *Chronicles of the Photographs of Spiritual Beings and Phenomena Invisible to the Material Eye*. Surely one of the most grotesque, but revealing suggestions about the possible applications of photography was the notion, broached in the 1890s, of the "post-mortem photograph." Breathtaking in its loony rationality, it involved the reprinting of a photograph taken during life by using the crematorial ashes of the departed sitter. "They will adhere to the parts unexposed to light and a portrait is obtained composed entirely of the person it represents."[10]

Now the spirit-photograph may have been a somewhat freakish idea and rather limited in its currency. But with the industrialization of portrait photography that took place in the 1860s came the wholesale production of deathbed photographs. The deathbed portrait is a phenomenon that most histories of photography acknowledge but pass by rather quickly. A combination of curiosity and embarrassment, very few of these objects survive relative to the enormous number that were made. Yet for the commercial photographer of the nineteenth century, the deathbed commission was one of the major staples of his practice.[11] It is our present-day inability to view this phenomenon as anything but ghoulish that indicates our own removal from a crucial part of photography's history: precisely that part Nadar hoped to evoke through his memoir.

The mysteriousness that surrounded the initial appearance of pho-

tography and permitted some of the more bizarre of its later practices is easy enough to patronize. But this sense of mystery is an aspect of the most serious aspirations of the early makers of photographs, Nadar included, and it is this seriousness which is harder to understand. Just as it is hard to understand as anything more than a piety of literary history the incredible, contemporaneous eminence of Swedenborg. It therefore might be helpful to draw a parallel between the initiation of Nadar's account of photography with a story of Balzac at his most Swedenborgian, and the inauguration of Immanuel Kant's career with a work called *Dreams of a Spirit Seer*—an unexpected text on Swedenborg.

In drawing this parallel I wish to point to more than just the prestige of Swedenborg—to the kind of fame and respect that was granted him in the late eighteenth century, and which made him a strangely persistent object of attention for the young Kant. As *Dreams of a Spirit Seer* makes clear, Kant's decision to take on Swedenborg as an adversary, to bother to attack the great visionary who was busy taking down dictation from the World of Spirits, arises from the way in which Swedenborg's solutions come as perfectly logical responses to the problems of eighteenth-century metaphysics. In Kant's eyes the system of Swedenborg's *Celestial Arcanum* is no more benighted than any other metaphysical system. Why not write about him, Kant asks, "After all the philosophy which has helped us to introduce the subject is itself no more than a fairytale from the Wonderland of Metaphysics."[12] And he concludes by saying, "Questions which concern the nature of spirits, freedom, predestination and our future state, etc., etc., at first arouse all our energies and reason, and lure us by the excellence of their subject-matter into the arena of competitive speculations where we argue indiscriminately, decide, teach, reason, just as pseudo-knowledge dictates."[13]

But the point about Swedenborg cuts much closer to the bone. No matter how preposterous the outcome of his endeavors, the question that animates them in the first place was utterly serious for the founder of analytic philosophy: how to find data by which to prove the existence of an intelligible (as distinct from a merely material or sensible) world.[14]

Swedenborg's labors as scientist-turned-mystic compose an incredible cadenza on the theme of intelligibility. They turn, as I have said, on the issue of light. Beginning from Newton's view of light as corpuscular—made of infinitely small particles—and adding this to the

Cartesian notion that matter consists of particles that are indefinitely divisible, it was possible to think of light as a spectrum that begins in the world of the senses and shades off into the world of spirits. Insofar as the universe is permeated by light, some part of which is divine, it can be seen as a system of symbols, as a great hieroglyphics from which to read off the meaning of divinity. This legibility of the world is Swedenborg's message; the *Celestial Arcanum* is a massive demonstration of how propositions from the natural sphere are transformed into their correspondence in the spiritual one.

Thus the visible world is, once again, a world of traces, with the invisible charged with imprinting itself on the visible. "It is a constant law of the organic body," Swedenborg insisted, "that large compounds or visible forms exist and subsist from smaller, simpler and ultimately invisible forms, which act similarly to the larger ones, but more perfectly and universally; and the least forms so perfectly and universally as to involve an idea representative of their entire universe." Glossing this passage in 1850, Emerson explains, "What was too small for the eye to detect, was read by the aggregates; what was too large, by the units."[15] It is the visibility of the noumenal world which thus concerns Swedenborg, and the demonstration of the way this is possible by light's acting on phenomena to produce an image.[16]

Photography was born in the 1830s by, in Nadar's words, "exploding suddenly into existence, surpass[ing] all possible expectations." And into the initial responses to this event are folded the themes of Spiritualism. For photography was the first available demonstration that light could indeed "exert an *action* . . . sufficient to cause changes in material bodies."[17]

Those are the words of Fox Talbot, published in 1844 in *The Pencil of Nature*, a book laid out as an object lesson in the wonders and possibilities of photography. On the face of it there is no reason why Fox Talbot's statement about light should be read as anything more than the comment of a gentleman-scientist. Yet it is the curious nature of certain of the plates, which form the bulk of *The Pencil of Nature*, that induces one to hear in his statement the overtones of metaphysics.

Most of the plates are just what one would have expected of such a volume: views of buildings, landscapes, reproductions of works of art. But some of the images are rather peculiar. One of these, Plate VIII, is entitled "Scene in a Library," and what it presents, head-on

there are certain ways in which Nadar is interested in both acknowl-
edging and using it as a theme: one of the very few deathbed com-
missions Nadar consented to was to photograph the deceased Victor
Hugo, himself a frequenter of séances; and, for the subject of the
first of his series of underground photographs, he chose the cata-
combs of Paris, where skeletons heaped one on top of the other trace
in archeological fashion their own record of death; and, as if to pay
this theme a special kind of homage, he begins his memoir with the
Theory of Specters.

To criticize a subject is not necessarily to annihilate it. Sometimes,
as with Kant's *Dreams of a Spirit Seer,* it is to carry it, transformed,
into a new method of inquiry. And for Nadar the question of the
intelligible trace remained viable as an *esthetic* (rather than a real)
basis for photography. Which is to say that it is a possible, though
not a necessary, condition of a photograph that it render phenom-
ena in terms of their meaning.

Nadar's early ambitions in this respect can best be documented
in a series of photographs that he took when he and his brother
Adrien Tournachon were still working together. Called "Expressions
of Pierrot: A Series of Heads," this suite of images was entered into
the photographic section of the 1855 Exposition Universelle where
it won a gold medal. Depicting the face of Charles Debureau as he
assumed the various facial gestures from his repertory of "expres-
sions," the series of photographs becomes the record, and the dou-
bling, of the mime's enactment of the physiological trace. Recent
scholarship (I am referring to Judith Wechsler's study *Physiognomy,
Bearing and Gesture in 19th Century Paris*)[19] focuses attention on
the relationship between the science of physiognomy and the art of
pantomime that was being drawn toward the middle of the nine-
teenth century. This means, for example, that in the plays he was
writing for Debureau, Champfleury assumed the possibility of a per-
formance that would fuse the physiological specificity of the char-
acter-revealing trace with the highly conventionalized gesture of the
traditional mime.[20]

Now clearly, to render the physiognomic trace by way of the mime
is to pass this phenomenon through an esthetic filter. For by the
nature of his role as performer, the mime must transform the au-
tomatism of the trace, its feature as a kind of mechanical imprint-
ing, into a set of willed and controlled gestures, into the language
that Mallarmé would later designate as "writing."[21]

The explicit relationship between the mime's estheticising of the

trace and photography's own, similar, highly self-conscious perform-
ance is drawn in the images of Debureau. In one of these, signed
Nadar Jeune (Adrien Tournachon), the mime appears with a cam-
era, miming the recording of his own image. In this work light, pho-
tography's own form of "writing," plays an important part. For while
the mime is enacting his role in the image, a set of shadows constel-
late across his body as a simultaneously perceived and read subtext.

First, in the area of the head, Debureau's face, whitened by make-
up, is further flattened by harsh lighting. This effect, added to the
sharp shadow, which detaches the face visually from the underlying
mass of the skull, intensifies the face's character as mask. A surface
which, then, both belongs to the head and can nevertheless operate
independently of it, the face-as-mask is the ground on which the
physiognomic trace is rendered as a sign. To perform the physiog-
nomic trace, Debureau had not so much to act as to artificially re-
compose his face—to achieve the thin lips of avarice, for example,
in an ephemeral gesture that embodies physiognomy by "speaking it."

Second, the costume of Pierrot worn by the mime becomes the
white field onto which cast shadows are thrown, creating a second-
ary set of traces that double two of the elements crucial to the image.
One of these is the Pierrot's hand as it points to the camera; the
other is the camera itself, the apparatus that is both the subject of
the mime's gesture and the object of recording it. On the surface of
the mime's clothing, these shadows, which combine the conventional
language of gesture (pointing) and the technical mechanism of re-
cording (camera) into a single visual substance, have the character
of merely ephemeral traces. But the ultimate surface on which the
multiple traces are not simply registered, but fixed, is that of the
photograph itself.

This idea of the photographic print as the ultimate locale of the
trace is at work in this image in two different ways, and on two dif-
ferent levels of articulation. The first is on the level of the subject
matter: the mise-en-scène of the image, so to speak. The second
operates through a reflection of the role of the cast shadow: the op-
erational fact of the image.

On the first level, we confront a performance of reflexiveness in
which the mime doubles in the roles of photographer and photo-
graphed. Posed alongside the camera, he weaves that peculiar fig-
ure of consciousness in which the line that connects subject and
object loops back on itself to begin and end in the same place. The

mime enacts the awareness of watching himself being watched, of producing himself as the one who is watched. It is a doubleness that could not occur, of course, in the absence of this photograph of it. It is only because Debureau is the actual subject of the image for which he plays photographer, only by performing for the photographic mirror, that the issue of doubling arises. Obviously, were Debureau to perform his action on a simple stage, there would be no effect of doubling. He would merely be playing "photographer." Only if he were to play his gesture in front of a mirror would he be able simultaneously to enact the capture of his own image. But even then he would be rendered as two separate players: the one in "life" and the one in the mirror. The photographic print, because it is itself a mirror, is thus the only place where an absolute simultaneity of subject and object—a doubling that involves a spatial collapse—can occur. The print is here defined, then, as a logically unique sort of mirror.

At the second, operational level, the theme of doubling and mirroring functions in relation to the shadows cast on Debureau's clothing. I have said that those shadows thrown by two separate objects (camera and gesture) combine on a physically distinct surface to produce a specific relationship, a meaning that points to the double persona of the mime. But the cast shadow itself is a type of trace that is the operational double of the photographic one. For the photographic trace, like the cast shadow, is a function of light's projection of an object onto another surface. In this image of Debureau, the idea of the mirror is carried into the semiological fabric of the work: the photograph is a mirror of the mime's own body in that it is a surface that will receive the luminous trace as a set of displaced signs, and more importantly, will constitute itself as the place in which their relationship can constellate as meaning.

Thus the aspirations working in this photograph are to surpass the condition of being the merely passive vehicle of the mime's performance. They are to depict the photograph itself as a complex sort of mirror. Echoing the theme of doubling through the agency of cast shadow, the photograph stages at one and the same time its own constitutive process as a luminous trace and its own condition as a field of physically displaced signs. Which is to say that doubling is not here simply recorded, but recreated through means internal to the photograph, through a set of signs that are purely the functions of light.

In Talbot's brief speculation woven around the "Scene in the Library," the camera obscura emerges as a double metaphor for both recording mechanism and mind. In the photograph of Debureau, the connection implied by this metaphor is projected through the image of the mirror, itself a metaphor for that reflexive seeing which is consciousness. If the trace (the shadow) can double as both the subject and object of its own recording, it can begin to function as an intelligible sign.

In using terms like "consciousness" or "reflexiveness" to speak of this photograph of mime and camera, I am of course invoking the language of modernism. And this may seem unwarranted, given the direction that most photography was to take during the bulk of Nadar's lifetime. But in rehearsing the attitude towards the trace that was peculiar to an age that was simultaneously fascinated by science and spiritualism, I am trying to construct a very particular framework within which to set this image. The analytic attitude of which this photograph is a document has a very special genealogy, one that is relevant only to photography's own means of forming an image.

The kind of cultural frame that could have produced this photograph, that could have made the image of a mime next to a camera so extraordinarily resonant, is not only lost to us, but was, one feels, largely unavailable to Nadar as he wrote his memoir. Or at least it had become accessible to him only in memory. But Nadar's urgency in trying to recall that mood reminds us that esthetic media have surprising histories just as they have uncertain futures: difficult to predict, impossible to foreclose.

Notes

1. This situation is presented in my "Notes on the Index: American Art of the '70s," *October*, nos. 3 and 4 (Spring and Fall, 1977).

2. See Nadar, "My Life as a Photographer," p. 9, above.

3. In his essays on photography, Roland Barthes analyzes these limitations, which he attributes to the status of photography as "a message without a code." See "The Photographic Message" and "Rhetoric of the Image," collected in *Image, Music, Text*, New York, Hill and Wang, 1977.

4. Honoré de Balzac, "Traité de la vie élégante," *Œuvres Complètes*, Vol. XX, Paris, Editions Calmann Levy, 1879, p. 504.

5. Gilbert Malcom Fess, *The Correspondence of Physical and Material Factors with Character in Balzac*, Philadelphia, University of Pennsylvania (Publications: Series in Romantic Language and Literature), 1924, p. 90.

6. The examples are everywhere. One, from the 1833 *Théorie de la démarche*, goes: "Nevertheless, Lavater said, before I did, that since everything in man is homogeneous, one's gait must be at least as eloquent as one's physiognomy; bearing is the physiognomy of the body. Of course this is a natural deduction from his initial premise; everything about us corresponds to an internal cause." Balzac, *Œuvres Complètes*, Vol. XX, p. 572.

7. In order to locate physiognomy at that point of convergence that it established for itself, and staunchly maintained, between anatomy, psychology, and moral philosophy, it is useful to consider Charles Darwin's need finally to attack this "science" in the 1870s. In his study *On the Expression of the Emotions in Man and Animals* (1872) Darwin launches an assault on physiognomy as one of the principal strongholds of the opposition to the theory of evolution. Operating on the principle that many of man's facial muscles were put in place solely for the purpose of "expressing" his inner states, physiognomy based its investigations of this unique musculature on the belief that it was species-specific. That is, there was a mutual reinforcement between the idea that each species, man included, had come into existence in its present condition, and the notion that the musculature of the human species had been specially fashioned as the instrumentality of a unique capacity to feel and to express, which man shared with none of the lower animals. This capacity arose not simply from a psychological structure far richer and more complex than that of other species, but, ultimately, from the soul. In an argument such as this one, blushing, for example, is taken as a manifestation of a moral life not shared by lower animal orders.

8. Johann Caspar Lavater, *L'Art de connaître les hommes par la physionomie*, Vol. I. Paris, Depélafol, 1820, p. 127.

9. Erich Auerbach, *Mimesis*, Princeton, New Jersey, Princeton University Press, 1968, p. 472.

10. Aaron Scharf, *Creative Photography*, London, Studio Vista, 1965, p. 25.

11. Nigel Gosling speaks of Nadar's own scruples about participating in this industry: "He was rarely tempted (as his son was later to be) to exploit his talent in banal journalism and publicity pictures, and rarely accepted commissions for the ever-popular deathbed pictures (Victor Hugo and the gentle poetess Mme Desbordes-Valmore were exceptions)." See Gosling, *Nadar*, New York, Alfred A. Knopf, 1976, p. 13.

12. Immanuel Kant, *Dreams of a Spirit Seer*, trans. John Marolesco, New York, Vantage Press, 1969, p. 76. This treatise was first published, anonymously, in Königsberg in 1766.

13. Ibid., p. 94.

14. Kant's motives for undertaking *Dreams*. . . are discussed by Marolesco in his introduction to the translation.

15. Ralph Waldo Emerson, *Representative Men: Seven Lectures*, Boston, Phillips Sampson and Company, 1850, p. 115.

16. Thus Swedenborg writes, "Man is a kind of very minute heaven corresponding to the world of spirits and to heaven. Every particular idea of man, and every affection, yea, every smallest part of his affection is an image and effigy of him." Cited by Emerson, *Representative Men*, p. 116.

17. William Henry Fox Talbot, *The Pencil of Nature*, facsimile edition, New York, Da Capo Press, 1969, introduction, n. p.

18. Ibid.

19. To be published by Thames & Hudson, London.

20. In the same years both Gautier and Duranty were writing with a similar relationship in mind. Professor Wechsler has kindly called my attention to this material which is presented and analyzed in her study, referred to above.

21. In his analysis of Mallarmé's essay *"Mimique,"* Jacques Derrida examines this notion of the mime's gestures as a kind of writing, which becomes, in Mallarmé's words, *". . . soliloque muet que, tout du long à son âme tient et du visage et des gestes le fantôme blanc comme une page pas encore écrite."* See "La double séance," in Derrida, *La dissémination*, Paris, Editions du Seuil, 1972, p. 222.

12

Art + Photography

Susan P. Compton

Photography played an important role in the twenty years of hectic developments in art that occurred in Russia between 1910 and 1930. Artists passed from using photographic and cinematic subject matter in easel paintings (Larionov, *Impressions du cinéma*, 1911),[1] through the incorporation of pieces of photographic material into Cubo-Futurist collage (Malevich, *Woman at the Tram Stop*, 1913–14),[2] to the construction of new artifacts, photomontages, using photographic ingredients in techniques borrowed from moving pictures (Klutsis, Rodchenko, the Stenberg brothers) and multiple exposures (Lissitzky).

The changes in the approach to photography simultaneously record the altering role of art in Russia during the period. This can be summarized by the challenge that the dynamic of modern life gave to the previously accepted function of art as a mirror of reality. Although the October Revolution added another force to this dynamic, the challenge to traditional art was already completed by the end of 1915 when Malevich first exhibited his Suprematist paintings and

Reprinted with the permission of Print Collector's Newsletter, Inc., from *PCN*, March–April 1977.

Tatlin his counterreliefs.[3] Both represent a move beyond the partial eclipse of representation to the construction of art from its basic ingredients, color, form, and texture, devoid of symbols or referential meaning.

In the period of development of a language peculiar to art that followed,[4] photographic elements were first used as another ingredient of the language, one that by its intrinsic representational properties re-introduced a ready-made "reality" into abstract art. The earliest example of such use is to be found in *Dynamic City* by Gustav Klutsis, made in 1919. Klutsis was deliberately trying to shatter the integrity of a non-objective art language. His photomontage bears the caption: "Voluminally spatial Suprematism + photomontage. The overthrow of non-objectivity and the birth of photomontage as an independent art-form."[5] He had transformed his own lithographed Suprematist spatial composition by using photographically reproduced textures and a full range of tonal variation (in place of color) and tiny cutout photographs.[6] In Klutsis' most interesting attempt to signal a new era in art as well as in life, today the incorporation of "real" elements has the effect of suggesting a caricature or cartoon. Not only the human figures and buildings but also the recognizably "real" materials, glass, metal, stone, here extended the language of non-objective art but without the connotations demanded of "laboratory art"; neither can it be seen as a tryout for "productive art," both slogans of post-Revolutionary years.

A need for useful purpose transformed both "laboratory art" and artists' photography in the social turmoil of the following decade. Klutsis became involved in graphic art, in which he soon found ways effectively to use the shorthand for "reality" that photographic elements could provide. His earliest attempt to transform the science-fiction *Dynamic City* composition into a project for a poster entitled *Lenin-Electrification* proved an unhappy marriage of diverse elements. The "real" materials of the plane-structure in *Dynamic City* were revised as a drawing of an architectural elevation, the looming planet becoming a flattened world onto which the figure of Lenin, represented by a cutout photograph, strides, carrying a drawing of an electric pylon in his arms. Even in this revision, the formal spatial precedent of Suprematist infinite space does not lend itself to invasion by problems of everyday existence, and Klutsis seems to have been aware of the unsatisfactory juxtaposition. He continued to be involved with problems of graphic art and arrived at very in-

teresting solutions. An early example is *Sport*, in which he used an overlapping technique derived from Cubist collage for the lettering and drawn elements, laying down a spatially credible structure onto which he could freely position the photographic elements (in this case athletes working on bars).[7] *Sport* bears an interesting compositional relationship to contemporary Constructivist theater design: Klutsis uses the same ingredients—geometry and moving people—as Popova in the stage machinery for *The Magnanimous Cuckold* (1922). In the photomontage the dynamic of actual movement of a mill wheel (one of the scenic devices) is replaced by a stationary target on which athletes in movement, represented by photographic stills, are positioned in a manner impossible on a real stage. They occupy a kind of unreal third dimension, derived from Klutsis' earlier Suprematist experiments. He later rejected these roots, maintaining only the relationship between photomontage and film: "Photomontage can only be compared among the other arts with cinema which unites a mass of frames into a whole work."[8]

This definition is exceptionally applicable to the development and use of the technique of photomontage by Rodchenko. From 1922, Rodchenko was closely concerned with the magazine *Kinephot*, founded in that year by Alexei Gan. Rodchenko made all the covers for *Kinephot*, except two; the one for No. 4 is especially revealing. Rodchenko has illustrated it with a still from *Not for Money Born*, a film in which Mayakovsky had starred in 1918, which Rodchenko transformed by photomontage. The original still shows Mayakovsky standing beside an upright, shrouded corpse, whose skull emerges from the wrappings. The shot is taken from a very low viewpoint, and the scene is lit by an eerie brilliant light that exaggerates the expressionist qualities of the film. By cutting off the lower part of the still, Rodchenko has established a more ordinary viewpoint, and by substituting a photograph of an airplane for the body of the corpse he has, as it were, given it a decent coffin. The rest of the environment is replaced by simple gradations of grey planes, toning down the external dramatic element of the film shot. The unexpected conjunction of Mayakovsky's hand with the skull is reduced to a reference to a modern Hamlet.

Such manipulation of factual ingredients to create a revised "reality" through illusion was soon carried much further by Rodchenko. Using techniques borrowed from the silent film experiment of Dziga Vertov (for whom he was already drawing film titles), Rodchenko

began to reassemble photographic clippings to create a new kind of reality. For the cover of the second issue of the magazine *Lef* (from 1923 to 1925 the platform of the avant-garde), he combined photographs of people with newspaper clippings to make an assemblage suggesting the rotative axis, not of his own earlier linear constructions, but of Vertov's zooms and cutting. This particular photomontage is overprinted with a large X and bordered by two straight bars. The X acts visually more as a structural device than as a destructive crossing out. It seems closer to the bars of contemporary Constructivist theater machinery than to the deletion Malevich had made on a photograph of the Mona Lisa he incorporated into a Cubo-Futurist collage (1914).[9]

Although in 1919 Rodchenko had made a number of collages incorporating photographic and other ready-made material combined with linear abstract elements, the photomontages he was making by 1923 seem already related as closely to contemporary theater and film developments as to his own earlier work.[10] The correlation of experimental film to theater at this date is shown by the inclusion in *Lef* No. 3 of both Vertov's manifesto "Cinema Eye" and Eisenstein's first theory of the "Montage of Attractions." (Eisenstein was still working in the theater in 1923.) Extracts from both statements are appropriate to photomontage, especially Vertov: ". . . I coordinate any and all points of the universe, wherever I want them to be. My way leads towards the creation of a fresh perception of the world. Thus I explain in a new way the world unknown to you."[11] And Eisenstein: "Instead of a static 'reflection' of an event with all possibilities for activity within the limits of the event's logical action, we advance to a new plane—free montage of arbitrarily selected, independent (within the given composition and the subject links that hold the influencing action together) attractions—all from the stand of establishing certain final thematic effects—this is montage of attractions."[12]

Both writers emphasize a dynamic use of thematic material to construct rather than reflect events, using a basis of fact rather than fiction. Both manifestos are admirably illustrated, albeit in static form, by the series of eleven photomontages Rodchenko made between April and June 1923 to accompany Mayakovsky's poem *About This*.[13] These photomontages act more as visual parallels to the epic poem than as illustrations, looking back to the pre-Revolutionary avant-garde publications in which lithographs had complemented

the text as another facet of creative process. Rodchenko's photomontages are made up almost exclusively of cutout photographic material, including silhouettes of people (often Lili Brik and Mayakovsky himself), views of buildings, crowds, individual machines, corners of rooms, and everyday objects cluttering the page in a welter of confusion, with totally arbitrary changes of scale reminiscent of nineteenth-century screens with stuck-on scraps. All these are related to the subject matter of the poem "establishing certain final thematic effects," a montage of attractions quite unlike the transformational approach to collage with photomontage used by such artists as Raoul Haussman, John Heartfield, and Hannah Höch.

Although the photomontages for *About This* are peculiarly Russian phenomena, Rodchenko was certainly aware of artistic developments in Europe, and certain aspects of choice and composition can be read as an "answer" to Paris. Mayakovsky had taken his first trip abroad in 1922 and had written "A Seven Day Review of French Painting" that, although it remained unpublished, gives a very good picture of the way he must have talked to his friends on his return to Russia. "He is not copying nature but transforming all his previous cubistic analyses" is a sentence he wrote about Picasso, which admirably describes Rodchenko's photomontages for the poem.[14] Rodchenko was using a photographic record of "nature" but transforming it by selection, cutting, and rearrangement, sometimes in the manner of his earlier three-dimensional experiments. All the illustrations lack the symmetry of the advertising graphics on which Rodchenko was working with Mayakovsky at the same time. The large-scale silhouettes of objects, the telephone receiver, the oversize spoons and forks seem as closely related to Rodchenko's experiences gained from drawing advertisements as to emerging Parisian Purism.

In Paris, Mayakovsky had especially liked Léger and described him as looking "like an authentic painter-worker who regards his work not as a divine calling but as an interesting, necessary craft, equal to other crafts in life. I have seen his outstanding work. I am glad about the esthetics of industrial forms, about his lack of fear as far as the most brutal realism is concerned."[15] Rodchenko would surely have been fascinated by Léger's experiments with close-ups and frames borrowed from film technique in his paintings of 1919–21, which looked closer to photomontage in black and white photographs brought back from Paris by Mayakovsky. But Léger's large, fully rep-

resentational canvases of 1921–22, such as *Le grand déjeuner* in the Museum of Modern Art, approach more closely Rodchenko's photomontage illustrations in which the close-up heads are allowed to dominate the crowd of everyday objects.

Rodchenko's strangest inventions are the black, negative forms of spoon and mug that have been formed either by cutting an object printed by chance on the back of the photographic elements selected or by laying down a photograph on a montaged surface and simply cutting it out, leaving the backing paper to show through. Perhaps the experience of working on advertising posters enabled Rodchenko to use such telling but arbitrary cutouts, just as the invention of advertising slogans helped Mayakovsky to purge his poetic language of its more literary elements. The still-life objects fulfill the requirements demanded of revolutionary artists in 1921: "By exerting the nerves and muscles of visual proof, I shall surely be enabled to speak without lyricism and rhetoric, which are always false."[16] Rodchenko's raw material is no longer the texture, color, and form of an abstract art-language, but ready-mades excerpted from "real-life" and used as the vocabulary of a formal language that creates a response of recognition and, at the most, surprise in the ideally proletarian viewer rather than confirming any notions about "picture making."

Mayakovsky wrote: "Of course the Russian production of pictures cannot be compared with the French. . . . That is not the point. The point is that the time has put a question mark on the existence of pictures, and on their makers. It has put a question mark on the existence of a society content with the little artistic culture of the picture decorated salon."[17] This was true of Rodchenko, and it is the reason why one has to discuss such a "second-hand" art form as photomontage book illustrations in terms of works of art. But Mayakovsky also wrote: "I went to Paris trembling. I saw everything with a schoolboy's diligence. What if we turn out to be provincial again? . . . I expect some new artistic task to be posed. I look at the corners of the pictures trying to find at least one new name. In vain. . . . How enviously, avidly, and with what interest they ask about Russia's tendencies and possibilities. . . . For the first time, not from France but from Russia, a new word in art has come: constructivism. . . . For the time being, in spite of all our technical backwardness, we, the workers, of art in Soviet Russia, are the leaders of the world's art, the carriers of avant-garde ideas."[18]

Mayakovsky was able to overcome the physical limitations in Rus-

sia imposed by poor paper, badly equipped printing presses, and shortages of technology by calling on the services of Lissitzky to produce *For the Voice* in Berlin in 1923.[19] Lissitzky followed the 1920s slogan "The book should be produced with the tools of the book," but unlike Rodchenko, who in Russia was usually hand-drawing the letterpress elements of his graphic work, Lissitzky was able to exploit the richness of the typesetter's font. He went to the boundaries of inventiveness using all the compositional devices at his command, transforming *For the Voice* into "for the eye." This handsome product of Constructivist invention by a fellow Russian hampered by shortages helped to link Mayakovsky to Europe, demonstrating Constructivism in practice and incidentally affirming Lissitzky's close connections with the Russian avant-garde.

Lissitzky's position in the 1920s was unique. He belongs in a discussion of the Russian use of photography in art, even though much of his work was carried out in Europe. In the extraordinary quality of printing in the book *The Isms of Art* (1925), Lissitzky provided magnificent illustrations of broadly constructivist styles in which Russian art was shown to be highly competitive with contemporary European avant-garde art.[20] He enlarged the classifications of "fine art" by hanging his photographically produced *Hand of the Constructor* with Neo-Plastic and other easel paintings in his first exhibition room at the International Art Exhibition held in Dresden in 1926.[21]

Lissitzky used the technique of photogram rather than photomontage in *Hand of the Constructor*; the hand itself was exposed to obtain a print. In a further development, *Self-Portrait—The Constructor* (1924), Lissitzky pushed photographic and printing techniques to the limit, with elements superimposed in successive exposures. Both subjects invite speculation about the role of the artist's traditional methods of working once his own hand is recorded mechanically, but Lissitzky's cool approach is more consistent with Constructivism than with either Expressionism or Dada. The end product falls more naturally into the canons of traditional art than work being done by his friends inside the Soviet Union. This is partly because Lissitzky was free from the political pressures, the interminable arguments between rival factions that were the background of so much of the art of the 1920s in Russia.

After 1926, when Lissitzky undertook more exhibition design, he became subject to the understandable demand for political prestige,

and he increasingly came to rely on the forthright directness that could best be conveyed by the use of photography. Both inside and outside of the Soviet Union, by the bold use of large-scale photographs allied to his ingenious manipulation of the space of exhibition halls, Lissitzky succeeded in conveying an account of "reality" without compromising the advances made by the pioneers of Constructivism.[22]

An area of activity that remained free from much of the seriousness of propaganda was that of the cinema poster, where a marriage of fantasy with Constructivist ideas achieved free reign in the 1920s.[23] This was a natural medium for the exploitation of photomontage, which was powerfully used by Rodchenko in a poster for Vertov's *Cinema Eye* (1924), in which he made great play with the contrast of positive and negative imagery. The possibilities of spatial composition inherent in the adapation of Vertov's developments in cutting and reassembling film for use in photomontage were explored by the creators of many film posters through the 1920s, though some of the most telling are the relatively simple ones invented by the Stenberg brothers.

Vladimir and Georgii Stenberg, like Rodchenko, had experimented with three-dimensional constructions in various materials in 1919–20. In the early 1920s, they worked in the theater, making constructed sets for Tairov's productions (*Joan of Arc*, 1924; *The Man Who Was Thursday*, 1924). This experience seems partly to account for their particular approach to cinema-poster design, which is characterized by the use of an allover, repeated layout with a few simple photomontage additions. They usually combined photomontage with drawn or cutout shapes, arranged in an overall bold, contrasting pattern. This was ultimately derived as much from Tairov's insistence on using the full height of the stage, which always remained framed by a proscenium arch in his productions, as from cinema techniques. The interplay of positive and negative imagery was, of course, derived from photography, though it extended into the use of background color, which the Stenberg brothers always used very strikingly.

In a short account it is not possible to cover the complete range of discoveries made by artists exploring the possibilities of photography as an ingredient of art. One thing is certain: the implications of the extension of an approach made possible by the acceptance of photography as an adjunct rather than as rival to art were very richly exploited in this comparatively short period of revolutionary activity.

Notes

1. At the *Donkey's Tail* exhibition (Moscow, 1912), Larionov exhibited four paintings with photographic titles: 119, *Photographic study of a street after nature;* 122, *Shapshot;* 123, *Scene (cinema);* 124, *Photographic study of melting snow in spring.* I assume that *Impressions du cinéma,* now in the Musée d'art moderne, Paris, is 123 (the signature and date are later additions).

2. Malevich included photographic collage elements in a number of Cubo-Futurist paintings, of which *Woman at the Tram Stop,* Stedelijk Museum, Amsterdam, is only one example.

3. At the exhibition *0.10* held at the Dobychina Gallery, Petrograd, in December 1915. (Tatlin had previously exhibited reliefs in March 1915).

4. Theories of the development of abstract art as a language closely relate to contemporary studies in linguistics. Interesting translations, including two on film theory, appear in *Twentieth Century Studies: Russian Formalism,* edited by S. Bann and J. E. Bowlt, Edinburgh, 1973.

5. Quoted from Szymon Bojko, *New Graphic Design in Revolutionary Russia,* Washington and New York, 1972, p. 30.

6. For a discussion of Klutsis' *Dynamic City,* see Andréi B. Nakov, *Russian Constructivism: "Laboratory Period,"* exhibition catalogue, London and Ontario, 1975.

7. Klutsis' *Sport* photomontage made in 1922 and published in *Krasnoe studenchestvo* No. 2, 1923, reproduced in Bojko, *op. cit.*

8. Quoted from L. Oginskaya, "Gustav Klutsis—khudojhnik leninskoy temi," *Dekorativnoe Isskusstvo SSSR,* April 22, 1970, pp. 36–41.

9. *Composition with Mona Lisa,* private collection, Leningrad. Reproduced in Troels Andersen, *Malevich,* Stedelijk Museum, Amsterdam, 1970, p. 25.

10. Rodchenko's collages are reproduced on plates 102–4 in German Karginov, *Rodcsenko,* Budapest, 1975. I am very grateful to Peter Sherwood, lecturer in Hungarian language and literature at the School of Slavonic and East European Studies, University of London, for his translation of pp. 92–122, which deal with Rodchenko's use of collage and photomontage and on which I have drawn freely in writing this article.

11. Quoted in English translation of Lutz Becker, "Film + October," from the catalogue *Art in Revolution,* Arts Council, London, 1971.

12. *Ibid.,* p. 86.

13. V. Mayakovsky, *Pro eto,* Moscow-Petrograd, 1923.

14. Quoted in English on p. 357 in Wictor Woroszylski, *The Life of Mayakovsky,* London, 1972, where the whole passage is printed on pp. 334–38.

15. *Ibid.,* p. 337.

16. A. Torpokov, "Technological & Artistic Form," from *Isskusstvo v proizvodstve,* 1921. Quoted from p. 26 of the English translation of *The Documents of 20th Century Art: The Tradition of Constructivism,* edited by S. Bann, New York, 1974. Other articles in this collection give helpful background theoretical documentation.

17. Woroszylski, *op. cit.,* p. 336. The observations, made by Andréi B. Nakov in his introduction to the French translation of Nikolai Tarabukin, *Le dernier tableau,* shed further light on the fate of the easel painting in Russia in the 1920s. Editions Champ Libre, Paris, 1972.

18. Woroszylski, *op. cit.,* p. 338.

19. V. Mayakovsky, *Dlya golosa*, Berlin, 1923, illustrated plates 94–108 in Sophie Lissitzky-Küppers, *El Lissitzky*, London, 1968.

20. Lissitzky and Hans Arp. *Die Kunstismen/Les ismes de l'art/The Isms of Art*, Zurich, Munich, Leipzig, 1925.

21. Lissitzky-Küppers, *op. cit.* illustrated plate 187.

22. Photographs of installations and catalogues of a number of these exhibitions are included in Lissitzky-Küppers, *op.cit.*

23. In *"The Silent Film Poster,"* *his recent article in Projekt*, No. 108, Warsaw, May 1975, Szymon Bojko outlines the importance of developments in film for innovations in Soviet poster design in the 1920s.

13

Philosophy and Photography in the Nineteenth Century

A Note on the Matter of Influence

Dennis P. Grady

Our understanding of the history of photography is not complete without some reference to the history of ideas. In the nineteenth century, certain aspects of philosophy played an important role in the development of photography, a role which has been largely ignored. This article represents a small step toward recognizing what the role was.

The major dialectic of nineteenth-century thought was already in full swing before photography was a decade old. The schools of thought that were involved in this argument were "Metaphysical Idealism" and "Positivism." It would be best to begin with definitions of these terms, as they are not generally known and are often misused. Metaphysical Idealism "holds that within natural human experience one can find the clue to the understanding of the ultimate nature of reality, and this clue is revealed through those traits which distinguish man as a spiritual being."[1] The key ideas here are that reality has an *ultimate* nature which sense impressions do not reveal, that knowledge of that ultimate reality is attainable through

Reprinted from *Exposure*, February 1977, by courtesy of the Society for Photographic Education.

reason and intuition, and that man is not mere physical matter but a spiritual being. Positivism, on the other hand, totally rejects metaphysics as a worthwhile pursuit. Instead, *science* constitutes the ideal form of knowledge and has the task of discovering what is experienced and deriving laws of predictability from repeated correlations of experience.[2] This is not to say that positivism is to be equated with science. To be precise, positivism is a development of nineteenth-century philosophy which began to discover the importance and the reliability of science, and to distrust the uncertainties and the dubious constructions of metaphysics. By the end of the century, positivism had become primarily a theory of philosophical method which relied upon the primacy of science, and had taken on the task of classifying and extrapolating kinds of scientific inquiry. The most important aspect of positivism in relation to metaphysical idealism, though, is that positivism rejects metaphysics, refuses to deal with uncertainties, and holds that reality is exactly what we perceive.

It can easily be seen how the widespread popularity of photography could contribute to the positivist view. The photograph is evidence that what we see is really there, and, through consensus, that what we see is all that is there. The photograph seems to attest to the reliability of sense impressions. Undoubtedly, the ubiquitous presence of photographs throughout the nineteenth century thus nurtured the rise of positivism as a popular view. But, in reaching an understanding of the development of photograpy, it is more important to note how the development of nineteenth-century philosophy—and its influence on the general intellectual climate of the age—created an atmosphere in which the divergent developments of photographic *intent* were not only possible, but inevitable.

The transition from the eighteenth to the nineteenth century marked a time of great changes in man's conception of himself and the world. It will therefore be necessary to back up a bit in order to introduce and clarify the key issues at stake in the nineteenth century.

The seventeenth-century work of Newton, Descartes, and Leibniz led to a predominance of science in the eighteenth century, by which time Newtonian science had developed into a logico-mathematical cosmology.[3] Although Newton, Descartes, and Leibniz were all working in the realm of science and mathematics, especially in regard to the discovery of the laws of gravity, Newton was alone among

them in refusing to explain the *cause* of gravity. In 1830, Auguste Comte, the first positivist philosopher, wrote that this was the first major step toward the positivist view:

Descartes could not rise to a mechnical conception of general phenomena without occupying himself with a baseless hypothesis about their mode of production. This was, doubtless, a necessary process of transition from the old notions of the absolute to the positive view; but too long a continuance in this state would have seriously impeded human progress. The Newtonian discovery set us forward in the true positive direction. It retains Descartes' fundamental idea of a mechanism, but casts aside all inquiry into its origin and mode of production. It shows practically how, without attempting to penetrate into the essence of phenomena, we may connect and assimilate them, so as to attain, with precision and certainty, the true end of our studies—that exact prevision of events which a-priori conceptions are necessarily unable to supply.[4]

Again, Comte is speaking here specifically about the laws of gravity. Descartes had used the term "attraction," which implies the *cause* of the relationship. Newton, in using the term "gravitation," simply refers to the fact of the relationship and its mathematical description.

Other ideas were also beginning to develop toward the end of the eighteenth century which were to become central in the nineteenth. The focus on mathematical applications to mechanics as an explanation or model of the universe had overlooked change entirely. In the beginning of the eighteenth century, the seventeeth-century disregard of change had carried over. Linnaeus, the great scientist of the eighteenth century, in classifying everything in the known world, presupposed the immutability of that world.[5] This non-evolutionary idea became the predominant intellectual supposition of the eighteenth century in everything from biology and physics to human civilization itself, as can be seen in the social contract idea of Rousseau, Hobbes, and Locke. But the work of these scientists and thinkers inevitably led to different conceptions. Linnaeus himself began to doubt when he later realized that his own research implied a developmental process. The growing faith in the progress of civilization since the social contract, and in the perfectability of man, implied social dynamism and biological evolution. Geological and embryological studies, and speculative ideas on the origin of the solar system, also contributed to the inevitability of the recognition of

evolution.[6] One interesting case in point makes the transition clear: Malthus wrote *Essay on Population* in 1798. Darwin read it in 1838,[7] and published on the *Origin of Species* in 1859.

So as the eighteenth century became the nineteenth, the scientific view of nature changed from Newtonian to Darwinian, from logico-mathematical to biologico-evolutionary, from a vital interest in logical abstractions to strict reliance on concrete phenomena.[8] It was the success of science in this reliance on experience and concrete data that the first nineteenth-century philosophers of positivism admired. They saw in science an indication for the direction of their own work, in their reaction against Hegel. Dampier, in his *History of Science*, sees "Darwin as the Newton of biology—the central figure of nineteenth-century thought."[9]

What Alfred North Whitehead called the "romantic reaction" of literature and philosophy against a mechanistic and non-evolving world-view also had its roots in the eighteenth century. In Germany, Herder had developed by 1774 a philosophy of history based on genesis, growth, and development. This view was the exact opposite of that of the Enlightenment, which saw itself as a radical departure from the barbaric middle ages. Herder extended the biological metaphor in his understanding of the history of art and esthetics.[10] Goethe in Germany and Coleridge in England, both working from the eighteenth into the nineteenth century, also used the biological metaphor. Goethe, who was vehemently anti-Newton, saw life, growth, and experience as central. Coleridge, influenced by both Herder and Goethe, used terms such as "growth," "vital," and "evolution" in his theory of literary invention. He promoted a vitalistic and teleological view of both nature and culture.[11] All these developments contributed to the questioning and probing nature of nineteenth-century thought.

Philosophy, up through the early nineteenth century, culminated in the work of Georg Wilhelm Friedrich Hegel (1770–1831) in Germany. For the most part, the succeeding philosophy of the century was either an elucidation of, or a reaction against, Hegel. As his system was immense and exhaustive, touching on every possible subject, a brief description of his basic ideas, especially as they pertain to the purposes of this paper, will have to suffice. The following quotations from the *Encyclopedia Britannica Micropedia* serve this purpose well. Hegel

developed a dialectical scheme [of thought] that repeatedly swung from thesis to antithesis and back again to a higher and richer synthesis; one of the great modern creators of a philosophical system whose thought influenced the development of Existentialism, Marxism, Positivism, and Analytic philosophy . . . [he] was deeply impressed with Kant's philosophy . . . [but], convinced that the limitations placed on reason by Kant were unjustified, he began to work out his phenomenology of mind. . . . [By 1807 he had formulated his position that] the human mind has risen from mere consciousness, through self-consciousness, reason, spirit, and religion, to absolute knowledge. . . . The keynote of his teaching was to present the entire universe as a systematic whole. . . . [The German Idealism which followed] was proposed as a unitary solution to all the problems of philosophy . . . Hegelianism thus focusses upon history and logic, a history in which it sees that "the rational is the real," and a logic in which it sees that "the truth is the whole."[12]

German Idealism, as espoused by Hegel and his followers, in all its variations of spiritualism and intuitionism, became the dominant philosophical dogma of early nineteenth-century Europe. It was *the* academic philosophy. It is important to note, also, that up until this time philosophy and science had always gone hand-in-hand, in a mutually respecting and dependent way. But with Hegel a schism developed which was to affect the entire century, and which is still unresolved today. Helmholtz, the nineteenth-century scientist, wrote in 1862 that Hegel had developed a system of nature that was untenable to "natural philosophers" (scientists). Hegel attacked Newton, and scientists attacked Hegel.[13]

In Germany, Idealism began as a philosophy of freedom, but ended up as a "semi-official defense of the existing order and a half-slavish invocation of 'tradition.' "[14] This condition prevailed in varying degrees throughout the rest of Europe, where the position of German Metaphysical Idealism was analogous to the position of French academic painters in their authority. But outside the universities and strongholds of academia, the progress of science and the success of the scientific method were instigating a new breed of philosopher. By mid-century the antithesis of metaphysical idealism, the movement which came to be known as positivism, had become the common base of philosophy and science, affecting all aspects of culture.

The general development of positivistic philosophy took place in three stages[15]: From 1830 to 1860 the new ideas were being formu-

lated—in France, the Positivism of Comte; in England, the new Empiricism of John Stuart Mill; and in Germany, the dialectical materialism of Marx and Engels. Between 1860 and 1880 the general trend of positivism became the dominant philosophy of Europe. Finally, from 1880 through the end of the century there began the questioning of positivism as a sole method of inquiry and as a completely tenable world-view. During the first stage the ideas were not yet widely known, but they were being formulated rapidly and intensively. Again, Hegel did not die until 1831, and few were able or willing to oppose him while alive.

For the sake of brevity and clarity, the development of Marxism will not be discussed here. Although Marx and Engels were very much a part of their time, their particular brand of materialistic socialism was not to take real effect until the twentieth century. The French socialism of the nineteenth century, which will be discussed later, did not have its roots in Marx's dialectical materialism, but in the early socialist-utopians of France such as Saint-Simon.[16] In fact, Proudhon, the French socialist philosopher, was opposed to Marx's communism in favor of anarchism. It was aspects of Marx's and Engels' thought other than their systematic philosophy that connected them with the times,[17] for example, the belief that art, morality, and economics are intermingled and interdependent.[18] It is enough to note that Marx and Engels were formulating their communism, agitating revolutions, and bearing some influence on the thought of other philosophers of the time.

The beginning of the positivist movement occurred in France. In 1830 August Comte introduced his positivism with the first of his six-volume *Course of Positive Philosophy*. Born in 1798, Comte was the first philosopher to complete a course in technical studies. Between 1818 and 1824 he had associated with the utopian social reformer Saint-Simon, but later broke with him. In 1826 an outline of his ideas was presented in lecture form to scholars, mathematicians, and natural scientists. His work was interrupted by a nervous breakdown. From 1832 to 1848 he was a tutor and examiner at the Polytechnic. He was unable to secure a higher position mainly because of his radical view of science and his feeling that science should be completely reformed. This antagonized the official representatives of science and eventually led to his termination.

The other philosophical camp in France at the time was Spiritualism. It was led by Cousin, who remained prevalent for a long time

and had to be contended with by any new currents of thought. In fact, few read Comte's *Course of Positive Philosophy,* the sixth volume of which appeared in 1842. A shortened version, *Discourse on the Positive Spirit,* appeared in 1844. His four-volume *System of Positive Polity,* which contained his later views on social, metaphysical, and religious matters, was published from 1851 to 1854.

Comte was preceded by the mathematician Sophie Germain (1776–1831), who felt that errors ultimately arise when people try to explain such things as the origin of the universe. Mathematics, because it does not attempt such explanations, could lead to a reform of philosophy, focusing not on "why" but "how" things are. Saint-Simon taught Comte that universal happiness was possible through science and industry, that science should be a *means* of reforming the world.

Comte was the first to use the term "positivism," and was first to formulate the ideas involved into a system. Although Comte's particular system was not strictly adhered to by later positivists, the term itself was retained to apply to the general school of thought derived from Comte's initial work.

Positivistic philosophy concerned itself only with real objects and useful themes: the improvement of life, not the satisfaction of curiosity. Comte wanted to deal only with those things about which certain knowledge was attainable. Uncertainties lead only to unsolvable disputes, detaining the progress of philosophy. Questions should be formulated precisely, and answers considered to be relative assertions only—subject to change upon the introduction of new data—and never absolute. Comte believed that knowledge was of physical facts, about material objects only.

Comte saw positivism as the ultimate stage of human intellectual development. Free from mythology and metaphysics, positive philosophy could be put to the task of the betterment of mankind. Perhaps the most significant aspect of Comte's philosophy was the relationship he found between science and human behavior. Philosophy, for Comte, relies upon science to find relationships among facts—laws—thus leading to the ability to make predictions. In applying this idea to human behavior, Comte became the founder of sociology. He saw society as an organism of mutually dependent parts, and distinguished social statics (the social order) from social dynamics (progress). It was this novel application of the scientific method which determined the development of sociology throughout the nineteenth century.

Comte was also the first to recognize that science is socially dependent, that because it cannot unify all the available facts, it derives its unity from the present needs of man. He said, "All theoretical considerations should be considered as the creation of the intellect intended to satisfy our needs . . . [in science] we must always return to man."[19] Positivistic politics, therefore, has the goal of finding the social order most attuned to man's happiness and progress, the improvement of human nature. This became the central ideal of the positivist spirit throughout the century, especially the social movements in France which involved many artists and photographers, and was reflected in the growing social awareness of their work.

The French revolution of 1848 nurtured a new liberal spirit which had a strong effect on the arts. This spirit was not shared, however, by the academic Salon painters nor by anyone else in authority after the revolution was put down. By 1850 Courbet had announced Realism, and already the realist painters had something in common with French photographers: exclusion from the Salon. A close relationship among anarchists, realists, and some photographers became inevitable. The central utopian-socialist philosopher of the time was Pierre-Joseph Proudhon (1807–65). He bore a direct lineage to Saint-Simon and Comte, and, in 1840, was the first to proclaim himself an anarchist. Saint-Simon and Comte had earlier recognized the importance of the artist in social evolution. Proudhon advocated the idea of art as a means for expressing moral and ethical ideas.[20]

Hauser in his *Social History of Art,* notes that "naturalism and political rebellion are different expressions of the same attitude," and goes on to quote Courbet as saying, in 1851, "I am not only a socialist but also a democrat and a republican, in a word, a partisan of revolution and, above all, a realist, that is, the sincere friend of the real truth."[21] This is the same "real truth" that interested the positivistic philosophers and scientists.

Just how tightly knit this group was can be seen from the following example from Coke's *The Painter and the Photograph:* Proudhon was photographed by Reutlinger, and then painted, from the photographs by Courbet, who was a friend of photographer Etienne Carjat, who supplied photographs for Courbet's illustrations of Baudry's *Le Camp de bourgeois* (1867), which dealt with bourgeois types.[22]

But the intense political situation in France, especially in the way it influenced art, brought about a strange paradox in the develop-

ment of French photography. Scharf points out that "in France, be-tween 1850 and 1859, a 'school' of Realism appeared which advocated an extreme of pictorial objectivity feasible only with the photographic camera. During the same period, photographers proposed invest-ing their pictures with the spiritual, with the subjective qualities, ordinarily associated with painting."[23] Actually, this development was quite logical. Photographers wanted their work to be accepted as art. Realism was not being accepted as art, while academic paint-ing was. The solution was to join the establishment, which, in France, reflected the metaphysical idealism that was being attacked by posi-tivism. The Realist school was of the positivist spirit. Scharf con-tinues, "the great error, [Courbet's] critics asserted, was to believe that veracity was truth."[24] This, of course, was the very equation that was the cornerstone of positivism. The principal battle of met-aphysical idealism vs. positivism was over this very issue: is Truth a-priori, apart from and above man and sensation—or simply mate-rial nature as seen by the human eye?

The schism which developed in French photography was, there-fore, between those who wanted to create acceptable art, and those who were more interested in social progress. The former can be seen right through the end of the century with the work of Demachy. In the latter case, such people as Charles Negre, who in 1860 made a photographic report on the Imperial Asylum at Vincennes for Na-poleon III,[25] and Nadar, who photographed only the great liberals of his day, and who allowed the first Impressionist exhibition to be held in a studio he had just vacated, are examples. Also the Paris Commune of 1871, which involved many artists, including Courbet, was photographed from the destruction of the Vendome Column to the execution of many of the rebels.[26]

These occurrences were very much entangled with the philosophi-cal argument that was raging at the time. All French authority, from the government to the Salon, depended on metaphysical idealism as its base. Positivism, like Realism, attacked that base and was there-fore seen as quite dangerous. The two main kinds of photography, as cited, then became an inevitable development in France.

In England, a similar situation developed, largely because of the coming of the new philosophy. The key thinkers involved were John Stuart Mill and Thomas Carlyle. Their argument over the value of the machine age, Utilitarianism, and the nature of history was to be felt by the entire culture.

John Stuart Mill (1806–37) was educated from the age of three to be a liberal empiricist. His father, James Mill, schooled John specifically for this purpose. Drawing on eighteenth-century empiricism and science, John Stuart Mill evolved a new Empiricism with broader social implications. He was very much aware of the philosophical turmoil in which he was taking part, and clearly delineated the issues. In 1831 he wrote:

A change has taken place in the human mind; a change which, being effected by insensible gradations, and without noise, had already proceeded far before it was generally perceived. When the fact disclosed itself, thousands awoke as from a dream. They knew not what processes had been going on in the minds of others, or even in their own, until the change began to invade outward objects; and it became clear that these were indeed new men, who insisted on being governed in a new way. . . . The nineteenth century will be known to posterity as the era of one of the greatest revolutions of which history has preserved the remembrance, in the human mind, and in the whole constitution of human society.[27]

Mill read Comte and joined him in the battle against metaphysical idealism. In his autobiography, Mill wrote:

The German, or a-priori view of human knowledge . . . is likely for some time longer . . . to predominate among those who occupy themselves with such inquiries, both here and on the Continent. But the System of Logic [which Mill published in 1843] supplies what was much wanted, a textbook of the opposite doctrine—that which derives all knowledge from experience. . . . The notion that truths external to the mind may be known to intuition or consciousness, independently of observation and experience is . . . the great intellectual support of false doctrines and bad institutions.[28]

Finally, Mill developed (after Jeremy Bentham) the ethical theory of Utilitarianism, which held that "Good" is the greatest pleasure for the greatest number of people. He wrote in his *System of Logic*:

. . . after the science of individual men comes the science of man in society—of the actions of collective masses of mankind, and the various phenomena which constitute social life. . . . All phenomena of society are phenomena of human nature, generated by the action of outward circumstances upon masses of human beings; and if, therefore, the phenomena of human thought, feeling and action are subject to fixed laws, the phenomena of society cannot but conform to fixed laws.[29]

It was perhaps this point which infuriated Thomas Carlyle the most. Carlyle (1795–1881) rose from humble beginnings to become the darling of Victorian culture. He was greatly influenced by the German idealism and romanticism that had rebelled against the Enlightenment's conception of man and nature and "proposed new thoughts on the *inner* forces of man, culture, and nature, and their unity."[30] He left Scotland for London and there found fame and success as a lecturer and writer. In 1840 and 1841 he lectured on, and published a book entitled *On Heroes, Heroe-Worship, and the Heroic in History.* The main idea of the book is that material things are manifestations of God and that great men in history (heroes) are symbols of God on earth.[31] History is shaped by the actions of these people, not by "circumstances" acting upon the masses. Carlyle continued his romantic crusade despite the onslaught of positivism, which, with the publication in 1859 of Darwin's *Origin of Species*, had become dominant.

Victorian England, however, was still conservative and aristocratic. High-society circles lived in dread of revolution (which a growing antagonism between the classes seemed to threaten) and took heroic literature as a political symbol.[32] Carlyle said that disorder was the greatest evil and that force must be used against it.[33] He came to epitomize Victorian culture in the way of "moral fervor, courage, dissatisfaction with the present, and devotion to strange causes."[34] The mood in England is described by William Gaunt:

The times were disturbed. The hungry forties had reached their crisis. Europe was menaced by liberals; dangerous folk whose badge was a beard. England was bewildered by the first big slump in industry. There were riots in Berlin, in Munich, in Milan, in Madrid, in Glasgow, barricades in Paris. Louis Phillippe and his wife came scuttling over to Newhaven as plain Mr. and Mrs. Smith. Mazzini left London to join in the Lombard revolt. On Bankside Bill Sykes prowled with his cudgel in an angry mood. Special constables looked hard at a group of small boys squabbling over an orange. Thomas Carlyle, a mature prophet of fifty-three, who some years earlier had (in Past and Present) contrasted the new age to its disadvantage with the days of monastery and guild, asked for "some scheme or counsel" in the "abyss and imbroglio." Holman Hunt and John Millais followed in the wake of the Chartists' monster petition from Russell Square to Kensington Common. They, too, felt the spirit of the revolt.[35]

Considering Carlyle's position of esteem in Victorian England, it is not surprising that Julia Margaret Cameron, who lived within her

own Victorian-aristocratic circle, should come to admire and befriend Carlyle.[36] Carlyle's influence is obvious in Cameron's portraits (her portrait of Carlyle himself is a case in point) in that her portraits are nothing if not prayers to heroes—and, indeed, her heroes were the heroes of the romantic ideal. But a more complex relationship between Carlyle and Cameron had its effect in her allegorical pictures, specifically in their similarlity to Pre-Raphaelite paintings and drawings.

Like Carlyle, the Pre-Raphaelites saw a great evil in the industrial revolution, and put the blame largely on the new philosophy— especially Utilitarianism as espoused by Mill. As William Gaunt said, the Pre-Raphaelites were "baffled idealists in a material age."[37] They were revolutionaries, but in a reactionary way. They wanted to reform society in the direction of the Middle Ages.[38] Their work was not immediately accepted because, as Ruskin pointed out, it was felt that they were returning to the ignorance of the Middle Ages. But, Ruskin said, they were actually trying to bring back the *principles* of the Middle Ages—belief in God, honor, and morality— which were lacking in the modern age.[39] Under the influence of Ruskin and Carlyle, then, Pre-Raphaelitism became an attempt at social reform in contest with Utilitarianism.[40]

The impact of Carlyle on the Pre-Raphaelites was great. Rossetti notes in the *P. R. B. Journal* that "[Thomas] Woolner is impressed by [Carlyle] as a perfect development of man in his highest attributes."[41] W. Holman Hunt's feelings toward Carlyle are quite clear: "Living at Chelsea, I was near to the house of the philosopher who had from his genius pure and simple won worship of such degree that it was treason at the time I write of to limit the adoration offered at his shrine."[42] At times, the admiration held by the Pre-Raphaelites for Carlyle was reflected directly in their work. In 1858 Wallis exhibited a painting of a dead stonebreaker which bore a quotation from Carlyle's *Sartor Resartus* as its title.[43] And Carlyle himself, along with F. D. Maurice, appears in Ford Madox Brown's painting "Work." Brown says that they are "brain-workers, who . . . are the cause of well-ordained work and happiness in others."[44] Here, Linda Nochlin points out, "the obvious debt owed by the painter to the ideas of Thomas Carlyle . . . especially those in [Carlyle's] *Past and Present* [1843, a shattering exposure of the evils of present-day society], is frankly acknowledged by Brown."[45]

When seen together, the similarities between the Pre-Raphaelite

paintings and Cameron's allegorical pictures become striking. This is well documented in Ovenden's book *Pre-Raphaelite Photography,* in which Ovenden states that ". . . certain artists and photographers working during the mid-Victorian period are clearly linked by shared assumptions, attitudes and sentiments typical of the Pre-Raphaelite Brotherhood."[46] Throughout the book, the resemblances between the photographs of Bedford, Cameron, Robinson, Somers, etc., and the paintings and drawings of Hunt, Brown, Millais, Rossetti, etc., are shown. In fact, many of the Pre-Raphaelites and their associates sat for Cameron's camera. In Kensington, Cameron's social circle included, among others, Millais, Rossetti, and Watts.[47] Various anecdotes concerning the relationships among Cameron, Carlyle, and the Pre-Raphaelites are documented in Brian Hill's *Julia Margaret Cameron—A Victorian Family Portrait.*

Carlyle was a dominant figure for both Cameron and the Pre-Raphaelites. His ideas, which were largely formed and felt as a result of the prevailing philosophical argument of the nineteenth century, were reflected in the work of Julia Margaret Cameron and many of her contemporaries. In this instance, then, it is clear that the development of nineteenth-century philosophy had a definitive influence on the development of photography.

At the same time, also in England, other photographers were developing a social awareness which led to a photography of a different sort. The rise of positivism involved a growing awareness of social dynamics. It should be remembered that Comte first formulated sociology. Eventually, photographers became aware of the power of photography to effect social change. It became obvious that industrial society was here to stay, and that the "Pre-Raphaelite Dream" was, after all, a dream. So it became important to try to change things toward the future rather than toward the past, to use the photographic documents to improve the lot of mankind.

One of the first to do this was Dr. Hugh W. Diamond (1809–86). He was Resident Superintendent of Female Patients at Surrey County Asylum from 1848 to 1858. He was the first to use photography in treating mental patients. He would show patients their own pictures in various states of mind and note the effects.[48] Between 1868 and 1877 Thomas Annan photographed the slums of Glasgow for the Glasgow City Improvement Trust, and became very aware of the power of this kind of work to arouse emotions.[49] In 1870, Dr. Bernardo began to use photographs of wayward children to raise money

for his child-care work. He, too, was conscious of the ability of photography to affect people's attitudes and thereby help the social conditions of the poor.[50] John Thomson, in the 1870s, photographed *Street Life in London* with the purpose of educating people as to the plight of London's poor.[51]

The most effective use of photography in this mode, however, was done in America by Jacob A. Riis (1849–1914). Riis had come to this country as a poor immigrant in 1870, and, in 1877, while working for the "New York Evening Sun" as a police reporter, began his crusades against the slums.[52] He was very much aware of social dynamics. Donald Bigelow, in his introduction to the 1957 edition of Riis' *How the Other Half Lives*, quotes Riis as saying in 1890:

We now know that there is no way out; that the "system" that was the evil offspring of public neglect and private greed has come to stay, a storm-center forever of our civilization. Nothing is left but to make the best of a bad bargain.[53]

He understood that the afflictions, crimes, and disease of the slums could be eliminated only by eradicting the cause—the slums themselves.[54]

Riis chose the path of a reformer rather than a revolutionary, though he was aware of revolutionary ideas. He joined the Social Reform Club and there heard lectures by such people as the Russian anarchist Kropotkin. Some of the club members became socialists. But Riis elected to work through the system rather than against it, to reform the system in order to make it more workable.[55] Through the publication of his books, his slide-show lectures, and with the help of Theodore Roosevelt as City Police Commissioner, Riis was able to effect changes through the use of photography. And though these changes came at the very end of the nineteenth century, the consciousness that understood enough about social dynamics, and the conscience which cared enough about humanity to want to bother with such changes, can be traced back to the very beginning of the century, to the positivistic philosophy of Auguste Comte.

The study of philosophy is often seen as an irrelevant, obscure, and esoteric pursuit. The foregoing article, however, should indicate that the study of philosophy can be an integral factor in our understanding of the history of photography. As such, it is not intended as a definitive treatise, but as a suggestion for further work in this area.

14

Walker Evans, Rhetoric, and Photography

Daniel A. Lindley, Jr.

It is not difficult to see why photography in general, and the work of Walker Evans in particular, seem to resist responsive explication. Here is a list of difficulties peculiar to both the medium and Evans' use of it:

1. In Evans' photographs of the interiors of the Alabama share-croppers' houses, for example, are we not moved primarily by the unconscious artistry of the people who lived in those houses? Has the photograph *per se* anything to do with the perfect arrangement of silverware and containers on a kitchen wall?[1] Obviously we give the photographer credit for emphasizing the relationships between the objects and the planks of the wall with his frame, and perhaps we give the medium in general, or the 8" x 10" camera in particular, credit for helping the tableware look like metal and the worn wood look like worn wood. But, having noted these things, we allow our attention to shift away from the photograph and into the kitchen it-self and then, by extrapolation, to the people who used it and shaped it. Indeed, we are attracted, as William Stott[2] points out, both by

Reprinted from *Exposure*, March 1978, by courtesy of the Society of Photographic Education.

their artistry in the subtle placement of these objects and by their utter lack of awareness of what they have done. Taken together, artistry and innocence make up an attractive paradox, but it is a paradox in the house itself, and in the lives of a particular family. To be sure the photographer must notice it. But it was not "put" into the photograph in the way that an image in Agee's accompanying prose moves from intuition to the written line by being deliberately placed there by the writer:

. . . and the breakfasts ended, the houses are broken open like pods in the increase of the sun, and they [their inhabitants] are scattered on the wind of a day's work.[3]

Here we are in the presence of what seems an entirely different order of creating, a mind creating a figure and following it through, as opposed to finding one already, if unconsciously, constructed. (Interestingly, when Agee gets to the point of describing this particular kitchen, he devotes two sentences to the stove and then lets the photograph take over: "In the opposite side of the kitchen is a small bare table from which they eat; and on the walls, what you may see in one of the photographs."[4]

2. *Seeing aside*, is not the craft of photography too easily acquired, being merely a matter of mastering some equipment, a few ideas about optics, perspective, and sensitometry, and a few dependable chemical procedures? In other words, does the craft of photography somehow undercut or trivialize the importance of seeing? I have put this as a question: it could as well be phrased as an often unstated, but felt, assumption.

3. Is not the motive for making many photographs rather more a matter of journalism, or documentation, than a matter of trying to create a work with a life of its own? Surely the elegant subjects of Henry VIII who sat for Holbein expected not merely a "likeness," but also a work which would last, and stand alone, unreferenced to their particular time and place. This tension, between specific documentation and timeless autonomy, is an obvious source of power in painting: it may be clearly and poignantly seen in a series of Rembrandt or Van Gogh self-portraits, for example. In contrast, the initial impression conveyed by most of Evans' work for the Farm Security Administration was (and, for many people new to the photographs, still is) far more one of documentation than of a reaching for permanence. Indeed, this was one of the sources of tension, one suppos-

es, between Evans and Roy Stryker, the then director of the FSA's Photography Unit. A combination of nostalgia and adulation has given these photographs an authority which they hardly seemed to have at the time they were made. The problem, in short, is: where is the "high seriousness" in documentation? Indeed, there often seems to be an inverse relationship between documentation and individual expression.

4. In the process of painting or sculpting or composing music, the artist is engaged in a cybernetic relationship with the work itself. That is, the artist works slowly, and each new gesture adds to, and therefore changes, what has gone before, both in the work itself and in the mind of its creator. The work teaches the artist, the artists changes and adds to the work, learns something new from those changes or additions, adds something else, learns, adds, and so on. Creation and growth become synonymous and inseparable as the work proceeds toward completion. It is a circular process, a cybernetic loop, often with a life of its own. Novelists, for example, often tell of the feeling that the characters they have created "take over" the motion of the plot. Clearly, then, the maintenance of this loop is fascinating, difficult, and (most important here) only possible over a period of time.

In photography, though, creation is instantaneous, perhaps impulsive, and unmodifiable after the fact, in most instances. (The elaborate multiple printing of Jerry Uelsmann, the staged narratives of Duane Michals, and the Photograms of Man Ray and Moholy-Nagy may represent attempts to overcome this limitation.) Or, to put this another way, creation in photography seems to be primarily a matter of noticing, or seeing, or looking. To be sure, noticing is not trivial. Evans was fond of quoting an art teacher acquaintance of his who had once said to him that "looking is much harder than it looks." But even so, the most important work in photography seems to take place (1) almost entirely in the mind, and (2) before (*just* before) or even during, the split second of the exposure.[5] The elegant maintenance of the artist's cybernetic loop through a long composing process is simply never done in behalf of any one photograph. If it is done at all, it is done as part of the general obligation of the photographer to stay aware of the world and alert to its nuances of light and form. But this is no different from similar obligations imposed by their work upon the writer or the painter. The specifically momentary work of "taking" a picture seems very casual by comparison.

These, then, are some of the ideas about photography that make it a recalcitrant medium to take seriously, let alone a medium from which we should expect any important clarification of experience or deepening of understanding. In spite of such difficulties (and I do not pretend to have listed all of them) there has been an enormous amount of attention paid to photography in recent years, surely enough to suggest, among other things, that the difficulties listed above deserve to be overcome. What follows, then, is an effort in that direction—an outline of a critical approach, based on some formulations from the field of rhetoric, and applied to photography. There are some borrowings from other critical strategies as well. The aim is to clarify the experience we have of the medium and of particular photographs. The work of Walker Evans provides the examples, with a few mentions of other photographers for illustrations of other approaches, and for comparison.

"Rhetoric," Rhys Roberts says Aristotle says, "may be defined as the faculty of observing, in any given case, the available means of persuasion."[6] There are two important ideas here. First, there is the attention to persuasion. Second, there is the delightfully ambiguous word "observing," which may mean either to *do*, or to *notice*. Either the artist or the critic (any informed observer) may be considered, then, as potentially able to employ the "faculty" of rhetoric. But I wish to turn first to the problem of persuasion.

Aristotle was chiefly concerned with persuasion in a narrow context, the court of law; but even his own treatment of the subject goes beyond that, and of course has been extrapolated by others ever since. What is important about persuasion, for this treatment of photography, is that the motive to persuade comes, evidently, from some feeling of *difference*, or *distance*, both physical and psychological, between the speaker (or writer, or photographer) and his audience. This theme of difference, or imbalance, runs through the *Rhetoric* (as in the long discussion of friendship and enmity in Book II, and in the discussions of anger and calm, fear and confidence). A modern restatement of this idea, by Richard Young and Alton Becker and based upon the work of Kenneth Pike, puts the matter this way:

. . . if a writer has anything new to say, his image of the world must be in some way different from that of his reader. It is at this point of difference that his message lies. He may seek to expand or clarify some feature of the reader's image, thus making it more nearly like his own, or he may seek to replace some feature of the reader's image. In the first instance he would be informing; in the second, persuading.[7]

Now in the case of the photographs for either edition of *Let Us Now Praise Famous Men*, superficial attention to the matter of persuasion would yield at least the following "points of difference" between the photographer and his audience: (1) Evans went to Alabama, and lived among his subjects; (2) he and James Agee either had, or developed, a specifically focused concern for those people in that place. It follows, therefore, that the motive for their work would seem to be, using Young and Becker's formulation, to persuade, rather than to inform. That is, their motive is not to "expand or clarify" the viewer's image, because the viewer almost certainly has no image worth working on in that way. Rather, they seek to "replace some feature of the reader's image," because the reader's image is fundamentally flawed: it is (presumably) an image of worthless, unthoughtful, and shiftless "poor people" whose sufferings are their own problem; hence the task of the photographer is to help the viewer to substitute a more humane understanding of these people for a prior notion that at best held little or no compassion and at worst did not exist at all. And, given the sponsorship of the Farm Security Administration—supported, after all, by federal taxes—such a view of the purpose of these photographs makes good social and political sense, especially at the beginning of Roosevelt's first term. It is true, of course, that Stryker's ideas for his work in the agency were more complex and more subtle than this, but the point remains valid.

A much more blatant piece of evidence for the idea that these photographs were supposed to be efforts to persuade is to be found in the nature and the tone of the original assignment given Agee and Evans by *Fortune* in April of 1936.[8] It was an assignment typical of Time Incorporated's idea of what its writers and photographers should be doing: that is, acting as the eyes and ears (to quote from another medium) of their readers. It is the "you are there" illusion, an illusion necessary for successful persuasion, the assumption being that the world of the tenant farmers can be, and should be, made a *new* part of the reader's awareness of the world. (This newness, it should be recalled, is implied in Young and Becker's use of the word "replace": ". . . he may seek to replace some feature of the reader's image.") This idea of persuasion through a sort of awesome novelty seems to make good journalistic sense, and at first it seems to account for much of the power in Evans' photographs. But it will not do.

It will not do because it fails to account for the fact that so many

of these photographs have a continuing power to engage us, whether or not we know anything of the circumstances surrounding their creation, as Stott's bibliography for his discussion of them shows.[9] They have this power because they are *not* primarily efforts to persuade, in Young and Becker's sense of that word; rather, they succeed because they do what those authors call "informing." That is, they "seek to expand or clarify some feature of the reader's image, thus making it more nearly like his [the photographer's] own." In other words, these photographs assume that we *do* have something of an image of these abashed and unfortunate people. In essence, it is not what the photographs bring to us that is ultimately persuasive. It is what we bring to the photographs; and what we bring is what makes these photographs matter.

We bring ourselves into these photographs because there are points of similarity between our experience of the world and the contents of Evans' images. Other photographers working for the FSA or for the magazines—Arthur Rothstein or Margaret Bourke-White, say—accomplished less than Evans because they sought out and accentuated *differences* between themselves (and us) and their subjects, and in so doing made their audience's interpretation of their photographs an easy, often trivial, task. (Stott[10] makes this same point in another way, especially with regard to Bourke-White.) Evans alone sought out, and found, the common ground shared by himself and his subjects and, in so doing, he found psychological spaces inhabited by both his subjects and his audience. Almost invariably he places his camera so as to give the view that we would have had if we were simply standing on the ground, or in a room, looking straight ahead. As Szarkowski says, "These photographs persuade us that this is just what we would have seen, and understood, and recorded, had we been there; they have so persuaded even those of us who were in fact there."[11]

Now, we have to face here an apparent contradiction. On the one hand there is no motive to communicate anything unless and until there is some point of difference between the artist and his audience. On the other hand Evans is concerned with the essential, if subconsciously established, similarities between his subjects and ourselves. The essential point is that we expect the documentary to emphasize differences, and we are moved by the unexpected attention to the common ground shared by ourselves and these subjects of Evans' camera. This attention to what we share with these people—

so far removed from us in time and circumstance—is manifested everywhere in the work. Where we might expect to see example after example of sloppiness or carelessness, Evans finds instead an exemplary orderliness, a necessary placement of objects. For example, in the photograph of Floyd Burroughs' wash stand[12] the whiteness of the towel (in fact a piece of flour sack), the readiness of the enamel dish, the pristine floor, all reflect a shared preoccupation with neatness and cleanliness. But even more important, the whole photograph speaks of an acute sense of where things belong, a sense of the "rightness" of how we arrange our own things, our own rooms, the idiosyncratic rightness of comfortable habit.

A small correspondence, perhaps; but take the placement of a similar dish at the exact center of the mound of earth over a child's grave.[13] The dish is placed as a gesture, a reflection of the universal need to "do something" in the face of death. The mound underneath the plate seems to have taken the shape of the body underneath it, whether it really has or not; but the plate sits lightly on top, white and very touching, a sign that there are people about, still alive and still caring: as we are, and as we do.

Or, again, there is the picture of Squeakie Burroughs (the baby) asleep under a white cloth.[14] The unnatural sprawl of the uncovered legs, coupled with the covered face, speak of death. Ironically, only the bandaged foot tells of life. It is a photograph of sleep turning into death: again, an idea we recognize, a fear we know. The idea that we *do* know is a theme repeated in Agee's account as well:

And thus, too, these families, not otherwise than with every family in the earth, how each, apart, how inconceivably lonely, sorrowful, and remote! Not one other on earth, nor in any dream, that can care so much what comes to them, so that even as they sit at the lamp and eat their supper, the joke they are laughing at could not be so funny to anyone else; and the littlest child I speak of is not there, he is of another family, and it is a different woman who wipes the food from his cheeks and takes his weight upon her thighs and against her body and who feeds him, and lets his weight slacken against her in his heaving sleep. . . . All over the whole round earth and in the settlements, the towns, and the great iron stones of cities, people are drawn inward within their little shells of rooms, and are to be seen in their wondrous and pitiful actions through the surfaces of their lighted windows by thousands, by millions, little golden aquariums. . . .[15]

What Evans knew—must have known, intuitively—was that all of us, no matter when or where, arrange ourselves and our possessions

in ways bordering on the magical: ways intended to project our inner ideas of order out into the otherwise neutral universe of inanimate things. Thus do we maintain our dignity, our sense of self. And thus do we join with everyone, because everyone does this, with things, and face, and clothing, and pose, and gesture. (This is one theme of *Many Are Called*[16] as well.) This knowledge separated Evans from all of us who would have remained impressed only with our own identities and arrangements, and would therefore see almost everyone else as different.

But let us look more closely at a way of defining the "points of difference" between the photographer and his audience. Consider the photographer as the central character, or "hero," and consider the world as a drama, or a novel, or an epic: some narrative structure containing a series of actions. What stance may the hero take toward the world? We have, from Northrop Frye, an outline of the possibilities for the hero in literature.[17] I propose to place the photographer in Frye's scheme. (Of course the analogy cannot be a perfect one. The hero in literature is defined by his actions, or by being acted upon. The photographer seldom, if ever, acts in this way. But he must, like the hero, adopt a stance toward the world. Any photographer is at once both participant and observer because it is necessary to be where the subject is in order to make a photograph of it—compare the writer—and being there must inevitably lead to at least a minimal kind of participation. Once there, the photographer must decide whether to try to observe as one of the other participants would do, or as an omniscient being might, or through the eyes of some editor, or through the "collective" eye of an organization, such as Time, Inc., or the FSA. Or he may try to find a stance uniquely his own.)

If the photographer consciously works at creating a reality entirely of his own making, then he is working as a *mythic* hero; that is, as a god. He is, in Frye's words, "superior in *kind* both to other men and to the environment of other men."[18] (Not that he really sees himself this way. Frye refers to myths involving gods supposed to be truly gods. I mean to suggest that such photography stems from efforts by the photographer to act *as if* he had, through the medium, some sort of divine control over the world.)

Such *hubris* seems to me forgivable. Examples may be found in the multiply-printed creations of Jerry Uelsmann in our own time, and in the strange allegorical constructions of Oscar Rejlander and

Henry P. Robinson of roughly a hundred years ago. The idea of creating a world is also what makes connections between photography and meditation attractive, as in some of the photographs and most of the later writing of Minor White.

Samples of what some of these people have written about their work give hints of the photographer's tentative grasp for the power of a deity. Here is Uelsmann:

. . . if I like the image, I try to run an edition. . . . One advantage of this last step is that I have more sustained contact with the image. As I continue to look at it, my mind considers what else can happen, how it could change. It occurred to me that maybe I could work this same rock form in with another background. . . . I do some changing of scale with the enlargers so that the tree blends with the foreground rock and they come together to form a cohesive image.

One of the hazards of working this way for a long time is that you begin to previsualize your postvisualization.[19]

"Previsualization" is, of course, an idea of Edward Weston's; but when Ueslmann talks of "postvisualization" he means that he sometimes looks at the world and *actually sees it changed by his manipulations*. Or, in the darkroom, his "mind begins to consider what else can happen. . . ." He means changes in the image, of course, yet he cannot help but see the changes he will make before he makes them; and sometimes he sees them in the world: he is a creator of his own particular genesis, making things over to suit an inner vision.

Here is Robinson, writing in 1892:

Photography gives us the means of a nearer imitation of nature than any other art, yet has sufficient elasticity to show *the directing mind*, and therefore is the most perfect art of all.[20]

And here, finally, is Minor White, on what he takes to be his responsibility toward students, or toward younger photographers generally:

Whether I or any other critic or teacher has the capacity to judge the depths and breadths and heights of the new photographers' rapport, he looks to us for affirmation on the dark road of his Way. . . .

The spiritual crisis of the times demands that we should heed him. *The healing capacity of the process of creative work is desperately needed, now!* . . . Best of all is the using of art and camerawork consciously for healing *no matter how few* the psychological wounds caused by a society destroying itself.[21]

This is the photographer in the role of spiritual guide—if not a god, at least a priest. And he associates a healing process with the doing of photography: a healing based on faith in the inner journey, a journey which, in White's view, guarantees integrity to the work even if it does not yield strong photographs. The integrity somehow comes from inside the photographer, and not from his relationships with the people or things photographed.

The strange allegorical constructions of Robinson or Rejlander are not merely representative of a quaint Victorian taste; they have an unwitting ally in White. Both Rejlander and Robinson could have painted what they created instead of making photographs—they were both so trained— but they *did* make photographs, and this fact gives their old accomplishments a special force. Anyone knows that a painter can imagine. What they did, though, was to adopt a medium in which they could imply that what they invented was actually there, out in the world. It is this confusion of vision and fact which seems to me to suggest a godlike stance. And it is this same confusion which seems to have therapeutic significance for White.

The strongest conventional idea about photography is that it shows us things found by the photographer, not made by him. The difference between "I found this" and "I created this" is a difference between man and god, where photography is concerned. (This stance may have more importance in a consideration of ways of teaching photography than for actual photographic practice; it may be a phase for photographers to either grow into or out of.)

Frye moves next from myth to romance:

If superior in degree to other men and to his environment, the hero is the typical hero of *romance*, whose actions are marvelous but who is himself identified as a human being. The hero of romance moves in a world where the ordinary laws of nature are slightly suspended . . . enchanted weapons, talking animals, terrifying ogres and witches, and talismans of miraculous power violate no rule of probability once the postulates of romance have been established.[22]

Here we are not faced with the issue of changing or creating a world; rather, what this hero does is to somehow remove himself, through magic, some little distance from actuality. The work of Clarence John Laughlin seems to me informed by this urge. He gives us shapes turning magically into symbols, or at least this is what he *says* he gives us, as for example:

Naturalistically, this is only an iron door in a New Orleans cemetery, with a cracked knob surrounded by cobwebs. But Imaginative pre-conditioning caused me to see the cracks in the knob as suggestive of drawings of the so-called canals on Mars. Mars now emerges from a black sky of iron in the house of Time (the cemetery); and the camera has been used to make a poetic meaning *transcend* a naturalistic meaning.[23]

Thus *things* (the cemetery, the doorknob) take on, for Laughlin and in romance, allegorical meanings. These meanings are not created by the photographer; rather they are seen by him in the objects, and the objects thereby become endowed with magical properties. As a result, they have the potential of becoming more important to us than we might have expected. Furthermore, the romantic vision is often of a world in process: a boulder with a sword thrust into it; Acrasia's garden and Alma's castle; Prospero's inhabited island. All are full of objects, but they are objects metamorphosing into something more: they are changing into signs, into guides. Objects can be photographed so as to suggest that this is what they are doing. Laughlin does this. So, sometimes, does Ralph Gibson (as for example in some of the pictures in *The Somnambulist*).[24] There are examples, too, in the work of Ralph Meatyard and Wynn Bullock, among others. Overall, though, it is not a common mode for photographers to work in: it tends toward the sentimental, on the one hand, and the bizarre, on the other.

"If superior in degree to other men but not to his natural environment, the hero is a leader," writes Frye.[25] "He has authority, passions, and powers of expression far greater than ours, but what he does is subject both to social criticism and the order of nature. This is the hero of the high mimetic mode, of most epic and tragedy. . . ." For Frye, the word "degree" carries its political sense. For our purposes, it is not political power, but the power to *see*, that counts. The photographer in this mode "leads" by seeing, is at the forefront of whatever territory human sensibility may hope to occupy. The overwhelming majority of photographic work that has remained important is in this mode. For this reason I shall return to it shortly, but I wish to say something about Frye's two other modes before doing so.

In the *low mimetic* mode, the hero is superior neither to other men nor to his environment: "The hero is one of us: we respond to a sense of his common humanity, and demand from the poet the same canons of probability that we find in our own experience. . . ."[26]

Two ideas should be emphasized here: one, that if the photographer operates in this mode, he automatically makes it impossible for himself to establish any point of difference, any imbalance, between his view of the world and that of his audience. He will produce post cards. The other is that the mere making of a photograph cannot establish any sense of imbalance if the photographer's vision stays in the low mimetic mode. For example most of the work of Ansel Adams fails to move me, in spite of its awesome technical proficiency, whereas the work of Edward Weston does move me, because it is done in the high mimetic stance.

In the *ironic* mode, the hero is "inferior in power or intelligence to ourselves."[27] Such a mode accounts, perhaps, for those occasional strong photographs that are made truly by accident. Efforts to build dignity into the snapshot are sometimes designed to get around having to admit that snapshots done by "Senior" photographers are in fact ironic in the sense here suggested.

To return to the high mimetic mode: we have said that this mode is reflected in an ability to *see*. More particularly, it is revealed in an ability to see those things which, for most people, tend to remain below the level of conscious awareness, but not so far below as to be inaccessible. The dramatic parallel lies in the growth of the tragic hero's awareness of self, whether it is exemplified by King Lear's reconciliation with Cordelia together with its paradox of imprisoned freedom; or Achilles' ultimate understanding of the supplicant Priam; or Othello's somewhat self-serving summation, "Speak of one who loved, not wisely. . . ." Othello, as T. S. Eliot remarks,[28] is concerned with "cheering himself up." Eliot's idea seems casual, but the idea of reassurance is actually crucial for all these examples. The act of *becoming* aware is, ultimately, nothing less than an affirmation of existence. Statements, or images, which are already familiar do not have the power to do this. The power of photographs in the high mimetic mode is derived from a sense of continual movement from a state of inchoate but powerful intuition to a state of a definitive, concrete image.

Here are some examples of how this movement informs Walker Evans' work. There is, to begin with, the whole sequence of images in the 1941 edition of *Let Us Now Praise Famous Men*, from the "external" power of the landowner[29] through the intimacies of the three families (selves, homes, work); a transitional image of travel toward town; the town itself with its temptations of the possibility of a small escape, a momentary reprieve; then the Sprott post office,[30]

fronted by roads, and with its implication of a larger, if inaccessible, world, followed immediately by the picture of the child's grave, the closing in again of the reality of helplessness, except for that white plate; then, the last picture, the long thin pole with the martin nests made of gourds, reaching obliquely toward a patch of clear sky. The whole sequence is a movement, like metaphysical tracking shot of the world—life, death, and hope.

The same expression of work, life, and death is to be found compressed in a single photograph, "Graveyard, Houses, and Steel Mill, Bethlehem, Pennsylvania,"[31] taken the previous year. The houses are literally a strip between the mills behind them and the graveyard in the foreground. Dismal as they are, at least they are lived in. Other photographs[32] from this same place say other things. The street scenes, the row houses, remind one of the view of Willa Cather's pathetically romantic protagonist in "Paul's Case":

The moment he turned into Cordelia Street he felt the waters close above his head. . . . he experienced all the physical depression which follows a debauch; the loathing of respectable beds, of common food, of a house penetrated by kitchen odours; a shuddering repulsion for the flavourless, colourless mass of everyday existence; . . .[33]

Or, again, there is that strange accident whereby the lady who happened to emerge from the doorway of a striped-facade New Orleans barbershop[34] seems to be imprinted with the stripes that surround her, because of her striped blouse. The picture starts as a mild joke and ends as a comment about how we are all touched by our surroundings. Or there is the cumulative effect of *Many Are Called*, which has the kinetic quality of the subway itself, together with the lonely individualism of its riders. We seldom see so deeply as these photographs seem to do; but we have had moments of such awareness, even if fragmentary or poorly sustained. If this were not so the photographs would not work; but we recognize their truth for ourselves, as the high mimetic protagonist finds the truth in his fictional world. Much recent photography, particularly that done in the more advanced settings for photographic studies, seems to me to fail precisely because it does not reaffirm our own insight in this way. It is, instead, idiosyncratic, reflecting a strained effort to look innovative. It is self-conscious without being conscious of the self; it is photography about photography, rather than photography about the resonance[35] between the outside world and our understanding of it.

Eliot again:

The only way of expressing emotion in the form of art is by finding an "objective correlative"; in other words, a set of objects, a situation, a chain of events which shall be the formula of that *particular* emotion; such that when the external facts, which must terminate in sensory experience, are given, the emotion is immediately evoked.[36]

The "finding" referred to here is of course done by the artist; and, although Eliot's concern in this essay is with drama, the importance of "finding" is obvious for the work of the photographer as well. What this passage suggests is that the world is full of *potential* objective correlatives—that is, objects which, if properly recorded and presented, will reveal the "emotion" with which they would be charged by any alert and sensitive observer. (There is, as Vivas points out,[37] an ambiguity in Eliot's idea of "emotion": is it in the objective correlative, or is it in the person experiencing it? I find no problem here: the emotion is first in the artist, who feels a sense of recognition in the presence of the object, and then *uses* the object by transmitting it into some other form. Evans' Yale exhibition [1972] had both real signs and photographs of signs in it; if the signs had the power of photographs it was because Evans collected them. An object becomes a correlative of an emotion when the artist uses it to do so.)

If it is the perception of the *object* that causes the response, then might not a case be made for the idea that photography weakens our response to the object by presenting us with a poor imitation, whereas painting, while it removes the object, gives us the artist, at least? This notion seems to have some force. (It may account, for example for the fact that photography is to be found, in Yale's slide collection, under "minor arts.") But it is wrong. It is wrong because it fails to recognize what photography *does*. And what it does is to abstract, in specific ways, from what we ordinarily see.

But does the photograph present us its subject as the objective correlative, or is the photograph instead a *new* object and therefore a new correlative for a new set of responses? Edward Weston, as we have seen, was concerned to present the object exactly: "To see the *Thing Itself* is essential. . . ."[38] Nevertheless the photograph is not the thing; and to the extent that it *is* a new object, it engenders new responses.

The answer to how it does so lies in the relationship of film and print to light and experience. We may think that the object is one thing, and the photograph utterly another; but this idea is in error

174

to the extent that the medium of photography is bound, by its own limitations, to a very definite way of presenting its subjects. Or we may think that the photograph and its subject are the same ("I know it's true, I saw the picture in the paper"), an idea which turns the photographer into a mere collector, and vitiates the choices he must make about stance—in what mode of "heroic" existence he chooses to work, and how he will use light. The cure for either error lies in a better idea of what photography *is*. As Ivins notes,

. . . we find ourselves in the peculiar dilemma of having a technical knowledge and capacity that are far in advance of many of our settled, accepted modes of thought and valuation, which have remained just as they were even before the initial steps were taken toward photography and are based on notions that in many respects are incompatible with its modern developments.[39]

In short, we assume we know what photography is without knowing what it actually does to our idea of the world.

What it does—at least, what black and white photography does—is to set up a paradox which contains, on the one hand, strict and exact limitations built into film and paper, and on the other hand, an almost infinite possibility of choice given the photographer about how the finished print shall actually look. The photographer is both controlled and in control.

One way for the photographer to keep some degree of control is by careful manipulation of materials and the photographic process, as is possible through use of Ansel Adams' "zone system." The other way to achieve this sort of control is to wait for, or arrange for, the right light in the first place. In the one system method it is the medium which the photographer controls. In this latter approach, the world has the upper hand, and the photographer waits. It is a choice between the medium and the world. Walker Evans chose the world.

Evans was not a careful printer—in the last several years of his life, his students did most of his printing for him—nor was he especially troubled by large variations from print to print. Two versions of his "Breakfast Room–Belle Grove Plantation" bear out this assertion. The reproduction in *Messsage from the Interior*[40] is full of light, clearly a "morning" picture. But in the print that was exhibited in the 1972 Museum of Modern Art retrospective,[41] the effect is of gloom and decay, with only the crosslike gleam of light through the shutters to suggest a more hopeful world outside. So, although these

two prints do suggest the consequences of control over the medium, they also demonstrate that this control was not very interesting to Evans. His concern lay elsewhere.

Specifically, his concern was with the world, and, because he was a photographer, his particular attention had to be given to how light falls on what is in the world. And here we can see an overwhelming theme that runs throughout Evans' work. The light he finds, or the lights he creates (with flash), is almost always *frontal*—in effect directionless—falling on the subject almost as if it came from the camera itself. The subjects often almost glow. We rarely see long, angular shadows used as parts of the plan of a picture. We see instead a diffused, all-pervading, universal *light*.

He seeks, in short, the world, and he adopts a stance toward it, as we have seen. But, having done that, he waits, or he is lucky—either will do—until the light is *his* light, doing what it must do to present these people, these houses, these signs and streets, in a way so uncolored by accident or circumstance as to seem *not* part of the passing changes of sun and weather but, rather, objects and inhabitants of a whole other world, a world seemingly more permanent, because clearer and simpler, than the one in which we live our ordinary days.

For this is what the medium of photography finally requires: it demands, on the one hand, the taking of a stance toward the world; and, on the other, the knowledge that light and understanding are, at bottom, the same. Evans had both. There are photographers who know more of light and of the medium, and there are photographers who have developed a stance that serves them well. But the combination is so rare that, when we find it, we know we are in the presence of a body of work which clarifies both our world and ourselves.

Notes

1. *Walker Evans: Photographs for the Farm Security Administration* (New York: Da Capo Press, 1973), Library of Congress file number 8144A, plate number 338 in this edition. Hereafter, this publication is referred to as *FSA*, with the photographs numbered as above.

2. William Stott, *Documentary Expression and Thirties America* (New York: Oxford University Press, 1973), p. 271.

3. James Agee and Walker Evans, *Let Us Now Praise Famous Men* (Boston: Houghton Mifflin, 1960), p. 91.

4. Agee and Evans, p. 192.

5. Henri Cartier-Bresson, *The Decisive Moment* (New York: Simon and Schuster, 1952), Introduction.

6. Richard McKeon, ed., *The Basic Works of Aristotle* (New York: Random House, 1941), p. 1329.

7. Richard E. Young and Alton L. Becker, "Toward a Modern Theory of Rhetoric: A Tagmemic Contribution," reprinted in Martin Steinmann, Jr., ed., *New Rhetorics* (New York: Charles Scribner's Sons, 1967), p. 91.

8. Stott, pp. 261–63.

9. Stott, pp. 342–44.

10. Stott, p. 271.

11. Walker Evans, *Message from the Interior* (New York: Eakins Press, 1966). Hereafter cited as *Message*.

12. *FSA*, LC 8133A, #260.

13. *FSA*, LC 8175A, #345.

14. *FSA*, LC 31294-M2, #258.

15. Agee and Evans, pp. 53–54.

16. Walker Evans, *Many Are Called* (Boston: Houghton Mifflin, 1966).

17. Northrop Frye, *Anatomy of Criticism: Four Essays* (Princeton: Princeton University Press, 1957).

18. Frye, p. 33.

19. Jerry N. Uelsmann, "How Jerry Uelsmann Creates his Multiple Images." *Popular Photography,* January 1977, p. 128.

20. Henry P. Robinson, "Paradoxes of Art, Science and Photography," reprinted in *Photographers on Photography*, Nathan Lyons, ed. (Englewood Cliffs, N.J.: Prentice-Hall, 1966), p. 84. Italics added.

21. Minor White, *Octave of Prayer* (Millerton, N.Y.: Aperture, 1972), p. 26. Italics in original.

22. Frye, p. 33.

23. *Clarence John Laughlin*, (Millerton, N.Y.: Aperture, 1973, Vol. 17, numbers 3 and 4), p. 124.

24. Ralph Gibson, *The Somnambulist*, (New York: Lustrum Press, 1970).

25. Frye, p. 34.

26. Frye, p. 34.

27. Frye, p. 36.

28. T. S. Eliot, quoted in Hugh Kenner, *The Invisible Poet* (New York: McDowell, Obolensky, 1959), p. 121.

29. *FSA*, LC 8127A, #244.

30. *FSA*, LC 8158, #215.

31. *FSA*, LC 1167A. #61.

32. For example: *FSA*, LC 1178A, #54; LC 1168A, #53; LC 1174A, #57; and, perhaps especially in the context of the Cather story, "Billboards and Frame Houses, Atlanta, Georgia," which is LC 8057A, #163.

33. Willa Cather, "Paul's Case," reprinted in *Willa Cather's Collected Short Fiction, 1892–1912* (University of Nebraska Press, 1965), p. 248.

34. Walker Evans, *American Photographs* (New York: Museum of Modern Art, 1938), p. 15.

35. There is a useful discussion of the implications of the idea of "resonance" in Tony Schwartz, *The Responsive Chord* (New York: Doubleday, Anchor Press, 1974).

36. T. S. Eliot, "Hamlet and his Problems," in *The Sacred Wood* (London: Methuen and Co., 1950), p. 100.

37. Eliseo Vivas, "The Ojective Correlative of T. S. Eliot," reprinted in R. W. Stallman, ed., *Critiques and Essays in Criticism* (New York: Ronald Press, 1949), pp. 389–400.

38. Edward Weston, wall card for an exhibit of photographs, Houston, Texas, 1930.

39. William M. Ivins, Jr., *Prints and Visual Communication* (Cambridge, Mass.: Harvard University Press, 1953), p. 134.

40. *Message,* plate #3.

41. This print is in the possession of the author. Evans carefully supervised the production of the plates used for *Message from the Interior,* but whether he chose this print for the exhibition I do not know.

15

Review Essay:

Portraiture

Eugenia Parry Janis

Victorian Studio Photographs from the Collections of Studio Bassano and Elliott & Fry, London. By Bevis Hillier, with contributions by Brian Coe, Russell Ash, and Helen Varley. *Published by David R. Godine, Boston, 1976.*

Portraits. By Richard Avedon, with an essay "Meditations on Likeness" by Harold Rosenberg. *Published by Farrar, Straus & Giroux, New York, 1976.*

Disfarmer: The Heber Springs Portraits, 1939–1946. Text by Julia Scully, Disfarmer photographs from Peter Miller, The Group, Inc. *Published by Addison House, Danbury, New Hamphsire, 1976.*

The Spirit of Fact: The Daguerreotypes of Southworth & Hawes, 1843–1862. By Robert A. Sobieszek and Odette M. Appel, with research by Charles R. Moore. *Published by David R. Godine, Boston, and The International Museum of Photography at George Eastman House, Rochester, 1976.*

Karsh Portraits. By Yousuf Karsh. *Published by New York Graphic Society, Boston, 1976.*

Faces: A Narrative History of the Portrait in Photography. By Ben Maddow, photographs compiled and edited by Constance Sullivan. *Published by New York Graphic Society, Boston, 1977.*

Reprinted with the permission of Print Collector's Newsletter, Inc., from *PCN*, May–June 1978.

The daguerreotype. It saddens me, not to see myself thus with respect to form, but to see myself a corpse, without my inner fire or my spirit: life, more or less!

Michelet, *Journal*[1]

The French historian Jules Michelet's melancholy reflections before his own portrait in 1850 have been repeated, if not magnified, in an examination of six recent books on photographic portraiture. Each of these collections has the distinct allure of the cemetery. The images appeal in the manner of graven tombstone texts, forcing a realization that Michelet's revulsion and despair over his posthumous self are part of the irresistible attraction to portrait photographs of others, or of seeing oneself so portrayed. One expects a likeness; one also learns to accept radical transformation of the self into a kind of grotesque.

Throughout its brief history, photography's aberrant verisimilitude has continuously attracted the human face and physiognomy. The study of photographs of people reveals how completely the act of photographing, with both view and handheld cameras not only transformed the conventions of portraiture established by other pictorial media but also redefined accepted notions of resemblance. Even such sophisticated observers of human nature as Michelet did not recognize themselves photographed; and early photographers eventually learned to invent more believable personae from those who surrendered to their instruments. They accomplished this with tricks borrowed from the theater, from the great painted portrait traditions, of course, and from another vocabulary adapted since ancient times to memorialize human forms, sculpture.

Photographers learned to use their medium ingeniously, as both Disdéri and the great Nadar were fond of pointing out in published advice or in instructive lowdown soliloquies about "what they don't teach you in photography." As a refinement, in the opinion of Disdéri, the goal of portraiture was "biography." This too had to be invented and brought to life in defiance of an automatically embalming photographic code. For what photography taught most forcibly is that its realism, so-called, was in fact another variant in the vast repertoire of artistic illusion.

The above books involve these matters in varying degrees of directness, intensity, and success. *The Spirit of Fact* deals with questions of "the perfect likeness" and its art in a beautifully integrated arrangement of informative text and exquisitely reproduced daguer-

reotypes from the Boston firm of Southworth & Hawes. The book is a work of art in itself and of the six, the one most worth owning.[2] On the whole, the shortcomings of the others are more often the fault of the writers than the photographers. In the case of Karsh, his texts are his own, a series of memoirs. The photographers no longer living suffer the fate of all who pass into history—they cannot choose their representatives. I mention this because of the peculiar poverty in current photographic publishing. Today the majority of text accompanying published pictures are frankly execrable, hastily thrown off, or, if trouble has been taken with them, often of an insupportable pomposity. Their writers not only purport to discuss the work of photographers but feel it necessary to assume the impossible task of defining photography whole, for all time. This is not the case for all six books in review; but, oddly enough, it distinguishes those with texts by seasoned writers and critics turning to photography from other arts they hardly would have presumed to define. These writers are either exceedingly weak in their grasp of the facts or prone to improvisations showing almost complete ignorance of the nature of photographic pictures. Harold Rosenberg's "Portraits: A Meditation on Likeness" in the Avedon book is one such example. Its pretension, however, diminishes before one of the most fantastical demonstrations of excess and confusion in print concerning photography—Ben Maddow's whirlwind-patchwork-tour-of-mankind-and-civilization, *Faces*.

But to begin with the others, in one production, *Victorian Studio Photographs*, the writing actually redeems the book. Ensembles of nineteenth-century English studio portraits, carefully chosen for quality, can be satisfying indeed, but here we have an unimaginably repugnant collection of photographic taxidermy, with Cardinal Manning and Lord Shaftesbury tied for most calcified fossil. The editing of the pictures has produced a nasty gallery, and the design is dull—an exception for Godine publishers, who were transcendent with *The Spirit of Fact* and who, at their worst, rarely fall below conservative good taste. But the biographies accompanying each portrait have been garnered with delight and the details written with obvious relish. Bevis Hillier, editor of *The Connoisseur*, has the good sense to remain within his area of expertise, and his evocation of the special implacability of certain Victorian countenances is brilliant. The tone of the book is best summarized in his quotation of Bishop Paget's description of Joseph Chamberlain:

The face, somehow, fenced me off. . . . The compact outline had no suggestiveness in it. There seemed no inviting problems to be worked out: no vague impressions: no attractive obscurities: no ins and outs: no minglings: no fancies: no dreams. You left off at the face. You never got deeper. The clear clean surface repelled all inquiry. It prompted no curiosities. It simply asked you to take it or leave it, just as you liked. . . . It remained, fixed and unelastic, betraying nothing of what was passing before or behind it. After all my very best endeavor to be interested, I left off exactly where I had begun. [p. 22]

Hillier is a match for the Bishop. Characterizing with historical perspective and humor, he plumps the essence of his subjects:

Whatever they were, whatever they did, they became—and looked—the quintessence of it. All of them were "types"; some were archetypes. Their "self-ness" or "inscape," to use the word Gerard Hopkins minted, was of unprecedented intensity. None needed bidding to "Be Yourself"; with most of them, it was a positive profession. . . . [p. 19]

Karsh Portraits illustrates an updating of nineteenth-century hero worship applied to studio photography with an interesting twist. The photographer has grasped the aura of one portrait "type" (Winston Churchill comes to mind) and applied it universally to all his distinguished sitters. The intention behind Yousuf Karsh's monolithic style is, above all, to blur distinctions among the great and join individuals within a single pantheon. The *look* of greatness is provided by the photographer. Often, the subject has been told to do something quite silly. Karsh's all-encompassing visual mode must accommodate human achievement of such different degrees and kinds as that of Norman Mailer and Robert Oppenheimer. With such a goal, Karsh can expect 50 percent success at most, and so it goes. Under the monotonous lighting, everyone becomes a well-oiled monument: Schweitzer, Sibelius, Castro, Mauriac, and Steinbeck are descendants of Rodin's *Balzac* emerging in the moonlight—histrionics that today seem less compelling than ever. Not only do we feel we know too much about our contemporary titans (such as they are) to accept Karsh's rhetoric, but the mode, in its attempt at applicability to all, begins to seem unsuitable to any.

In the recent collection, Karsh fails badly, particularly with some of the newer entrants into the community of greatness. The built-in solemnity appears grossly misplaced and exaggerated: Joan Baez, in profile, holding a sprig of lilac, heavily retouched, becomes a Pre-

Raphaelite penitent Magdalene. A coy portrait of Prince Charles, featuring his diamond pinkie-ring, coupled with the words, "I hope this portrait conveys the directness, sympathy, and disarming lack of affectation of His Royal Highness," introduces a new dimension of obsequiousness into the Karsh search.

The book is the fourth installment of a collection that originated in 1959 with the *Portraits of Greatness,* and this original title, which successfully confuses the subjects with the photographic style, accurately expresses Karsh's aims. His felicitous introduction merely restates his quest for greatness. Handsome, tasteful, but ultimately lackluster, the portraits, more than ever before, seem destined as models for corporate executives and their families.

Richard Avedon's *Portraits* demonstrates a mode of photographic expression more to the taste of the current phase of our age of anxiety. Seeming at first a reaction to the Karsh romance, Avedon's style continues it; it is Karsh with the houselights on—a no-less-poignant romance of unmitigated straightforwardness and suffering. What began as a more modest, tender, and palpitating mug shot or photo-booth style in the late 1950s, delectable for Marilyn Monroe and Robert Flaherty, authentic for the Duke and Duchess of Windsor, has become an obsessive repetition of the dilapidated anti-hero, inventoried and typed by physical, psychic, and societal malady. Avedon's sitters are people of recent or ephemeral distinction, and their look of greatness relates to a chic of mortal fragility. Avedon's notables are notably crippled, mutilated, unshaven, senile, alcoholic, sexually deviant, neglected, diseased, embattled, harnessed, at odds with the law or angry, but—survivors all. Repellent, yet affecting, the style is positively becoming for some, Evelyn Avedon, for example; the portrait of John Szarkowski is undeniably glamorous.

With the anticlimactic tone that characterizes his essay, Harold Rosenberg states that Avedon insists that the photographs are " 'fictions,' creations of the photographer." What else could they be? Directing his sitters to elicit scowl and grimace, Avedon continues to refine a notion of modern portraiture conceived in scientifically based physiognomic studies since the eighteenth century. The formal device for Avedon's investigation does not appear to have been derived strictly from police or other institutional record-making, although the earmarks are there. Nineteenth-century painters tried to convey a sense of contemporaneity at least 100 years ago and probably

borrowed heavily from what they had observed in earlier popular prints. In Degas' painting *Bouderie,* distinguished by the sulk of a young woman looking directly at the observer and her mysteriously enraged companion behind a desk, there is the semblance of narrative, of situation, where none can be established. The picture looks "authentic" as life history and as "now"; Degas invented its photographic character before such images actually existed in photography.

A similar semblance of authentic history, of biography, is what Avedon's sufferers individually offer to engage our attention. As rigid tablets of isolation the subjects project the photographer's own personal confrontation with the fragility of human life. It is not surprising that the book's apotheosis is a series devoted to his terminally ill father. Relentless insistence on isolation for the living is heightened in the group pictures. In police lineup arrangements, people identified by the actual association in the titles, the Chicago Seven or Andy Warhol and the members of the Factory, seem as if they have never been together before the moment of the photograph and will never be again. Gestures of comfort or reaching out between two sitters, as in the portrait of Dr. Spock and his daughter, are startlingly bathetic in this context. In contrast to the nineteenth-century moderns who "look at you," the preoccupied gaze of the miserable dominates Avedon's portraits of our current human condition.

Harold Rosenberg's essay serves Avedon's gallery poorly. The title "meditation" hardly justifies its ineptitude and rambling disorder. Mr. Rosenberg has neither meditated long enough on photography nor examined photographic pictures extensively enough to enlighten. And what amounts to the critic's self-education in progress can only confuse. Purporting to discuss Avedon's particular approach to portraiture, he stabs in the dark in an attempt to distinguish all photographic activity from painting, and comes up with such formulations as "selection is as vital" and "the camera falsifies through the credulity of likeness. If it looks that way, that's the way it is." Does this last express Rosenberg's opinion or does he speak for some nineteenth-century public? In any case, it is surprising to discover a critic confusing the characteristics of an instrument with the intentions of the individual using it, and furthermore confounding real life with visual illusion. If it looks that way in a photograph, you can bet that is *not* the way it *is.* Mr. Rosenberg might well consider training his eye to distinguish between kinds of photographic appearances. The following paragraph typifies the kinds of distinctions he likes to make:

Lacking the inhibitions of a nervous system, the camera holds the threat of mindless accumulation of data, without limit and without purpose, like the accumulation of profit in the economic system in which photography originated. One-man exhibitions of photographs occasionally display the stylistic consistency and formal subtlety of the individual craftsman. Such accomplishments do not, however, alter the fundamental fact that, in the photographic medium, finding can be substituted for making. It is undeniably a factor in the vast popularity of snap shooting that no concept of the subject is needed to take pictures—the thing pictured can be found and refound with each click of the shutter. One can make esthetic choices from a roll of film shot without a single insight, the way one chooses among pebbles on a beach.

The "effective photographers" deal with this "threat of mindless accumulation" by knowing "in advance what they are seeking." Rosenberg does not hesitate to add that "this will not prevent them from appropriating images other than those they expect to find." "To achieve truth, the photographer needs to curtail his resources, which means he must make photography more difficult." Rosenberg means that Avedon reduced the details in the portraits to purge "his art of inessential or meretricious elements," as Barnett Newman or Clyfford Still had done in painting. While being a comfortable idiom to fall back on, this comparison with non-objective painting to formulate the problem of portraiture seems beside the point. One imagines that Avedon is supposed to feel complimented that he has not sunk so low as to show his artists "peeking around . . . a sculpture" or cuddling a cat."

"Portraiture originated as an art devoted to the dead: their images . . . kept them secure in the company of the living." Rosenberg might have developed this idea to define Avedon's art of mortification, as it parodies and exaggerates the life-robbing qualities of the instrument's mechanical structuring—Michelet's "life, more or less!" Instead, the critic's jejune epithets contradict his own words about photography's moral principle of "respect for the identity of the subject." "Galanos . . . an erect worm," is a cheap shot. To say that "Rose Mary Woods packaged herself" to look like a heavily labeled steamer trunk ignores the more interesting problem of how Avedon has "packaged" Rose Mary Woods.

Julia Scully's text in *Disfarmer*, by contrast, is admirable for its simplicity and factual straightforwardness. She records the studio portrait photographer's life history with reminiscences of those who knew this eccentric loner. When Mike Meyer, called Disfarmer, of Heber Springs, Arkansas, died in 1959, a town resident salvaged

the negatives from his studio. In 1973, they were published regularly in *The Arkansas Sun*, a Heber Springs weekly. Julia Scully, with others, has brought the pictures to a wider audience with this first book.

Scully anticipates questions, doubtless raised by many, about why the work of this particular rural studio was chosen from countless other possibilities across America. She justifies her choice by equating Disfarmer's pictures with the activities of the Farm Security Administration photographers of the 1930s, stating that Disfarmer gave expression to a closed society of Americans during wartime (1939–46) and that herein lies the compelling force of his photographs. There is a better reason for doing the book: Disfarmer's pictures are good.

In contrast to the tactics of isolation of Karsh or Avedon to promote an individual's integrity through notions of greatness or mortality, the Heber Springs portraits resonate with the rich and refreshing associations of relationship. Turning the pages of this well-produced book, one is struck by a definition of individuality in Disfarmer's work that depends on identification with a group or family. The folk of Heber Springs are a community isolated from world events and worldly success who express their integrity by the groups they form. These groups take on various shapes in the photographs through the different kinds of bonding of the sitters, often contrived for the photograph.

The most engrossing relationships in these ceremonial structures are those of family resemblance. Lineups of family members denote the startling richness and intricacy of genetic design and divergences. Couples posing with children let us puzzle over the features contributed by each parent, and we examine childless couples with the same curiosity, imagining their combination in some future child. With the most sophisticated of formal structures, symmetry, Disfarmer counterpoints similarities and opposites in twins, brothers, sisters close or astonishingly distant in age, half-sisters, brothers with brothers-in-law, look-alikes, people joined by affinities. In the light of Disfarmer's self-imposed bachelorhood, these bonds are especially touching. Happily, the names of the sitters were salvaged with the negatives, for they enhance the quality of richness in the actual relationships and their visual equivalents. The sitters' identities ring out as exotic melodic counterparts to the photographs: we are given Buel and Jewell, Eula and Euda, twins; Cloyce and Loy, cousins; Imajean and Irene, Lela and Stella, Picola and Iola, sisters. The child of Vernon and Martha is Verna May. Willabea is daughter of Will.

There are memorable arrangements of mothers or fathers alone with a child. A little boy standing in front of his father clutches his father's trouser leg and the two produce a single new form (p. 23). A mother and daughter wear identical flowers in their hair (p. 119). One mother holds up her son like a trophy (p. 79). Children are clearly treasures, some named Opal, Pearly Ann, Ivory, or Blanche.

The portraits also introduce new communities of loyalty or comradeship. Friends dress alike to form sisterhoods, in handmade skirts or pinafores, with clasped hands. Fraternity is punctuated with a bottle, cigars, or cigarettes. Wartime enters in the presence of the military uniforms, whose wearers are often the focus of the portrait. A wife's dress may imitate her husband's sailor uniform (p. 45). Relationships extend outside Heber Springs. The self-styled glamour girls posing Hollywood fashion in playsuits or sequined dresses (p. 57) remind us of Crawford or Grable discovered through movie magazines. Overlays of the world outside sit gingerly in tweezed and penciled eyebrows, comb-held upsweep hairdos and liprouge over liplines on the soft boneless faces of these Arkansas farmers' daughters (p. 41).

Thus it becomes difficult to accept Julia Scully's attempts to define these portraits by comparisons with the "ennobling" style of Irving Penn: she concludes that in contrast "the viewer confronts [Disfarmer's people] as equals." Or her comparison of Arbus' "sinister or disturbing" style with Disfarmer's working with "force and clarity." The problem is not with the choice of comparisons as such but with the accuracy of Scully's characterizations and distinctions. The primary purpose of comparison is that the works involved mutually illuminate. Comparisons court danger for they require clear understanding of each artist. With regard to Penn's style, the word "ennobling" must be qualified, if not eliminated, to get to the heart of his attitude toward portraiture. It is Penn's steel-will battling for ascendance over his sitters that results in rigid standoffs between sitter and photographer. If the resulting pictures ennoble the sitters, their dignity is precarious indeed; and to introduce the idea of human "equals" in such a contest of styles is unconvincing.

Similarly, Scully short-shrifts Arbus' style. To describe Arbus' "sinister and disturbing" vision of humanity and Disfarmer's working with "force and clarity" describes two different attributes. When the expressive result of one and the process of the other are compared as if the same, both artists lose out.

If the author of a photography book is not responsible for clear

critical distinctions about the photographer in question, who is? In such works one begins to accept the fact that the author, so-called, is not someone who writes the book, but one whose name is associated with a presentation of pictures (possibly a confusion with the role of the photographer himself). This places the reviewer in the uneasy position of supplying texts and methodology after the fact. But if the reader comes away from Scully's book suspecting he himself could have better elucidated the art of Disfarmer, such illusions fade before the grandiose problems of Ben Maddow's *Faces*.

Equal in weight and scale to the Gernsheims' *History*, *Faces* is called a narrative history of the portrait in photography. It is also called an anthology, but the reader is invited to edit further with the announcement: "Half the future of photography is in the past" (p. 12). Perplexed by this non sequitur, the reader soon realizes that the job ahead is not going to be easy. First, the book is not really a history, but an elaborate orchestration of words and pictures. The text throughout combines the most ponderous attempts at significance, psychologizing, free association, history, and fact in utter caprice. The way this occurs must be conveyed by the example of a single chapter. But to do justice to the book's thorough waywardness as narrative, anthology, or history unfortunately demands an exegesis as detailed as Maddow's volume is long.

In chapter one, called "In Defiance of time: The Tradition of Portraiture," Maddow's ideas for his project become clear: it will be nothing less than a complete tour of civilization. It begins with three photographs (not all of which are portraits, strictly speaking, and this is the tip-off): Lewis Hine's *Immigrant* (1909) carrying home materials for her family to process, a magnificent characterization of New York street life, not portraiture; Paul Strand's *Blind Woman* (1916); and Victor Hugo on his deathbed (1885) by Nadar. These and several others are preceded by the literary leitmotiv of the chapter, and perhaps the whole book, a butchered fragment from none other than Michelangelo, its original sense misunderstood, cited without context, and given its own page: "since through the eyes the heart is seen in the face" (p. 13). Can this simply be a device of poetic reversal? The eyes of Hine's immigrant are hidden by the shadow of the burden she carries. Such an attempt at eloquence is, of course, even more heavy-handed applied to the Strand and downright ludicrous for Hugo dead. One searches for enlightenment in the text, but Maddow introduces something very different: "We are not solitary mammals like the fox or the tiger; we are genetically

social, like the elephant, the whale, and the ape" (p. 16). One wonders whether Maddow has consulted his picture editors. According to the text, the Hine and Strand images illustrate man's "commonality" and his "singularity." But in discussing the pictures, Maddow leaves the track to touch on the Great War, on Strand as Hine's student, and on the right-angle viewfinder. He then moves on to the lack of joy in the *Blind Woman*:

She is just as powerful as the laundress [immigrant woman], but older, and blind, or so, at least, the sign around her neck declares; the sideward glance of one eye makes you wonder. Still, you never doubt the stony muscles and bitter tenacity: this is woman, too, and just as monumental. In Strand's blind woman, we do not feel joy this time, but human knowledge: and the sort of knowledge that only art, and the very greatest art, can transmit. [ibid.]

The next paragraph begins "Portraits, luckily, are not pure pleasure." But what previously led to such an observation? From the sign around the woman's neck that "makes you wonder," we are carried to "belief"; we are told we never doubt the muscles or "bitter tenacity." From this we are led to Maddow's definition of womankind, to knowledge, art, to great art, and to art's ability to transmit knowledge. With heads reeling we veer off into another domain. Lack of pleasure in portraiture leads to analogies between portraits, painting, music, and literature. Nothing is said about such connections, nor are they dealt with in terms of pleasure, but of "fact and structure" (ibid)—it is unclear what this, or "reality and desire," mean. These qualities are assumed to be related, for in the next sentence they are used to suggest a criterion for critical judgment of photographs. The next paragraph suggests notions of portrait and character. Then we are led to the art of Reynolds, Boswell, and then to Johnson. All leads to the "zigzag geometry" (p. 18) that constitutes the art of the portraitist and an "ethical obligation" to portray "the resonant, complex harmony of a person" (ibid.).

The book proceeds tangentially, each sentence giving rise to another idea. Yet Maddow clings to his original thesis: that portraiture is a triangle of forces—photographer, sitter, viewer (p. 25). This platitude masquerades with endless embellishment for over 500 pages. The discussion must needs be simpleminded, encompassing so many bits and pieces applied to portraiture defined so generally as to include nearly every category of photography of human beings. Never is it clear how such a definition distinguishes portraiture in photog-

raphy from portraiture in the other arts or from portrayals of people in general.

Maddow is not interested in such distinctions. His pleasure is characterization, the melodrama of definition, self-indulgent and thoughtless. For all his attempts to make each notion crossing his mind a significant insight, there is little of substance. Non sequiturs are endless. Simplistic definition rambles: the triangle of forces of the photographic portrait are "the locus of that indefinable emotion that is embodied in the work" (ibid.). And crescendos: "It is a kind of locked, willing antagonism, a love that one weakly resists, a triangle distorted by the usual pressures of time and society, but real and true and powerful nevertheless" (ibid.). But Maddow is not finished: "the photograph, and in particular the portrait, . . . is not only an art; it is, in my opinion, a new form of human consciousness" (p. 28). And "the preservation of fragility is the very business of photography" (p. 30).

Maddow's obsessive eloquence leads to a kind of "epithet-itis:" the artist is a "skilled hypocrite." "The artist speaks through his flat rectangles" (p. 27). Rembrandt's portraits are "the most profound works ever brushed onto cloth by western man" (p. 28). Yet this is how he describes the reputation of Stieglitz: "a tremendous amount has been written about him, and as usual in photographic history, it is largely worshipful" (p. 213).

The naïveté of such writing climaxes in these early pages of the book with Maddow's version of the fifteenth century:

Imagine, in one century, two events as huge in their consequences as the invention of printing and the discovery of America! What magnificent talent lived on the jingling profits of kings and popes and dukes and middlemen! One thinks immediately of Michelangelo, Leonardo and his friend Botticelli, Dante, Boccaccio, Raphael, Machiavelli, Uccello, Brunelleschi, Piero della Francesca, and the glorious Titian. It is beyond our knowledge to comprehend an immense flowering of this kind. [p. 22]

This sense of wonder leads our author, midstream, away from the history of all portraiture. Following his fixation on "immense flowering," other flowerings occur to him. He plunges in:

For that matter, how can one explain the chorus of marvelous music by Bach, Mozart, Haydn, Beethoven, all in the compass of two centuries and a couple of hundred miles? [ibid.]

And then he is led to Marx, Freud, Einstein, Shakespeare, Marlowe, etc. Maddow goes out of control. Such dalliance is highly amusing at first, then sad, then embarrassing. In the end, the book is a nightmare of a B movie of the history of human consciousness run amok, the ravings of a nostalgic quiz-kid.

Three production credits appear on the title page: picture editor Constance Sullivan, designer Massimo Vignelli, and coordinator Gudrun Buettner. Their activities betray the same naïveté as the rest of the book. "Just imagine, for example," writes Maddow in the foreword, "going through the files of the Library of Congress or the Bibliothèque Nationale or even the National Geographic: each a marvelous lifetime job. So there's another world of the past century and a half of photography which is still unknown, and which might, when examined, hold forgotten vistas of aesthetic pleasure" (p. 12). This turns out to be a roundabout way of saying that, whatever unseen riches there are in these places, the editor has not ferreted them out. It might have been a marvelous job, but it was not done for this book. Well-published work from elsewhere is merely served up in new full-page blowups, bled to the very edge of the page, guttered in double-page spreads.

Both editor and designer are insensitive to the structures of photographic pictures. After enlargement, the earlier pictures particularly suffer. This happens in the pretentious presentation of the single portrait daguerreotype at the beginning: blowup follows blowup until each face is a fuzz. Calotypes confront one another, one greatly enlarged and bled, the other shown actual size floating on a white or black field. The result is a rare ugliness. Nearly every picture suffers by placement on the page, scale, or background. The consistency of this book lies in its inflated language, inordinate length, and visual insensitivity. The producers likely regarded their project with solemn piety, but their efforts unfortunately have produced the worst photographic book to appear in recent years.

The task of explaining photographic portraits is not to be taken lightly, for its subject requires the wisdom of philosophers. Photography has transformed the art of portraiture from a search for resemblance into a symbolic act epitomizing contemporary illusions of triumph over death, rendered, ironically, in the most deathly of formal transformations by the camera. To be fashioned into a photographic portrait always involves risks. The greatest artists in portrait photography always remind us that portraiture is an act of faith and

a sacrifice of the self. We cannot turn the pages of a book of photographic portraits without confronting this awesome fact, nor come away without feeling bereaved. Those who would write about such matters should heed the warning of Oscar Wilde: they "who go beneath the surface . . . who read the symbol, do so at their peril."[3]

Notes

1. Jules Michelet, *Journal*, Tome II, 1849–1860, . . . avec une introduction, des notes et de nombreux documents inédits par Paul Viallaneix, Paris, Gallimard, 1962, p. 91. English translation by the author.

2. A full review by this author on the merits of *The Spirit of Fact* appeared in "After M. Daguerre," *New Boston Review*, Fall 1976, Vol. II, No. 2, pp. 10–11.

3. Richard Ellmann, ed., "Preface to *The Picture of Dorian Gray*," *The Artist as Critic: Critical Writings of Oscar Wilde*, New York, Vintage Books, 1970, p. 236.

16

Photographs & History

Flexible Illustrations

James C. A. Kaufmann

Anyone who reads detective stories knows that this genre places absolute faith in the photograph. Photographs are the blackmailer's hole card and the private eye's first piece of working evidence; whether the photographs are true is rarely, if ever, questioned. In Raymond Chandler's *The Little Sister*, Orrin P. Quest's photographic activities serve the purpose of blackmail and the supposed truth of the photographs he takes leads to his murder—his Leica was his death, so to speak. In another Chandler novel, *The High Window*, a photograph, again used for the purpose of blackmail, is the driving force behind the action of the plot. When Philip Marlowe finally gains possession of that photograph he is unable to make sense of it.

There I was holding the photograph and looking at it. And so far as I could see it didn't mean a thing. I knew it had to. I just didn't know why. But I kept on looking at it. And in a little while something was wrong. It was a very small thing, but it was vital. The position of the man's hands, lined against the corner of the wall where it was cut out to make the window frame. The hands were not holding anything, they were not touching any-

Reprinted from *Exposure*, Summer 1978, by courtesy of the Society for Photographic Education.

thing. It was the inside of the wrists that lined against the angle of the bricks. The hands were in air.

The man was not leaning. He was falling.[1]

The passage is a simple exposition on the interpretation of photographs. Initially the photograph means nothing, but Marlowe believes that it must mean something—"it had to." His eyes search out what is wrong, and from the combination of this visual discrepancy and his knowledge of the case's history, Marlowe can correctly reconstruct the events of the case. What Marlowe provides, in terms of his knowledge of the case and its attendant events, is what E. H. Gombrich calls the "Beholder's Stare." Deprived of its proper context, the photograph would be useless; the establishment and acceptance of context is what enables the presence of meaning. The photograph is considered a purely historical document by Marlowe who is, in his own way, an historiographer. He takes his evidence, and arranges it until he gets the proper fit. The photograph is an historical fact, the cornerstone in Marlowe's comprehension of the events surrounding the "theft" of the Brasher Doubloon.

But not everyone considers photographs undistorted reflections of reality. Duane Michals, for example, thinks that photographs have nothing whatsoever to do with so-called reality. In fact, Michals' Platonic sensibility denies everyday life as reality. One of his photographs—not really a photograph in the common sense but simply a blank piece of paper—is titled "A Failed Attempt to Photograph Reality." It is a text without photograph:

How foolish of me to believe that it would be that easy. I had confused the appearances of people and automobiles and elevators with reality itself and believed that a photograph of these transient appearances to be a record of it. I am a reflection photographing other reflections within a reflection. It is a melancholy truth, but I must always fail. To photograph reality is to photograph nothing.[2]

Marlowe would have considered Michals as "crazy as two waltzing mice." Michals isn't crazy, just self-defeating; his argument rejects its own premises. Michals' statement represents a kind of conceptualist irony not unlike that found in Dadaism. The Dadaists were anti-everything, but to follow the implications of their "reasoning" is to realize that it contained a final self-destruct clause—to be anti-everything means to be anti-Dada as well. Michals' argument

is sophistical; it touches no base in its endless reflections and thus becomes something like a boomerang unimpeded in its flight which returns to the hand of the thrower, but with tragic results.

But the issue of whether photographs are or are not "of reality" should not be rendered in either/or or yes/no terminology. There is a middle ground to explore, which is well articulated in a short story by Lee Zacharias. Her story, "The Photograph Album," has two main characters: a young girl and her dying grandmother, both of whom display an inordinate fondness for the family photograph album. When the grandmother realizes that she is making her last trip to the hospital she requests the family album, which the young girl gives up grudgingly. The grandmother dies; the album is stored until some months later, at which point the girl cannot remember what her grandmother looked like. She turns to the photo album for visual aid, but discovers that all the photographs of the grandmother, save one, are gone. That one shows the grandmother as a young girl, "a beautiful young girl with a parasol and a smile."[3] Even though it is clearly not the whole truth, this single photograph attains the power of history by the default of the other visual historical documents.

Zacharias has here suggested what I take to be the crucial problem in regard to the historicity of photographs. Photographs show us something undeniably real, but only a part of the whole reality; they tell us something about real life, but not exactly what is real about it. We are left with a formulation wherein the photograph is a specifically selected and yet ambiguous image, something like a sentence extracted from a novel, or an event isolated from its historical matrix.

"Facts are the images of history, just as images are the data of fiction," said E. L. Doctorow,[4] The idea suggests the difference between a Michals and a Marlowe. Marlowe's approach, which treats photographs as simple facts whose meaning is derived from the context of a case, is historical in its bias. Michals, on the other hand, treats photographs not as facts but as fictive constructs, as parts of a narrative flow which participates in a higher and necessarily ahistorical truth. For Michals, photographs are images, apparitions which have no association with reality as Marlowe would construe it. Zacharias mediates these two views. In "The Photograph Album" photographs are treated in a somewhat ambivalent fashion. On the one hand, writes Zacharias, photographs "give something concrete, something that can be held in the way a moving face, a smile that begins

and ends never can." But that concreteness is embedded in a flexible fabric of history whose meaning can vary. (The grandmother's editorial activity is, no doubt, only one example of the kind of "impressionistic" history which has been created in other family albums.) The photograph (like the word) is a tool of ideology; it is rhetorical, able to serve the structures of more than one set of ideological precepts.

A good example of photographs in the service of an ideology foreign to their origin is to be found in Edward Steichen's *The Family of Man.* (Those who have read Ulrich Keller's "Photographs in Context" will be well aware of my debt to him in the discussion which follows.[5]) One of the expropriated photographs is by Dorothea Lange and has as its subject a group of Filipino stoop laborers. In *The Family of Man* it appears in a section we might loosely title Earth-as-Bountiful-Mother. It glorifies these workers and their labor; they are at one with the earth. But the original context is something quite different. As published in *An American Exodus*, this photograph was meant to show the dehumanizing effects of such labor, and the general suffering of the migrant workers. Anyone familiar with Lange's work for the F.S.A., and the political sentiments expressed by that institution, would understand immediately the implication of the photograph. Steichen's use of the photograph is in blatant contradiction of what we understand to be Lange's intentions.

A photograph of a gentleman farmer and his wife made by August Sander is similarly mistreated. Sander's work in 1920s Germany was scientific-sociological in nature; he meant to delineate the various social classes of his native land, to reveal class distinctions and characteristics through the lens of his camera. In *The Family of Man,* however, the image is used to illustrate the opposite point. Steichen includes it with photographs of other couples of different race, color, creed, and class to illustrate what he saw as their essential "sameness." It should be obvious from these two simple examples—so exhaustively explored by Keller—that photographs can be quite easily estranged from their original context by an appropriating ideology.

But sometimes it is difficult to determine the origin of a photographic statement. The work of Jacob Riis is a case in point. Riis is usually discussed in terms of the muckrakers, Progressive politics, and turn-of-the-century reform. He fits this context neatly; his photographs are the statistics which visually confirm his prose. But the

source of Riis' photographic statements was not his political conscience; rather, it was his subconsious. A psychoanalytic approach reveals the meaning of his images to be deeply rooted in early childhood experience. In the first chapter of his autobiography, *The Making of an American*, Riis recounted an event which, as he put it, stood "out more clearly than the rest."

I was . . . thrust howling into an empty hogshead by the ogre of a schoolmarm, who, when she had put the lid on, gnashed her yellow teeth at the bunghole and told me that so bad boys were dealt with in school. At recess she had me up to the pig-pen in the yard as a further warning. The pig had a slit in the ear. It was for being lazy, she explained, and showed me the shears. Boys were no better than pigs. Some were worse; then—a jab at the air with the scissors told the rest.

Indeed it does! I think it is clear that what gets cut off of pigs is not their tails; Riis associated living in filth with loss of manhood. Dirt was a personal affront to Riis, and he likened the cleaning out of the schools in New York City to "getting square with the ogre that plagued my childhood."[6] Riis' photographs are projections of that pig-pen fixed early on in his mind's eye; the frame is cluttered, dirt is everywhere. His photographs and written work satisfied both the demands of the psyche and the demands of society simultaneously. His work not only squared him with the "ogre" of his past, but was closely allied with fin-de-siècle Progressive politics. This interpretation of Riis provides a two-layer context in which to consider his work: the organic (personal), and the superorganic (cultural).

The use of psychoanalytic concepts does not, strictly speaking, create a new context, for psychoanalysis is fundamentally an historical method. In the case of Riis, such an approach simply stretches the limits of inquiry. It also suggests that for other photographers, adult expression may be linked to an early trauma that has been transformed by the sublimative matrix of culture into a socially appropriate idiom.

But some photographs can't meet the political demands made on them without suffering a considerable loss of meaning. I'd like to return briefly to Steichen's abuse of both Lange's and Sander's images to amplify this point. It has already been shown that the original meanings of their photographs were subverted in the context of *The Family of Man*—that they had lost their own particular historicity. Because of the shift of historical inflection they have become

fictions. By trying to work in the realm of universals, Steichen has employed photographs in a rhetorical mode which shows no allegiance to history. As connotative objects the photographs may support Steichen's claim that the world and all its people fit into one Waring blender, but the denotative level of the originals disproves this once it is stated. Steichen has created a marvelous social fiction, but a sad and specious history.

In order for a photographic fiction to work it must on some level disavow the reality of photographs. Duane Michals does this by arguing that a photograph is only and always a fiction, and thus sidesteps problems of a temporal nature. Not required to pay homage to "real" history, Michals works in a narrative mode which requires perfect relativity but not specificity. A sequence like "Things Are Queer" is typical. Like a Chinese box, this sequence unfolds and unfolds, confounding and dislocating us until we are, like Vonnegut's Billy Pilgrim, unstuck in time. Michals doesn't distinguish between illusion and reality because for him all is illusion. The question becomes: what illusion (s) do we choose to live by?

But the photograph is so real, so verisimilar, that by this power alone it threatens to stick us *to* time. That is one of the reasons for Susan Sontag's assertion that the "photograph-qua-photograph shows death."[7] The logical incompleteness of her notion notwithstanding, it implies that time is decay, things physical decay, the photograph is inevitably of things physical, and thus shows death. So the denial of reality in the photograph is not only the denial of history and everyday life as reality, but an attempt to deny death as well.

The grandmother in Zacharias' short story can't really deny death, but her editorial elisions are a symbolic gesture in that direction. She attains an afterlife in photographs. The material reality of her slow decay is erased, and she becomes instead an image—fictionally specific, but historically incomplete. Though the visual documentation of the grandmother's life is deficient, it becomes the substitute image for the sum of a life. History becomes a photograph.

But photographs, while in history and of history, are not really history itself. History is temporally evolved, the product of time, and the photograph deflates time. Even if we consider history to be a fiction, we still live in it or are ourselves history, something which a photograph—not an active participant in time—cannot claim. A photograph may become a symbol, but it does so at the risk of losing that which gave it historical specificity. In the long ascent to

symbolic status, meaning is emptied along the way. Unless the photograph remains as a fact, as a purely denotative expression, it will be subject to a multitude of possible meanings. But the photograph cannot remain as fact. As Nietzsche said, "for a fact to exist we must first introduce meaning."[8] And meaning is introduced by the way in which history is perceived and the interpretive function of an ideology practiced.

The photograph remains, paradoxically and of necessity, a highly specific and yet ambiguous image. Maintaining ambiguity is profitable, as Wallace Stevens knew. It enabled him to find not only thirteen distinctly different ways of looking at a blackbird, but also to observe that

> A violent order is disorder; and
> A great disorder is an order. These
> Two things are one. (Pages of illustrations.)[9]

He knew that visual evidence would support his claim either way.

Notes

1. Raymond Chandler, *The High Window*, in *The Raymond Chandler Omnibus* (New York: Alfred A. Knopf, 1975), p. 440.

2. Duane Michals, "A Failed Attempt to Photograph Reality," *Afterimage*, 4 (December 1976), cover illustration.

3. Lee Zacharias, "The Photograph Album" in *Helping Muriel Make it Through the Night* (Baton Rouge: Louisiana State University Press, 1975), pp. 72–79. All quotations used in this article are from page 79.

4. E. L. Doctorow, "False Documents," *American Review*, 26 (November 1977), p. 229.

5. Ulrich Keller, "Photographs in Context," *Image*, 19 (December 1976), pp. 1–12.

6. Jacob Riis, *The Making of an American* (New York: The Macmillan Company, 1901), pp. 4 and 5.

7. Peter Hujar, *Portraits in Life and Death* (New York: Da Capo Press, 1976), introduction.

8. Doctorow, "False Documents," p. 228.

9. Wallace Stevens, "Connoisseur of Chaos" in *Poems by Wallace Stevens* (New York: Vintage Books, 1959), p. 97.

17

Joe Deal's Optical Democracy

James Hugunin

Instead of fixing a proximate object, let the eye, passive but free, prolong
its line of vision to the limit of the visual field. What do we find then? The
structure of our hierarchized elements disappears. The ocular field is ho-
mogeneous; we do not see one thing clearly and the rest confusedly, for all
are submerged in an optical democracy.

<div align="right">

—José Ortega y Gasset, quoted
in *Northlight 4*

</div>

I had just set aside the fourth issue of *Northlight* (published by Ari-
zona State University, Tempe), which is devoted to the work of Joe
Deal, when in standing up from my chair I noticed I had uninten-
tionally juxtaposed a reproduction of one of Joe Deal's photographs
with another book with a print by Ansel Adams on the cover. I was
immediately intrigued by the dichotomous juxtaposition. This essay
was the result.

Modern physics conceives of matter as a field of energy, as a struc-
ture of probable events across space, rather than objects in it. Real-
ity is then conceived as the organization of everything around us.
Organization becomes rooted in structure. In classical physics space

Reprinted by permission from *Afterimage*, February 1979.

is conceived as continuous (Euclidean) with physical entities occupying volume and interacting with each other on a macroscopic level, whereas in modern physics interactions are carried out, according to probabilities, on an atomic level. More simply, classical physics is form-oriented, while quantum mechanics is structure-oriented.

How does this tie in with Ansel Adams or Joe Deal? Traditional landscape photography, as typified by Adams' work, implies a classical view of reality in that tonal values are used to render volumes in the space of one-point perspective. The organization of tones "draws" the illusion of physical bulk and the coherent interaction of all the pictorial elements. For Adams, light transforms raw matter, imparting various moods or possible "narrations" to the landscape. The resultant images can be seen as being consciously organized into a hierarchic arrangement of lights and darks. Through his zone system, Adams subjectively interprets tonal scale to match his previsualized (idealized) vision of the scene. He leads the viewer's eye on a planned journey through the illusion of three-dimensional space, where a large mass of darker value may beckon the eye, only to be led from this area to yet another point. A set of pictorial elements are ordered from "most important" to "least." Our eye is led through space in a way similar to the way a novel leads us through psychological space, that is, events build upon events. To borrow a term from dance, Adams "phrases" his compositions, building up climaxes and resolutions. The notions which readily come to mind with his landscapes are those of the sublime and the beautiful.

The antithesis of this type of landscape is currently being explored by contemporary photographers like Stephen Shore, Nicholas Nixon, Lewis Baltz, and Joe Deal; work by these photographers and others was packaged into "New Topographics," a recent exhibition at the International Museum of Photography at George Eastman House. In this new kind of landscape the beautiful is replaced by the mundane, the sublime by the ironic; the experience of objects situated in an ideal space is exchanged for the experience of seeing in itself. While Adams emphasizes the one-point perspective of a lens-produced image, Deal obfuscates spatial recession by eliminating the horizon-line and tilting the camera down.[1] He places the landscape onto what appears to be a flat plane perpendicular to the lens axis. Without the visual organization of a receding perspective, Deal's pictorial elements just hang there: up and down, and across.

The discrete elements in this grid structure are raw visual data which defy hierarchic arrangement.[2]

Specifically, in Deal's *View, Fountain Hills, Arizona, 1976* deep space is rendered flat, like a tapestry. The stones in the foreground are rendered with as much (or as little) emphasis as the buildings and trees in the background. A small stone, a tree, a building—all are subsumed into an overall visual field. The tactility of bulk is denied in favor of merely tonal elements that are without resistance or mass. The visual field is quite homogeneous.[3] Deal's photograph is printed in flat contrast, and shadows retain plenty of detail. The drama of an Adams print is not to be found here, for Deal has replaced the metaphoric quality of Adams' landscapes with a deromanticized structure of spatial and temporal contiguities. The discordant spaces of our Southwest landscape, in places where man is only now replacing the natural with the cultural, is merely *catalogued* by Deal into a visual equivalent of a list or matrix of nouns. This matrix of pictorial elements is "objectively" determined and presented with a "passive (square) frame."[4] Instead of a visual "narrative"—*beautiful* mountains near a *raging* river, under *ominous* clouds—Deal simply creates lists of nouns strung together by their fortuitous arrangement before the camera:

> tree, grass, home, street . . .
> water, brush, cacti, street . . .
> cacti, road, ground, road . . .
> stones, dirt, stones, dirt . . .

Borrowing from linguists, we can say that Deal's organization of picture elements is an arrangement at the horizontal level of word chains, while Adams' work stresses the vertical dimension of metaphor.

Adams either deliberately excludes man-made objects from his compositions, or he deliberately emphasizes them. Deal does neither. He uses the natural/cultural opposition as a basic antinomy in his photographs, choosing landscapes in transition from one state to the other, so that "landscape" or "social landscape" does not aptly describe the work. "Topographics," with its connotations of surface, seems an adequate compromise term. It is from this natural/cultural dichotomy, this basic binary opposition, that Deal generates his imagery. It is through this self-conscious system that Deal forces objects to gradually lose their instabilities and secrets and renounce

their pseudo-mystery, that suspect interiority seen in Adams' prints and which Roland Barthes has called "the romantic heart of things." Deal strives toward a world that is neither significant nor absurd but, as Robbe-Grillet would stress, is simply *there*. Robbe-Grillet says in *For a New Novel*:

Let us consider first the opacity. It is, quite as much, an excessive transparency. Since there is never anything beyond the thing described, that is, since no supernature is hidden in it, no symbolism . . . the eye is forced to rest on the very surface of things: a machine of ingenious and useless functioning, a post card from a seaside resort, a celebration whose progress is quite mechanical. . . . A total transparency, which allows neither shadow nor reflection to subsist, this amounts, as a matter of fact, to a "trompe-l'oeil" painting. The more that scruples, specifications, details of shape and size accumulate, the more the object loses its depth.

Substitute "Deal's photographs" for "a trompe-l'oeil painting" and the quote seems to aptly discuss Deal's "topographics."

It is this very "thereness" of the objects in Deal's photographs which has been mistakenly read as only satire on modern housing, trailer courts, and so forth. Deal himself said: "I think that a lot of the people looking at the photographs in 'New Topographics' think that the photographs are satirical. It really depends on your attitudes to different building styles and is really more of a result of what the viewer brings to the work than what the photographer intended to put there."[5]

This immediacy or "thereness" of Deal's images is enhanced by rendering distance (paradoxically) as close-up. Viewing his prints we do not fix our gaze on any one point nor move about the composition in a strictly determined manner. Rather, we take in the complete field of elements, including the boundaries, in a holistic fashion. We avoid focussing our eyes as much as possible. The actual "object" perceived is really our entire visual field.[6] Thus, the content of our perception is not strictly the surface at which hollow space ends (the print), but the whole hollow space itself from the cornea to the limits of vision in the print:

In pure distant vision, our attention, instead of being directed farther away, has drawn back to the absolutely proximate, and the eyebeam, instead of striking the convexity of solid body and staying fixed on it, penetrates a concave object, glides into a hollow.[7]

In Adams' landscapes the content of perception is not perception in itself, but an ideal construct of volumes in space delineated by chiaroscuro. Composition is built up by the macroscopic interaction of volumes in space. Deal's discrete elements lack any physcial interaction, that is, they are not hierarchically arranged. Instead, Deal's imagery imparts the germ of totality to each element in his photographs; Merleau-Ponty's notion of the "total part" is integral to this development of holistic vision. In biology, DNA strands are "total parts," capable of reproducing the entire organism. Similarly, a part of Deal's imagery contains all the visual information necessary to produce the whole photograph. And according to Deal's interview in *Northlight 4*, each of his prints are only parts ("total parts") of the whole series of photographs he has taken.

We can begin to understand the complete structure of Joe Deal's esthetic output. The basic natural/cultural opposition is built up into individual photographs, which are in turn only elements of a larger whole, which are also only elements in the larger cultural nexus. The result is a vast fabric of elements capable of infinite extension. "The photographs I am making now are a lot more about the subject, they are repeating themselves in that each photograph is an addition to the one just before it, modifying a larger body of work."[8]

Well, all this sounds quite impressive and innovative, yet painting has been concerned with these problems of reflexive vision for years, and the trend toward painting surfaces rather than volumes begins in earnest with Velásquez, is picked up again with the Impressionists, and is carried through Cubism and Modernism. The course of "development" in painting has run the continuum from painters painting first things, then sensations, and, finally, ideas. The continuum runs from concerns with external reality, to the subjective, and finally to the intrasubjective, that is, the *contents of consciousness* itself. Thus Deal's professed "objectivity" is actually a phenomenological investigation into the interiority of vision itself. Deal's "detachment and reluctuance to intrude personally in any way into the photograph" is a denial of the subjective, yet his presence as "investigator" behind the images is readily avowed by him:

One of the things I've often thought I aspire to is a disembodied eye. That of course is a delusion. But invisibility is an important quality of how my own personal prejudices enter into the work. Transparent might be a bet-

ter word. My presence in the work is always there, but not in the sense that it is calling attention to itself or proclaiming its importance in interpreting for the viewer what was before the camera.[9]

Of course, Ansel Adams' photographs proclaim the importance of the subjective control over the image; his eye is the servant of his emotions and intellections. His photographs are not investigations that result in an exposition of our interior visual processes, but celebrations of our sensations and our joy of seeing things. It is this joy of seeing *things* which modernist painting has given up for the investigation of perception itself.

It is this trend toward the intrasubjective in painting which has lent credence to the notion that photography's true path must parallel painting's, that "tough" photography must assimilate what's "tough" in painting. The result is that a great deal (pun not intended) of energy is expended by critics and curators in describing significant links in the chain of development along the lines of painterly vision's transformation from illusionistic depth to that of pure surface, and the transference of this trend toward purely formal concerns into the explication of the development of camera vision. Certainly, Atget and Ruscha are in a sense precursors of the type of photography seen in "New Topographics."

But in general, equating painting and photography ignores the fact that photography, as a different medium than painting, presents contextual problems and a myriad of sociological considerations which are foreign to painting. Other lines of development within the history of photography can be posited with as much justification as that of the formal problems of illusionistic space versus the flat support, or of subjective versus intrasubjective. For example, what about the obvious tradition of photography as a means toward social critique? Deal is the first to admit his work has no political content:

There are examples, like W. Eugene Smith who had definite goals and tried to change things as a result of his photography. It worked for him and it worked for others, Hine, Riis, they had those kinds of goals. But I don't feel that I am operating as a conscience of a larger public as much as a conscious eye. One of the things that makes the photographers in "New Topographics" different is that they are not only not involved in cultural problem solving, but they are refusing to be involved in personal problem solving through their photography, either.[10]

Consequently, to push only one stylistic trend as the one continuous thread running through history, to support one trend in photography as being the only way into the realm of "tough" photography, is to be esthetically and critically lobotomized. The very pluralism of the modern vision stressed in "New Topographics" is denied on the level of critical theorizing; a less "proximate" view of the problem of modernism itself would yield to a broader more distant overview, a critical democracy emergent along with an "optical democracy."

Notes

1. James Hajicek, ed., "Joe Deal: New Topographics" (an interview with Joe Deal), in *Northlight 4* (Arizona State University, Tempe), May 1977, p. 9.

2. Ibid., p. 11.

3. José Ortega y Gasset, "On Point of View in the Arts," in *The Dehumanization of Art and Other Essays* (Princeton, N.J.: Princeton University Press, 1968) p. 111.

4. *Northlight 4*, p. 13.

5. Ibid., p. 17.

6. "On Point of View in the Arts," p. 112.

7. Ibid., p. 112.

8. *Northlight 4*, p. 14.

9. Ibid., p. 6.

10. Ibid., p. 16.

18

Notes Toward an Integrated History of Picturemaking

Carl Chiarenza

Paul Valery once said, ". . . it is more useful to speak of what one has experienced than to pretend to a knowledge that is entirely impersonal, an observation with no observer. In fact, there is no theory that is not a fragment, carefully prepared, of some autobiography." I believe this to be true for what I will say here as I believe it to be true for any history written, spoken, or pictured.

The title of the series of lectures of which this is one[1] makes the assumption that there will be new histor*ies* of photography. It suggests seeing into the future—that is, seeing how the future will change the past. Of course there will be new histories. The past is "there" to be reinterpreted. The new histories will be critical of past histories, and will reflect the concerns of future individuals. They will be fragments of autobiographies.

We are presumably interested in photography and in history and, hopefully, in how they are related. It seems that we are obsessed with knowing (and perhaps that means controlling) everything about photography's past.

It wasn't so long ago that many of us were shouting that no one

Reprinted by permission from *Afterimage*, Summer 1979.

was taking photography seriously—neither historians nor critics, let alone philosophers and sociologists. Now my mind is littered with Barthes, Bazins, Benjamins, Bergers, Burgins, Burstins, et al.—the list is endless. The theories are confusing and conflicting; some are irritating. A reason for this is to be found in history.

Photography (or its history) is, apparently, many more things than P. H. Emerson, Alfred Stieglitz, Beaumont Newhall, Minor White, or John Szarkowski ever told us it was. (Remember the neat categories that Minor White and Walter Chappell placed in the slices of the photographic pie drawn on the pages of *Aperture* some twenty years ago?[2])

I will not today call for a new, or another, history of photography, but for a *first* meaningfully integrated history of picturemaking: one that asks tough questions about relations between pictures and worlds; one that examines why and how certain assumptions made in the past formed finite views of pictures and worlds and their interrelationships; one that examines the effects of those finite views on what followed their being made and on what preceded us; one that sees the overwhelming consequences for and of photography in light of the above. I would like to know, for example, what effects on our understanding of photography, painting, art, world, reality, ourselves, have been caused by the question posed in 1839, "Yes, but is it art?"

It is of the utmost importance that I am not misunderstood here. I do not care to discuss whether photography is art. It is a wrong question. I am concerned only with the effects caused by posing and reiterating that question for 140 years.

We have histories of photography which make little if any meaningful reference to other forms of picturemaking, and we have histories of art which all but ignore photography. There are very few exceptions. Those which pair paintings and photographs or which look for imitative influences are, I think, of limited usefulness toward answering important questions. Pictures have always been models for other pictures. Photography, like oil painting and lithography—like perspective even—is part of an ongoing conglomeration which is continually developing out of the distillates of past models. This is true for history as well.

Now, keeping in mind Valery's statement with which I opened my remarks, let me tell you an anecdote about a historian I once knew. He opened a history symposium at Harvard by saying, "History is a bag of tricks." The historian was black, a fact that amplified

what he had said, a fact which pointed to the tragic truth of what appeared to be a joke. History is *made up* by human beings. Robert Taft and Beaumont Newhall wrote histories of photography at about the same time, both in the United States. Why are they different?

Histories, like photographs, are controlled by the conventions, beliefs, and accidents of a time, a place; but that control is always modified by the individual maker. We all know this, but our behavior suggests that we do not believe it. Believing it might impede our functioning. And continued functioning is a first requirement. Let me give you a couple of concrete examples of this problem.

In the October, 1978, issue of the *Newsletter* of the Friends of Photography, David Featherstone reviewed the book, *The Face of China as Seen by Photographers and Travelers, 1860–1912*. (Millerton, N.Y.: Aperture, 1978). In that review he said:

One point touched upon only briefly [in the book] but well worth mentioning here, is that these photographers, finding themselves in an unfamiliar environment, saw, and responded photographically, only to what they thought they understood. The resulting photographs are not the objective documents that those who remained in Europe thought they were getting. Some of the distant landscape images, in a structural sense, might have been found in the English countryside, while the pictures of individuals and families look suspiciously similar to portraits made in Europe during the period. In other words, even though the specific content of the photographs was Chinese, the *forms* of the images remained European. This presents an obvious problem to those using historical photographs as primary resource material, and any analysis of late 19th century China based on these photographs must take this filtering into account. Photographs, it turns out, are little better than drawings or narratives as documentary tools.

Ernst Gombrich, in *Art and Illusion,* wrote of a similar situation: a Chinese artist, Chiang Yee, he said, pictured English scenery on a trip to England, "through Chinese eyes" and the "rigid vocabulary of the Chinese tradition."[3]

Why are the pictures in the first book generally not labeled art, and why are those in the second book usually labeled art? The answer has to do with how the media were defined before, during, and after 1839. It has to do with the reasons for asking the question, "Yes, but is it art?"

As the philosopher Nelson Goodman would say, histories and pictures are just some of the ways of worldmaking.[4] This is true for photographs as well as for paintings.

Why *do* we do history? Classic answers run something like: To

211

learn about ways and means, mistakes, etc., so that we will be better able to proceed into the future by changing ways and means, by avoiding past mistakes in order to make a better future for ourselves, our children—or perhaps more accurately in order to understand ourselves better. In truth, I think, we begin by looking for answers to the big questions which we rarely articulate—the questions that ask for an explanation of life—of the many unknowns that seem beyond our grasp. Somehow history involves faith—faith in progress, growth, development—maybe evolution—certainly faith in the possibility that there are answers. I think picturemaking serves a similar purpose. Both historians and picturemakers, however, tend to lose sight of this in the course of living, working, and especially in the course of coping with the increasingly microscopic details which the field of history has uncovered and continues to uncover. And, along the way, historians often become promoters of an ideology, a point of view which becomes a convention through repetition and acceptance. What we end up with in doing history and in making pictures is a way of making propositions and comparisons, which is, in part, how the question, "Yes, but is it art?" came about. History and picturemaking are ways of relation-making which allow us to posit ideas about the possibility of a world. To repeat Nelson Goodman, they are ways of worldmaking. Nothing can be considered more important.

Now, I freely admit that I do not know how or where or why life began, or how or why or where the first picture was made. I'm not convinced that I know where or why the first history was made. What I do know (or believe) is that pictures come from pictures and that history comes from history. Neither can "move" without reference (direct, indirect, conscious, unconscious) to what came before. For what came before provided a convention which had and has to be dealt with. I also believe that whatever is characterized by some term for a long enough period of time takes on in our minds the characteristics we usually associate with that term.

How the Renaissance answered the question, "what is art?" has certainly played a major role in defining the meaning and effects of pictures made before and since 1450. If painting with oil, for example, is characterized as art from its beginning and for hundreds of years thereafter, then it will be very difficult to conceive of oil painting differently. That is one reason why the characterization suggested by the question, "Yes, but is it art?" is so important. That question

and the characterization suggested by its obvious answer has created a segregation which, I think, has led to an increasing misconception about the meaning and real effects of all kinds of pictures—those made both before and after 1839.

As a youth I had very little interest in history. My world was composed of music, picturemaking, and some writing. In college my interest in history was still weak, though I did develop a curiosity about a few photographers and painters who had lived and worked in the past, and some who were still working. Three courses contributed to that new interest. One was an art and music appreciation course which, I recollect, never mentioned photography. The other two were histories of photography: one with a scientific and technical basis, taught by C. B. Neblette; the other with a picturemaker emphasis, though it did not avoid the technical evolution, and that was, as far as I know, Beaumont Newhall's first formal college course. Neither history of photography paid much attention to paintings or other forms of picturemaking. Then I went off to graduate school in journalism (why is too long a story to go into here—but it involved economics in a variety of ways). I read about, thought about, and wrote about communication, both verbal and visual—though my interest was primarily visual (I continued to make pictures). I began to wonder even more about the separation of categories: art and science, art and photography, etc. I began reading J. J. Gibson[5] and other psychologists of visual perception, and that seemed still another separate category. But somehow all these people/fields were supposedly concerned with two things: pictures, and the relationship between them and the visual world of things and ideas—either in terms of representation/communication or in terms of how we see the world directly—or how we act as a result of seeing either the world or pictures or both. Many seemed to feel that pictures and worlds were interchangeable in ways never acceptably defined.

I spent a lot of time thinking about all of this, and in the process began to read about art in history—not art history per se, but books by such people as Stephen Pepper, Rudolph Arnheim, William M. Ivins, Jr., Ernst Gombrich—people who might be called theoreticians rather than historians.[6] Well, while I was reading, thinking, and making photographs, I was drafted into the army, where I spent two years doing very little photography, some writing, and some reading—now dipping into general art history. But mostly I did a lot of other things that the army was more interested in.

I was still wondering about the separation of categories, and more and more about photography's inferiority complex—about photography's supposed mechanicalness and its unworthiness as art. (This, at the time when my photographs were hanging in Steichen's "Sense of Abstraction" exhibition at the Museum of Modern Art.) So, upon leaving the army I went to another graduate school to investigate art history. One of the things I discovered was that art history investigated all kinds of pictures made before 1839, but discriminated against certain kinds of pictures made after 1839. That bothered me more and more. I've been a member of an art history department ever since, and I'm still trying to find ways to integrate what have been considered separate kinds of pictures or picturemaking, because I firmly believe that they are all part of the same basic human desire to represent visually—a drive or need that can be traced historically to the people who lived in or around the caves.

Now, if I haven't made the point strongly enough, let me remind you as well as myself that the point of all this autobiography is to underline the personal nature of everything we do. I have been trying to tell you about my motivation to do picture history and, whether I am willing to admit it or not, I come to it with a set of blinders which I may not be aware of—what Gombrich, borrowing from psychology, calls "mental set" in referring to what an artist is restricted by when he/she makes a picture. Some may say that I'm trying to raise photography to a higher plane in some hierarchy or other—for fame or profit, etc.; that could be my bias, my mental set. Someone else will have to judge. The important fact, for me, is that we have both "distorted" histories of photography and "distorted" histories of art (without, of course, forgetting that all histories can be seen as distorted).

I think a similar feeling of discomfort with accepted histories of art motivated the writing of two important books in the 1950s: William M. Ivins, Jr., *Prints and Visual Communications* and E. H. Gombrich, *Art and Illusion*. Unfortunately neither author understood photography (their mental sets were too thoroughly infected by the traditional/conventional art-historical discrimination). If they had talked to us photographers, or if they had had available to them the excellent essay, "Photography, Vision, and Representation," by Joel Snyder and Neil Walsh Allen (published in *Critical Inquiry*, Autumn 1975 and reprinted here [chapter 9, above]), those two books might have been even more monumental than they are. But history doesn't always proceed in an orderly fashion. Indeed, my

thinking as well as Snyder's and Allen's was in part motivated by Ivins and Gombrich!

In any case both Ivins and Gombrich, it seems to me, were trying to trace the relationship that might obtain between pictures and worlds; that is, how pictures have participated in the making of what people in history have taken to be their environments, and their ideas about or their understanding of those environments. In a sense what these writers were doing was sidestepping, in different degrees, the more rarefied and thus limited and typical approaches to art history which involved hierarchies, connoisseurship, the notion of genius, the narrow view of formalistic/stylistic development, and the limited iconological approach to subject matter. Importantly, they both implied the difficulties of real understanding imposed by the traditional separation of form and content.

Neither Ivins nor Gombrich, however, understood to what extent photography was controlled by the same conventions—the same limitations— that affected older methods of picturemaking. Both fell into their own traps. (And, by the way, I wonder at this point which of my traps I might be falling into.) Of the two, Ivins was the more courageous rebel. He understood that "what we think about and act upon is the symbolic report and not the concrete event itself,"[7] and that this cognitive aspect of art (pictures) is at least as important as any other. On the other hand, he was as convinced as anyone since 1839 that, as he put it, photography had no "distorting syntax" and that therefore it could provide "accurate" and "exactly repeatable visual statements." This is one of the most difficult beliefs to break, and returns me to the question, "Yes, but is it art?" and therefore to the basic problem of photography's place in the history of picturemaking.

Since we really do not have a history of picturemaking, since all we really have are histories of art, we have to talk about photography's place (or non-place) in the histories of art.

Now let us ask why photography has not been included in the major art histories of the nineteenth and twentieth centuries. Can we assume that the authors did not consider photography art? Yes, we can assume that. Why didn't they? Because it did not fit into their definition of art. Why didn't it fit into their definition? Did they define art? And if they did, was their definition different from ours? We're getting into muddy waters, and I'd like to avoid them if possible. I think we can avoid them, but we can't ignore them.

To say, as most of us would like to say, that asking "what is art?" or

"is photography art?" is dumb—or that they are wrong questions—is probably true, but we must not let that cause us to ignore the muddy waters. I submit to you that we must not ignore these questions. We do not need to try to answer them, but we must deal with the importance of the fact that the latter question (and the former is implied by the latter) has been asked consistently since 1839 and that it's being asked for so long and so consistently implies that those who have asked it have already known their answer. And we all know that answer.

We need to know why the question was asked in 1839, why it continued to be asked. For the answers to those two questions will go a long way toward explaining why there are separate histories of art and photography, and perhaps even toward explaining why there are no histories of pictures. (I must point out, before we go on, that the only art we're concerned with here is picturemaking, not sculpture, architecture, decorative arts, etc.—I hope the reasoning is obvious.)

That dumb (or wrong) question and its so-frequently-offered answer have become so imbedded in thought that they have themselves become conventional or traditional—that is, question and answer have come to be asked and given without thought. The effect of that on the history and meaning of all kinds of pictures, I think, has been of the greatest order in terms of what we might call, for the moment, distortion. At the very least it has removed photography from consideration by a number of important critics, historians, and theorists, and has therefore not only caused ignorance of photography but misinformation about both photography and the other forms of picturemaking. Generations of art historians and critics have been affected. But so too have photographers and *their* critics, historians, and theorists. Let me remind you that with some few notable exceptions, most photographers and their chroniclers know very little about the other picturemaking media and their histories. Photographers and photo-historians, in this regard, have been as narrow-minded as traditional art historians. I daresay painters have always known more about photography than vice-versa—and it has been to their advantage. Photography did not come without a history and a tradition in 1839. Nothing that I know of has come that way since Genesis.

Without giving you chapter and verse of the ill effects imposed on literature and art by that "original" question and answer, let me give you just a couple of relatively recent sample examples: Stieglitz,

you will recall, in response to the lingering effects of the question/ answer, decided (as others did before him) that photography was a different kind of art (the title, by the way, of a recent essay by John Szarkowski,[8] which had the same effect), a different kind of art with its own special characteristics (variously defined throughout his life), thus in effect solidifying segregation. Minor White did the same— even to a greater segregation in the pages of *Aperture*. In the late '50s I contributed to that, and shortly after found myself editing *Contemporary Photographer* in an attempt to broaden the definition of what we considered *important* photography. We were still segregating it from other forms of picturemaking.

All of these and more were attempts to create an elitist, segregationist camp in the manner of what we found ourselves excluded from—the fine art club of the other magazines, journals, books, etc. Perhaps Newhall's history, too, is that kind of negative response. (If I can't get into your club, I'll form my own and keep you out.) And all of us played right into the hands of the effects of the question/ answer. We didn't agree that we were less good, less important, inferior, not artists—but we did. There is no end of analogous examples of how things long and well-defined, however wrongly, resulted in all parties believing an erroneous definition for centuries. I need mention only women, the flat earth, the revolving sun.

In 1964 Van Deren Coke, a photographer and photography historian, created an exhibition and catalogue entitled *The Painter and the Photograph*.[9] That title reflected the contents of both the exhibition and the catalogue: the paintings and painters were spotlighted, the photographs and photographers were, so to speak, kept in the back room (even though much of the innovative work was that of the photographers). In 1968, an art historian, Aaron Scharf, published an important history book with the title *Art and Photography* (London: Penguin Press). I wrote an extensive review[10] of it in which I argued both for its importance, in terms of its massive and important research, and against its bias. I tried to show how the mind set of an author (he was a student of Gombrich) who would select such a title had to have had a very restrictive effect on what he would be able to say about his subject: the relationship between painting and photography. Indeed, his training, and therefore what he saw when he looked, what he heard when he read, had to have been conditioned by the effects of the question/answer.

The notes in the book, even more than the text, testify to the

tenacity of the question/answer in the literature of the nineteenth and twentieth centuries. We can follow step by step how photography became defined, categorized, removed from the mainstream of picturemaking (or if you prefer, you may substitute the word "painting" for "photography" in the last sentence.) It is revealing both in terms of Scharf and in terms of the history of photography that as Scharf approached the last chapter of his book photography seemed to emerge slowly as art rather than as the something other that it was at the beginning of the book.

I want to say at some point, and perhaps this is as good a place as any, that I recognize that there are differences between painting, photography, and other picturemaking media. I do not wish to consider them here, for they are more than well-known—indeed, overly emphasized, though often incorrectly. I want to make a case for the consideration of where they overlap, for a consideration of why their differences are exaggerated and misunderstood, for a consideration of how one evolves out of the other. These are considerations which have not been emphasized, considerations which may lead to a more useful history.

Any viable history of photography has to be a part of a history of picturemaking, and any viable history of picturemaking must include photography. Any other may not be false, but it will be misleading in the extreme. Thus both Newhall and Arnason[11] (the most widely used text on modern art, and less than two years old in its most recent edition) are misleading, and misleading, I think, for reasons that go back to the question/answer (which by now may be beginning to sound to you like the equivalent of original sin).

Some writers saw the problem. Walter Benjamin did. He noted it and its importance, but did not follow it up for two reasons: 1) He could himself not get completely past the transparency fallacy—seeing the photograph as a window on the world—a problem directly and immediately following from the assumption in 1839 of the technological reality and therefore non-artness of photographs (the question and its answer); and 2) he had other concerns, more pressing at the time, that he wished to pursue.

In his important essay, "The Work of Art in the Age of Mechanical Reproduction," Benjamin wrote in 1937, "The nineteenth century dispute as to the artistic value of painting versus photography today seems devious and confused. This does not diminish its importance, however; if anything it underlines it. The dispute was in

fact the symptom of a historical transformation the universal impact of which was not realized by either of the rivals."[12] And he goes on to say, "The primary question—whether the very invention of photography had not transformed the entire nature of art—was not raised."[13]

I must interrupt this here to again remind you, lest there be any misunderstanding, you living in the midst of a ten-year-old wholesale acceptance of photography as art by museums, collectors, auction houses, etc., that I am not here calling for an acceptance of photograpy as art; I am calling for an understanding of why it was not accepted in the past, and more importantly I am calling for a new history which seriously engages those reasons and their effects on all picturemaking. I am calling for an understanding of the effect of the question/answer on all aspects of life in the last 140 years.

Benjamin, however, missed the major point of his own revelation because he too, as stated above, suffered from the transparency fallacy which had been in force for a hundred years before he began his essay. He sometimes confused film and photography, but more importantly he failed to take into serious account the fact that photography was developed in the image of pictorial conventions which had been evolving since at least the Renaissance—indeed, photography may be seen as the fulfillment (some 400 years later) of Leonardo's dream of a "scientific art of representation." That Benjamin missed this is clear from the following passage, which, while it deals with film, also clearly applied to photography in Benjamin's mind. He wrote,

The film has enriched our field of perception with methods which can be illustrated by those of Freudian theory. Fifty years ago, a slip of the tongue passed more or less unnoticed. Only exceptionally may such a slip have revealed dimensions of depth in a conversation which had seemed to be taking its course on the surface. Since the [book] *Psychopathology of Everyday Life* things have changed. This book isolated and made analyzable things which had heretofore floated along unnoticed in the broad stream of perception. For the entire spectrum of optical . . . perception the film has brought about a similar deepening of apperception. . . . As compared with painting, filmed behavior lends itself more readily to analysis because of its incomparably more precise statements of the situation. . . . This circumstance derives its chief importance from its tendency to promote the mutual penetration of art and science. Actually, of a screened behavior item . . . it is difficult to say which is more fascinating, its artistic value or its value for science. To demonstrate the identity of the

artistic and scientific uses of photography which heretofore usually were separated will be one of the revolutionary functions of the film.

. . . the film, on the one hand, extends our comprehension of the necessities which rule our lives; on the other hand, it manages to assure us of an immense and unexpected field of action. . . . The enlargement of a snapshot does not simply render more precise what in any case was visible, though unclear; it reveals entirely new structural formations of the subject. . . . Evidently a different nature opens itself to the camera than opens to the naked eye—if only because an unconsciously penetrated space is substituted for a space consciously explored by man. . . . Here the camera intervenes with the resources of its lowerings and liftings, its interruptions and isolations, its extensions and accelerations, its enlargements and reductions. The camera introduces us to unconscious optics as does psychoanalysis to unconscious impulses.[14]

Where Benjamin and the many critics and historians before him have fallen down, and where the question, "Is photography art?" arises, is precisely when the notion of photography's "unconscious optics" (transparency) is accepted as fact. That that is a paradox is important. A similar paradox is indicated by Gombrich in his exploration of the psychology of pictorial representation, where he says, ". . . the perfection of illusion was also the hour of disillusionment."[15]

What I am proposing here is that photography, while *appearing* to prove or perfect the reality of the illusion in a Renaissance single-point-perspectival rendering of space and volume—in a sense coming to the end of a long search—was at the same time both a spectacular wonder and an incredible disillusionment. The reasons for this, I think, are many and complex, and before I try to sort out a few of the possibilities I want to use Benjamin a bit further.

On the surface one may feel that there is nothing new or unusual about Benjamin's position as it is developed here. Basically he seems to be pointing to photography's apparent mechanical revelation of a visual truth beyond what is visible to the eye—Muybridge's motion studies, for example. Photography shows us more, says Benjamin, and shows it more precisely, and thus makes it possible for us to understand (control?) more of our life. Others have said this since 1839. This is the second of the two major convictions about photography: 1) that it pictures what we see; 2) that it pictures what is there, whether we see it or not, for in showing us what is there it shows us both what we miss from lack of attention and what we miss from the eye's inability to see it (which is probably what Benjamin means by "unconscious optics"). The Snyder-Allen essay is the best explana-

tion I have read about why both convictions are false, as any serious picturemaker has always known.

Benjamin's problem is a common one: the tenacity of the idea of photography's truthfulness to material reality with or without the presence of a human operator. No matter how often we deny it, no matter how often we read the Snyder-Allen essay, we all share this problem to some degree. Even I find myself falling though the window when I look casually at snapshots, magazines, television, and Walker Evans; and I like to think I have known about the trap for over twenty years. I do assume, however, the people will one day overcome—though it may take the long development of a major new convention of visual representation. The perspectival view has been the accepted view for 500 years. It can hardly be surprising that it is not easy to deny.

The importance of this for our comprehension of both art and reality cannot be overstated. Art, whatever it is, is a part of picturemaking, and picturemaking has been and is one of the ways of exploring and defining "realities" of various kinds and in various guises. And maybe one of the things we want to know from a history of photography as part of the history of picturemaking is how people have used pictures to shape the past and the present. For that might help us to guard against how pictures will be used to shape our future. How we perceive past and present is directly related to how we perceive and respond to pictures.[16]

And if we perceive photographs as technologically accurate or truthful, and paintings as esthetically imaginative or technologically inaccurate, our world perception is categorically affected and our actions will follow in due course—for better or for worse.

There is one sentence in the Benjamin statement quoted above which leaves an open end and that is: "To demonstrate the identity of the artistic and scientific uses of photography which heretofore usually were separated will be one of the revolutionary functions of the film." But film has not demonstrated this identity. Indeed, film's separation into fictional (artistic) vs. documentary has increased the confusion, and who either believes or can adequately define what the difference is between these two modes of filmmaking? How verité is cinema verité?

I'd like to play with the notion of "the identity of the artistic and scientific uses of photography" for a while.

Benjamin says they were "heretofore usually . . . separated,"

which is still true and which is at the heart of what I called the paradox at the birth of photography, and which is at the heart of most of the controversies surrounding photography ever since, including those proclaiming the greater scientific potential of the daguerreotype vs. the greater artistic potential of the calotype, and proceeding through to Robinson's arguments *for* combination printing vs. Emerson's arguments against, to the conflicts over the scientific vs. artistic truth, merit, and use of Muybridge's locomotion pictures, to the confrontations of Weston and Mortensen, Walker Evans and Stieglitz, and Szarkowski's Mirrors and Windows. And it is the core of the question/answer issue.

And the artistic and scientific separation or identity question is not unrelated to—indeed it is not unlike a similar controversy— over the relationship between art and knowledge. Do we learn from pictures? Do we learn one kind of thing from paintings and another kind of thing from photographs? Aren't all pictures related in terms of their cognitive function as well as in terms of their makeup based on conventions?

Photography was made to fit the needs and desires of individuals whose conceptions of what kinds of knowledge pictures provided, and what such pictures should look like, were based on experience with past or present pictures. Thus there can be no scientific accuracy in the sense of a pure record of reality. There can be no objective document. Thus photographs suffer the same consequences and enjoy the same possibilities as other kinds of pictures. There cannot even be degrees of "more accurate" for photographs vs. paintings. There can only be accepted norms for kinds of representation which can be learned and which can be more or less adhered to by photographers and painters alike.

Why *were* photographs immediately taken to be "real," to be true representations of reality, when they appeared in the nineteenth century (and why do we still so see them in our unguarded moments)? Part of the answer to that question, I propose, is to be found in the fact that photographs seemed to fulfill their audience's expectations about truth in representation in terms inherited from Renaissance conventions of single-point perspective, chiaroscuro, and other such characteristics of the "window-on-the-world" type of picture. Conversely, the only thing most early photographers could think to do with the camera was to reproduce those conventions. At the same time the scientific and technical aspects of the invention were ac-

claimed for their assurance of an automatic relation to the material world. Now, I propose to you that just by suggesting this partial and tentative hypothesis, I am at once linking artistic and scientific as well as art and knowledge, and at the same time am setting photography on an equal basis with other types of picturemaking. I am also insisting on the conventionality of our expectations about what counts as realistic. But all of what I have proposed in this hypothesis applies only to the Western world, and that is a very important point, because the conventions were different in the East. These thoughts are inspired by Gombrich's *Art and Illusion,* and represent the radically relativist side of his argument, a side he never fully admits or accepts because, I think, he misunderstands photography as something other than what he is talking about.

Gombrich goes to great lengths to prove the force of conventions in restricting an artist's and viewer's perceptions, but he fails to see, as most of us do, where the force of conventions restricts his own perceptions. He wants to both break and hold conventions simultaneously, and thus must disown his own radically relativist side when he sees it cutting the ground from beneath his feet.

If you accept my proposed hypothesis it follows that we must recognize that there can be no absolute distinction between the "straight" and "manipulated" image, or between mirror and window, etc. We must recognize that all conventions for representing space, time, and motion are in some sense equally valid. Conventions for other things and ideas (God, love, tension, Great Nature, etc.) must also. But conventions would not be conventions if they did not have staying power, if they did not have wide acceptance long enough to become habitual.

Some "proposed" conventions do, some do not.

Before photography, God, geometry, and geometric optics lent representational credence to pictures made with oil paint following the mathematical rules of linear perspective—representational credence for both spiritual and literal truth. Suzi Gablik wrote, "In the Renaissance, geometry was truth and all nature was a vast geometrical system."[17]

Since photography, however—and actually quite recently and paradoxically—linear perspective, which had been believed to be innate, has been shown to be a convention which must be learned— as indeed it was not, in the Eastern world, until long after it was generally accepted in the Western world. Non-Western and pre-

Renaissance Western people had different conventions, based on different concepts of reality—which is why non-Western people had and have difficulty with perspective pictures (and photographs) on the first exposure. The best book on the complexity of the development, meanings, and purpose of linear perspective and its distinction from human vision is S. Y. Edgerton, Jr., *The Renaissance Rediscovery of Linear Perspective*, published in 1975 (New York: Basic Books). What Edgerton says in that book and several more recent essays,[18] about perspective and the World from the fifteenth century forward, is applicable to photography and the world since the nineteenth century, as is what Ivins says about printmaking since the Renaissance. Both tell us that pictures before photography defined the visible world just as photographs (and other pictures) have been defining the world since 1839—that is, defining the world largely as we expect it to be defined, based on our beliefs.

Long before linear perspective, however, man's need to reproduce what he thought he saw, or knew, or believed, established itself as the first principle in picturemaking. It was, of course, the maker of pictures on the walls of caves who began this tradition and who formed the first conventions (at least, the first we know). I would like to think that there were cavemen who theorized about the art and science of those pictures. While that may seem far-fetched, I do like to think that there were cavemen who theorized about the reality of those pictures, and that that theorizing led to accepted beliefs about the world which were, in effect, created by the conventions developed in the process of picturemaking. Projecting into the future, I suspect a similar result following from the certain-to-be-coming pervasiveness of holography. We seem to need a picture which we can accept as real. Whether the holographic picture will be acceptable as that picture is perhaps not as certain as I suspect at this moment.

I suggest that that need or desire itself long ago became transformed into what we might call the insoluble problem of picturemaking. Each attempted solution has posed a new problem. Both solutions and problems have had extraordinary effects, not only on art but on reality. Indeed, all of this activity, while not providing reproduction, has made it possible for us to see "realities" never before seen or known, but never in any sense by what could be called mechanical automatism. Picturemaking is proof that there are many worlds, many realities. Picturemaking has made them. Photography

posed a greater problem than usual by being so widely accepted as what seemed a final solution, because it made it possible to do, with the aid of manufactured devices and chemistry, what had been done before by hand and handmade devices, and because so few thought to consider, as we are beginning to today, when we think of computers, that every aspect had been programmed to conform to conventions imagined and developed by men and women.

How many of us today question the reality of Muybridge's horses? Indeed, how many of us question the reality of the simultaneous presentation of three differently scaled views of Englebert Humperdinck on the television screen? We know, however, that an Egyptian living 3,000 years ago, or a person who has never learned to read pictures, would not only question the reality but would be totally confused by the photograph or the television screen. He would not be confused if a horse or Englebert crossed his path. As a pertinent aside let me put in your mind a simultaneous reference to Cubism and to Egyptian wall painting to remind you of how, as readers of pictorial conventions, on the one hand, sophisticated we are, and on the other hand how naive we are.

It is said that when a friend saw Picasso's newly painted portrait of Gertrude Stein, he exclaimed to Picasso that the painting didn't look like Stein. Picasso, it is said, replied, "Don't worry, it will." And indeed, for me it does—it is the only real Gertrude Stein I know. There are two photographs of Marian Anderson that I have known intimately for years; one is by Karsh, the other by Avedon. Now, I *know* that neither is Marian Anderson, but I *believe* Avedon's is.

Since 1839, then, what has been taken to be visibly real has been largely what has been seen in photographs, whether those photographs have been characterized as art, science, or the cloudy area in between. But how did photography come to be seen as a method of picturemaking both the same as, and different from, the older methods?

There is little to be gained by tracing the narrow but well-documented history of the pre-history of photography's technology here. There is something to be gained, however, by reviewing a few of the highlights of that history from a slightly different perspective.

We know that there is an intimate relation between the desire to represent the world visually, the development of perspectival rendering, the camera obscura, mirrors and windows, and geometric optics. It is unclear which came first or which exerted the greater

influence on the other. It is also unclear how much the impetus was scientific, how much was artistic, and where to draw a line, if any, between them.

We know that the image area of the camera obscura was designed via a mental set developed from Renaissance notions of pictures as windows-on-the-world. One might say that another type could not have been imagined.

We know that lenses were designed on principles of geometric optics and that those designed for use on cameras obscura were specifically made to project one-point perspective pictures onto a framed window; and that conforming to a rectangular or square window eliminated part of the lens-formed image, which was circular.

We know that camera and lens manufacturing, with few exceptions, has followed this rigid set of conventions ever since. That there may be other possibilities seems not to have been within the mental set of equipment designers, inventors, manufacturers—or most photographers—or most other picturemakers (very few painters—even of our generation—have broken with the basically rectangular format). That is an incredible testimony to the tenacity of the Renaissance convention. It is what we immediately visualize upon hearing the word "picture."

What we think of (or visualize) when we hear the word "frame" also testifies to the power of the conventions of Renaissance picturemaking. Look the word up in any dictionary and see how broadly it is used. To encourage you in this enterprise I'd like to list a few phrases: to frame a view; to frame a picture; to frame a proposition; to frame a concept; frame of reference; to include, enclose; to exclude; to impose; to fragment; to control; to limit; to arrange; to give expression to; to contrive; to draw up; to formulate; to shape; to devise falsely; the constructional system that gives shape or strength; a set or system (of facts or ideas) serving to orient or give particular meaning; frame up, etc.

About the motivations of the three best-known inventors of photography we know, among other things:

1. Niepce wanted to reproduce other pictures.

2. Daguerre wanted an easy method of preparing illusionistic settings for his diorama pictures.

3. Talbot wanted an automatic method of rendering pictures of picturesque scenes (in other words, an automatic method of making permanent the pictures he projected out onto the world).

4. Niepce's main occupation was as an inventor—we might say a technologist.

5. Talbot's main occupation was as a scientist (mathematics, physics, linguistics).

6. Daguerre's main occupation was as an artist (picturemaker).

Thus art (picturemaking), science, and technology as means of obtaining and communicating knowledge are not only in the ancestry but in the parentage of photography. Most important, however, is that each of the major motivations above has a history traceable within the traditions of picturemaking.

While, as we have noted, the daguerreotype and calotype pictures numbered many differences among their image characteristics, the major generalizations then and now about all kinds of photography revolve around the long-accepted traditions of the Renaissance perspectival oil painting. Only one characteristic of photography was and is consistently singled out as different and significant and that is, in one variation or another, photography's supposed mechanical nature (apparently different from the grids, perspective boxes, and other geometrically derived devices used from the sixteenth century on). Not even the lack of color received the kind of attention that the "automatic rendition of space, volume, mass, chiaroscuro, and detail" sparked in all accounts. It seemed to most people, as it seemed to Delaroche, that the Renaissance quest for the perfect two-dimensional illusion of reality had been fulfilled.

Here is a paradox—Renaissance art and science joined in an effort to study reality visually. Leonardo is acclaimed as a Renaissance man precisely because he brought every known field to bear on his exploration of the world as it was then known. By the time the central visual method of that study was "perfected" by photography, most (but not all) artists and scientists had separated company and found themselves in quite segregated academies.

You have all read, in the available histories, of the complex effects photography's emergence had on painters and printmakers—how some (generally seen as the less-than-great) were threatened, how some lost their patrons, clients—their business; how some became photographers or employees of photographers—the latter generally as hand colorists, etc.

You have, perhaps also read the multitude of treatises about Realism in the art of the nineteenth century—particularly those centering about Courbet, Manet, and the Impressionists. Perhaps you will

recall Constable's statement, made during a lecture in 1836, three years before photography was made public, that "Painting is a science and should be pursued as an inquiry into the laws of nature. Why, then, may not landscape painting be considered as a branch of natural philosophy, of which pictures are but the experiments?"[19] It wasn't until fifty years after photography (in 1890) that Maurice Denis wrote that "a picture—before being a war horse, a nude woman, or some sort of anecdote—is essentially a surface covered with colors arranged in a certain order."[20]

Now, obviously, I do not have the space to review the various concepts of realism here—even less possible is it for me to get into the philosophical notions of the word "reality." It is enough for now that you have in mind the importance of and the vast range of theorizing about realism, representation, reality, and art that has taken place since the late eighteenth century.

In passing let me remind you that most picturemakers in the Western world claimed to be realists of one sort or another. Most conventions of representation have been acceptably realistic in their own time. Vermeer and seventeenth-century Dutch realism in general were rediscovered and celebrated in the nineteenth century. The Romanticists of the early nineteenth century claimed to be realists. Courbet, the Barbizon painters, Manet, and the Impressionists claimed to be realists. Why else all the commerce between Romanticists, realists, and impressionists? Even the Cubists claimed to be realists. The Surrealists obviously claimed to be realists—or superrealists (reality for them being in the unconscious, etc.—but still based on an extension of conventions developed for conscious reality). In 1968 an exhibition was mounted at the Museum of Modern Art, directed by E. C. Goossen, called "The Art of the Real, USA 1948–1968," which contained no work based on Renaissance conventions; it contained work which was almost entirely geometric— but geometric in the form we have come to accept as abstract—work by such artists as Barnett Newman, Ellsworth Kelly, Frank Stella, Kenneth Noland, Agnes Martin, and Donald Judd. The "realism" of Pop Art, the New Realism, and Photo Realism in the painting of our time rephrases many of the old questions in the form of new propositions. Is the reality of Photo Realism the reality of photography, or of some absolute world, or of some combination of past and present?

Hasn't our reality itself become abstract and propositional? Can

we agree on any one convention for its representation? It should be fair to say that today there is widespread confusion not simply over reality in art but over reality itself, and that that confusion began at about the same time photography appeared—long before Einstein's theories of relativity (and Freud's psychoanalysis) but in fact already heading in that direction. Perhaps one can say that picturemaking was already beginning to suggest the radical difference between Newtonian physics and what would become the relativist revolution of Einstein. The revolutions against traditional conventions for visual representation parallel, if they do not precede, the revolutions in other fields investigating reality.

There always has to be some motive for rebelling against stereotyped ways of seeing (and making). That motive, or part of it, may be a growing discomfort with, displeasure with, or disbelief in, a reality (personal or general), or in a currently accepted convention of representing that reality. It may come about as the result of becoming conscious of the *fact* of conventions or mental sets—becoming conscious of one's own blinders. Then the motive may result from the question: what might we gain if we could remove conventional blinders—or more accurately, since they cannot be easily removed, how will we see differently if we try to be more conscious of the restrictions imposed on our perception by the conventions? For the viewer the result might be a lessened possibility of being easily manipulated by images—he/she would check the tendency to "fall through" the frame. But there is more to be had than this, there must be, since one can only stand that kind of ironic reserve and suspicion for so long.

The question becomes: What new things will we see, how will we respond differently, and what can we learn about the past or the present or the future by remembering that pictures are only pictures made by people and are largely based on learned and inherited conventions? And that the pictures are defined, delimited by other people, their use, and their contexts?

But we're getting ahead of ourselves. We must return to 1839.

Once photography was accepted as a scientific/mechanical/natural medium of representation (whether "true" or not), an interesting paradoxical situation regarding Western man's "picture of reality" evolved. Renaissance art had structured Western man's picture of reality. In 1839 that picture was "proved correct" by photography, and yet that picture led to a period of confusion about what both art

229

and reality were. What in fact was happening, however, and sort of beneath the surface, was a questioning of the very idea of a reality—whether seen, pictured, believed, or known.

The fact is that both photography and painting investigated the nature of that reality—or, more accurately, its picture. and the significant paradox of this is that painters and photographers did this sometimes in the same ways (holding largely to the inherited Renaissance convention) and sometimes in different ways (trying to break through the restrictions of that convention as a result of sensing a lack of correspondence with experience). The complexity of this was thoroughly compounded by the question of whether photography was art or science, and indeed whether there was any real difference between art and science in terms of the investigation of reality.

As a result both painting and photography—or more precisely, both painters and photographers—were left in an ambivalent state.

Photographs, while conforming to Renaissance conventions, began to reveal pictorial possibilities (detail, blur, multiple views, fragmented features) never before seriously considered. At first these revelations came largely by accident (aided by the relative quickness of getting a finished product even by those who were new to the picturemaking game), but soon they began to come by design—that is, with the conscious intent of the picturemaker. It was these accidents, these new pictorial possibilities, which seemed to be the result of science or the machine, which, perhaps even more than the adherence to geometric optics, supported the wholesale acceptance of photography's automatism.

This set of circumstances (and undoubtedly there are other factors) led to a *new* separation of kinds of pictures—Art, it was said, must be something else, something involving the hand, or genius, or—something other than what people did with photography (though, of course, people—the photographers—were for the most part discounted in terms of the camera's result). Photographers provided esthetic experience (a different kind of knowledge?).

Interestingly, this new separation (the result of the basic question/answer) led to new ways of picturemaking which found their way into pictures produced with all media—including photography itself. For conventions will be adapted by picturemakers and *they* will find ways of making their medium conform. Optically formed conventions, when seen in the work of Vermeer, Degas, Duchamp, were considered esthetic; the same conventions seen in the camera ob-

scura, in the work of Braun and Marey, were considered technological, mechanical or scientific.

That they were conventions was almost impossible to be seen by those whose mental set forced them to believe what they thought they saw in a photograph. I need only remind you of the incredible number of newspaper accounts at the birth of photography which spoke of its magical *taking* of nature—or of the magazine, *The Daguerreotype*, which had nothing to do with photography but used the word as its title to impress its readers with the truth or reality of the *words* it contained. This of course reflects the nineteenth-century shift from blind belief in an unknown God in man's image, to blind faith in an unknown God in a machine's image.

In less theoretical terms, but being conscious of making generalizations, let's look at two broadly structured categories of nineteenth-century photographers: those who saw themselves as artists and those whom we might call amateurs, pseudo-scientists, and others (job-hunters? money-seekers?) who were less well defined in the nineteenth century but who today occupy a vast number of recording/investigating/reporting positions in our highly specialized world of work, and who all accepted and accept the mechanical nature of photography as a given.

The would-be artists among the early photographers were led to try to make pictures which looked like art (something generally related to the Renaissance convention but which was assumed to be unscientific, unmechanical, untechnical, and therefore unphotographic—an interesting confusion). This meant that their conventional blinders were made to be even more restrictive (conservative) than most and therefore forced them to, not so much imitate other specific pictures as to conform to the general conventions of the pictorial past (immediate or long-term), and (and this is very important) this was true as much for the photographers who used the daguerreotype process (with its well-known characteristics), as it was for those who used the calotype process (with its well-known and opposing characteristics), as it was for those who used combination printing or any other technique or process. These picturemakers worked overtime to *overcome* the new pictorial possibilities revealed by the new medium. This may sound like what Newhall and others have said but it's not the same—the point is different. It does not ask for or suggest a *pure* or *straight* or *photographic* photography—whatever that may be.

231

This approach, as always is the case (see the history of printmaking techniques), slowed the development and understanding of the medium—slowed the development of new ideas (conventions) about pictures and therefore about reality. It did not, however, stop that process.

The other, larger group, one might say, simply proceeded to blithely make pictures, without great concern for art. Obviously, they too conformed largely to the inherited major conventions of picture-making. (We have, I hope, established how difficult it is to make a picture that doesn't have a family resemblance to pictures seen.) What they did, however, and usually not by choice, was to allow the "accidents" to happen. These un-art-educated results almost as slowly began to reveal unusual things which people saw either as technical mistakes (blur for example), or as Benjamin and others thought—as unconscious mechanical revelations of new truths about the world and its reality (daguerreotype detail, the fragmented forms and figures at the edges of the frame, the non-accidental Muybridge/Marey pictures pertaining to animal locomotion, etc.).

How you deal with these observations historically depends on how you define "mechanical," "unconscious," "accident," "truth," and "reality" in terms of photography. But however you define them the fact remains that these "new pictorial results" slowly began to transform our pictorial conventions of representation and therefore our visual perception of the world or the pictures of it (though not necessarily in that order). In other words, they promoted new ideas about life and times in a century when many other new developments were doing the same thing (the telegraph, the railroad, the steamship, positivism, etc.). And later in the century these were joined by the numerous and increasingly rapid revolutions in printing and reproduction which in symbiotic relationship produced the new, complexly dimensional realities of the twentieth-century world. Paradoxically again, as the realities grew more complex, the world became for most people more and more locked into a universal set of photographic conventions for representing itself, while artists using photography as well as paint and a multitude of other means continued to question the pictures, their conventions, and the reality those pictures and conventions represented.

Thus the painter Paul Delaroche was right in 1839 when he said, "From this day forward painting is dead." Not that the medium was dead, but that certain major conventions associated with it were

dying. Photography was only one of the causes of that long slow death, but it was a major cause. For in paradoxical ways it paved the way for the acceptance of the new possibilities opened up by those who tried with great effort to find other definitions for art, by those who began to take serious note of photographic "accidents," and by those who began to question a reality equated with a geometrically perspectivized picture.

Either non-photographic picturemaking was becoming something different from what pre-photographic picturemaking was, or all picturemaking was becoming different and photography, a medium invented in the image of the pre-photographic art media, but clearly capable of being used to make and follow different conventions, was the watershed which would become the basis for new visual ideas of representation in the twentieth century, where the sharing between media has become commonplace—just as the steam engine railroad, which was invented in the image of the covered wagon, became the basis for new ideas of locomotion in the twentieth century.

This is why photography's history must be part of the history of all picturemaking. It cannot be seen as something separate or as something of another class, for it is, no less than any other kind of picturemaking medium, a part of how we make our worlds.

And this is why inquiring into the reason for the asking of the question, "Is photography art?", into the reason for its so loudly and consistently given response, and into the effects of that response on all forms of picturemaking and their histories for so many years, is so important. Our recognized worlds—the ones in which we have operated—are directly related to the systems made believable by that question and answer. If we had been led to believe in the art-ness of photography—in man's control—we would not have been so easily manipulated.

Theory and history in this context may be synonyms. We may not need either history or theory to be able to enjoy pictures in an esthetic sense. We do need them in order to maintain our freedom, to avoid being manipulated by a system or a time or an individual. We need them in order to understand how pictures have contributed to the making of past and present worlds, how they have modified or directed our perception of our worlds and therefore of ourselves—indeed, how they have made the visual worlds what they have been and are.

Walter Benjamin was wrong when he compared the relationship

between the magician and the surgeon to that between the painter and the cameraman, saying, "The painter maintains in his work a natural distance from reality, the cameraman penetrates deeply into its web."[21]

Both the painter and the cameraman are up to the same tricks, as should be apparent, if not from what I have said, then surely from what that great magician, James Randi, said about us all when he wrote:

It is the ability of the human mind to arrive at conclusions with an incomplete set of facts or insufficient sensory data that the magician uses to achieve some of his most potent illusions. Without such a facility, the human organism—in fact any animal—would be unable to function; for every moment, we make assumptions about our surroundings that are based upon flimsy evidence, bolstered by memories of past experience in similar circumstances and by the presumption that the world is pretty much the way it was when last we tested it in this particular way.[22]

As long as a photograph is accepted as a mechanical representation, the world it presents will be accepted as being pretty much the same way it was when it was last tested in a photograph—or a Renaissance painting. And there are many magician photographers and magician-painters who capitalize on that knowledge. This is why we need a history of picturemaking that confronts all pictures with hard questions about their relationships to worldmaking.

I'd like to conclude by letting Edwin Land, a man who has done much to "demonstrate the identity of the artistic and scientific uses of photography" in our time, have the last and somewhat frightening word. The following is from "Notes on Polavision," published in *The Polaroid Report 1977*.[23]

We are told that long before there was writing and reading, the sense of history was carried by word of mouth from place to place and time to time and generation to generation, and what was transmitted by word of mouth were pictures, not the still pictures of the last century but moving pictures of going and coming and fighting and loving and herding, and the story teller and the story listener would presumably unite in visualizing into their present time and their present place what had happened elsewhere in another time. This reinstatement of past times and distant places for immediate reliving provided both pleasure and expansion of person and soul. . . . The adventure in which our group has been involved has been the creation of a technological aid to this nearly eternal mythological process of movie making. Our dream has been to revere and preserve this

prehistoric process, insinuating into it a procedure so subtle that it supports, with a minimum of mechanical distraction, our primeval competence in image making and image transmitting. . . . By stripping away all technological, electronic, and mechanical delays and intricacies, we have sought to push the movie-process toward the simplicity of our cortical-verbal competence. For only then can our synthetic movies become an adjunct and a partner to our biological movies. . . . The fulfillment of the dream is implied by the following pictures of Julia who at one year utilizes the Polavision player and the Phototape cassette to tell herself her story of herself and, in the essential spirit of the mythological process, to point out the images of herself as more real than she is.

Notes

1. This paper was presented on April 6, 1979, as part of "Towards the New Histories of Photography," held at the Art Institute of Chicago.

2. "Some Methods for Experiencing Photographs," *Aperture* 5:4 (1957), pp. 156–71.

3. E. H. Gombrich, *Art and Illusion*, 2nd rev. ed. (Princeton, N.J.: Princeton University Press, 1961), pp. 84–85.

4. Nelson Goodman, *Ways of Worldmaking* (Indianapolis, Ind.: Hackett Publishing Co., 1978), passim.

5. Esp. J. J. Gibson, *The Perception of the Visual World* (Boston: Houghton-Mifflin, 1950).

6 Among these were: Stephen Pepper, *Principles of Art Appreciation* (New York: Harcourt Brace and Co., 1949); Rudolph Arnheim, *Art and Visual Perception* (Berkeley: University of California Press, 1954); William M. Ivins, Jr., *Prints and Visual Communication* (Cambridge, Mass.: Harvard University Press, 1953); and Gombrich, *Art and Illusion*.

7. Ivins, op. cit., p. 180.

8. John Szarkowski, "Photography, A Different Kind of Art," *New York Times Magazine*, April 13, 1975, pp. 16ff.

9. The exhibition traveled to various museums; the book was published by the University of New Mexico Press, Albuquerque, 1964.

10. Carl Chiarenza, review of A. Scharf, *Art and Photography*, and R. Rudisill, *Mirror Image*, in *Art Journal 31:3* (1972), pp. 338–50.

11. H. H. Arnason, *History of Modern Art*, 2nd ed. (New York: Abrams, 1977).

12. Walter Benjamin, "The Work of Art in the Age of Mechanical Reproduction," in *Illuminations* (New York: Schocken Books, 1968), p. 228.

13. Ibid., p. 229.

14. Ibid., pp. 237–39.

15. Gombrich, *Art and Illusion*, p. 278.

16. One recent attempt to explore aspects of this discussion was the didactic exhibition of photographs and text called "Eye of the West: Camera Vision and Cultural Consensus," directed by Peter Schlessinger and mounted at M.I.T. in

1977. A related essay by Schlessinger appeared in *East/West* magazine, February, 1978.

17. Suzi Gablik, *Progress in Art* (New York: Rizzoli International, 1977), p. 70.

18. See, for example, S. Y. Edgerton, Jr., "Linear Perspective and the Western Mind: The Origins of Objective Representation in Art and Science," *Cultures* 3:3 (1976), pp. 77–104.

19. Gombrich, *Art and Illusion*, p. 33.

20. Quoted in G. H. Hamilton, *Painting and Sculpture in Europe 1880–1940* (Baltimore, Md.: Penguin Books, 1967), p. 64.

21. Benjamin, "The Work of Art in the Age of Mechanical Reproduction," p. 235.

22. James Randi, "The Psychology of Conjuring," *Technology Review,* January, 1978, p. 56. This article was brought to my attention by Dr. Martin Cohn.

23. Quoted by Martha Chahroudi in a review of M. Olshaker, *The Instant Image,* in *Exposure 16*:4 (Winter 1979), p. 40.

19

Self-Portraits in Photography

Ingrid Sischy

In the past two years, the ranks of American birders divided. There are those who swear by Roger Tory Peterson's classic work on bird identification, *A Field Guide to the Birds* (drawings), and now there are those who insist on the new *Audubon Society Field Guide to the North American Birds* (photographs). Peterson was first published in 1934. The type is blunt and the birds are drawn sparsely. They are laid out in schematic profile, with black lines running into their most salient features. The Audubon Society book uses color photographs and groups the birds according to resemblance, not biogenetic relationship.[1]

Since the purpose of both books is pragmatic—to help birdwatchers spot birds—the question must be "which works better?" When binoculars are focused on grey sky or green bush, which book most readily signals brain to name that bird that just flew across the field, or landed for an instant on a twig? I think Peterson's. The photographs show *a* bird at *a* given moment, but the drawings generalize, conceptualize a particular bird-essence. The photograph shows a real

Reprinted with the permission of Print Collector's Newsletter, Inc., from *PCN*, January–February 1980.

bird in a real place and because of its placement and fully inclusive description, often glosses over the most palpable, identifying details pertinent to *that family of birds*. The drawing, conversely, heightens and manipulates detail. The photograph—always with and in context—makes a jeweled portrait of a bird, but as portrait-subject that bird can only to a degree be an emblem for other "birds of a feather." The photograph is of *that* Northern Oriole (Baltimore) perching. The photo works in that it provides a system of shape and color through which to recognize other Northern Orioles. It tells us more than does the drawing about that Oriole's habitat, nest, diet, and we can certainly make assumptions about the living conditions of other Orioles. But the photo also tells us about that Oriole's instant of fear at being photographed, about its exact size, age, state of health and of molting. In every sense, it is a portrait of an Oriole; good or bad, true or false, depending on its quality and the photographer's perception.

In other words, if the goal is to recognize Woody the woodpecker or Jenny the wren, then the photographs prove more useful. But if it is to spot everysparrow, everymerle, then the drawings place first. Photography is always more specific than concept; and when photographs are used to catalogue—groups of birds or of people—types and portraits are always simultaneously created. (One recent advertising phenomenon, which appears most often in subways, could just be the fatal flaw in this argument. Although I'm not quite sure what the process used might be—combination photo-tinting, drawing, airbrush, psychlogy, genetics, etc.—one product offers a crispy brown fowl on a plate that could with equal ease be a chicken, a duck, or a turkey. Not a grouse. Photographs that have achieved "fowlness.")

Photography has been a fact of all of our lifetimes. Daguerre has held the wand, so has the Polaroid. But photography itself is not magic and never was. It is a complex, ubiquitous system of images, a process of picturemaking, subject to its own physical laws and conditions. The photographer most often "takes" a picture of that which already exists in the world and he too is subject to those specific physical and chemical laws. The conditions of photography tend to obfuscate understanding of the medium within the formal language of the plastic arts. The sometimes necessarily labyrinthine alleys toward understanding are often further complicated by an immature critical language that provides us with such ridiculous anthropomorphisms as "the camera never lies," or "the camera is the

objective recorder of events, people, places, etc." On the contrary, it is the photographer who makes the picture; and, as would be the case if language could exist without thought, so too in a photography without thought, understanding, choice, editing, and framing, nothing could be created.

This essay is about the range of photography's relation to self-portraiture. It includes many refracted kinds of self-portraiture as well as the literal. I am convinced of the symbiotic relationship between portraiture and self-portraiture. It is a fluctuant relationship and its balance has been affected by different decades, different photographers, and different subjects. But the two are never wholly divisible.

Photography has long been used to solve scientific dilemmas, particularly the dilemma of describing a species, race, or an aspect of these categories. Rejlander pioneered instantaneous photography with a series of photographs depicting fleeting facial expressions for Charles Darwin's *Expression of the Emotions* in 1872. Since Darwin's essential concern was survival and those variables within a single species that facilitate it, two facts stand to reason: within human emotion lie clues to human survival; before instantaneous photography, no method existed by which to record and examine such flickering clues. At about the same time, Eadweard Muybridge's studies of human and animal locomotion galvanized visual understanding of movement itself. Before his zoöpraxiscope (which was, in fact, the precursor to motion pictures) race-track regulars, like monks arguing angel dances on pins, would while away the time between post times betting on whether, at a gallop, for a flash, all four of a horse's legs left earth. (They do.)

Even when the problem of categorical description has not been a scientific imperative, photography as solution has often deployed scientific method. Adam Clark Vroman's analytic record of American Indians after the Civil War and August Sander's "archetype" portraits of Weimer Germans are both catalogues whose parts add up to a considerably greater whole than their sum would indicate. In 1911, Sander purposefully began a photographic documentation of the German people and took portraits of virtually every "kind" of German, from bricklayer to bureaucrat, from indusrialist to artist to Nazi. What he (and we) ended up with was the portrait of a nation. He called it *The Face of Our Time*. But of course portraits, even cumulative documentary portraits, are most often subjective. Rob-

ert Frank's bitter, personal view of America during the Eisenhower years gave Americans *The Americans,* a view, it seems, shared by very few and most were not ready to see. More recently, Chauncey Hare made a portrait of *Interior America,* pictures of neglected hearths, the hearts of seldom noticed communities, those shadowed by mines, mills, and refineries. *Interior America* is dedicated "For those who are awakening to their own authority." Hare's work is perhaps a more militant 1970s echo of Frank's lonelier, equally aliented vision.

Other national portraits are those that describe particular, even special, conditions within an aspect of society and thereby provide reflections to and of the larger society. Jacob Riis' photographs of New York City sweatshops in the 1880s and Lewis Hine's of immigrants reflected those who were not their literal subjects by implicitly positing the measure that might or could be taken on behalf of those suffering in the 1930s; this "posit" was given governmental clout when the Farm Security Administration commissioned such photographers as Walker Evans, Dorothea Lange, Ben Shahn, and Russell Lee to record Depression-era destitution in regions west and south of Washington, D.C., in dry, wrinkled, Dustbowl America. Those photographers also gave Americans a national/self portrait. Another unpleasant one.

Since the Industrial Revolution, the city has been the reigning metaphor (Dickens being among the first to notice) for culture and for those who evolved it. Photographers have therefore recorded and expressed cities and/or urbanism. Atget compiled Paris as the century turned. Abbott returned from there to New York where she was instrumental in giving this city its face for the '30s. Meanwhile— back in Paris—Brassaï brought to light the nocturnal underside of La Comédie Urbaine. Victorian houses in Boston in the early 1930s, Alabama storefronts in the mid-'30s, and New York City subway-riders in the late '30s, all by Walker Evans, hit veins running through our culture. Weegee's police-blotter shots went for the jugular.

Familyhood is probably the most commonly used metaphor (or euphemism) for nationhood. The *Family of Man,* exhibition, curated in 1955 by Edward Steichen, took that notion to its nearly ludicrous limit by proposing that humanity—in all of its races, classes, sizes, ages—is fundamentally "one." The very design of the installation anaesthetized all national or cultural differences and corroborated the mypoic view that poverty in the East looks like poverty in the

West, that love in the streets looks like toddlers holding hands in the forest, that a homeless infant resembles one in a pram. Photographers have very definitely shown us that even the capitalized "We" are not at one, and than even "benign" nations have bastard children. Our sense of who we are, what we belong to, who we take orders from, and who we want to be have often been shocked and changed by the mirrors photographers have held to our eyes. Diane Arbus' monsters *and* Cecil Beaton's peacocks conjoin to disprove the complacent myth of oneness. Eugene Smith's Minamata portraits and Arnold Newman's success stories, Larry Fink's farm people and Richard Avedon's brew of casual chic, Lewis Carroll's little girls and Robert Mapplethorpe's men at pain-and-play conjoin again and again and blast to smithereens the relentless, misguided optimism without which "oneness" cannot exist.

Lionel Trilling, in one of his essays from *The Liberal Imagination*, writes that:

That part of the mind which delights in discovery was permitted its delight by the margin that existed between speculation and proof; had the mind been able fully to prove what it believed, it would have fainted and failed before its own demonstration, but so strongly entrenched were the forces of respectable optimism and the belief in human and social goodness that the demonstration could never be finally established but had to be attempted over and over again. Now, however, the old margin no longer exists; the facade is down; society's resistance to the discovery of depravity has ceased; now everyone knows that Thackeray was wrong, Swift right. The world and the soul have split open of themselves and are all agape for our revolted inspection. The simple eye of the camera shows us, at Belsen and Buchenwald, horrors that quite surpass Swift's powers, a vision of life turned back to its corrupted elements which is more disgusting than any that Shakespeare could contrive, a cannibalism more literal and fantastic than that which Montaigne ascribed to organized society. A characteristic activity of mind is therefore no longer needed. Indeed, before what we now know the mind stops; the great psychological fact of our time which we all observe with baffled wonder and shame is that there is no possible way of responding to Belsen and Buchenwald. The activity of mind fails before the incommunicability of man's suffering.

By the 1960s the definition of family settled back into parochialism and we became sophisticated enough to recognize difference—in fact, we became obsessed by it: the difference between young and old, haves and have-nots. Many documentary photographers who matured during the '60s turned inward—away from the "outside

world"—toward "personal experience" in the '70s. They did so in order to understand their positions—as artists—within an ever more convoluted context. (As an aside: one of the first photographs one takes is of one's family, and one is not usually in it. Yet looking at it one cannot help but project into it, to those feeings that day about those people, to one's place among those people. . . . Since promiscuous shutterbugging was made possible by the Brownie and related inventions, we have been compelled to chronicle the family at all its stages, milestones, and events. Camera advertisements—Baby's first step, Bobby's first paper route, Susie's first marriage . . . —do more than anything else to drive this point home.) Nicholas Nixon's annual portraits of *Heather Brown McCann, Mimi Brown, Bebe Brown Nixon, and Laurie Brown,* Emmet Gowin's countless portraits of Edith Gowin, Duane Michals' preoccupation with his father, Richard Avedon's with his, Les Krims with his mother are but a few of the notable examples of contemporary photographers' self-implicating worlds. Arthur Freed's portraits of himself with Leslie, driving or arguing or whatever, rip the veil of the implied pictorial self to include the actual physical self within a family portrait (or family-type relationship), and here (I am not unaware) we come to the first mention of literal self-portraiture. James Collins' portraits of himself watching various beautiful women (the format usually a blowup, the scene a setup) have different formal roots—painting, commercial design, fashion—from those of Freed but they both are exploring the integrated pictorial self. Both men's photographs present highly personalized and erotic pictures of themselves.

The first, and most noticeable, formal element in (literal) photographic self-portraits is that, more often than not, the equipment *shows* (by equipment, I mean everything from the actual box, to the cords, to speed-blurs, to movement-blurs, to lighting, to setup, to positioning, etc.). This has both psychological and physical roots that, only recently, have been freed by the growing acceptance of photography as an art form as well as by the introduction of lighter, less obtrusive equipment. The fact itself, though, has far-reaching historical precedent and remains. In Germaine Greer's recently published volume on women artists, the illustrations point out that the majority of self-portraits executed by these forgotten painters were of themselves painting. Similarly, many photographers have had to struggle hard to establish their identities as artists. The number of self-portraits by photographers in which the subject is the photog-

rapher and his or her relationship to the camera is staggering. It is probably even safe to say that every photographer has made one. The response to and the performance by the photographer for his "own camera" is often quite bold and different from the performance-competition between photographer and "other" subject. However, as photography gains its hard-fought-for place in "art" and as "artists" include photography among their varied media, it seems obvious that the presence of "the equipment" will become subtler, and eventually only an element, like paint. Although it is much too facile a distinction, one could safely hint at the difference between photographers who make pictures and artists who are currently using photography, and one, if she were willing to step into even more treacherous waters, could even further suggest that self-portraiture among traditional photographers will continue to explore the role of the photographer in his or her world, whereas self-portraiture among artists using photography will continue to align with the more general, self-explanatory, or self-referential art issues of the day. However, one of the questions persistent in both kinds of photography is "where is the camera, where was the camera, and how was that problem solved?"

The obvious relationship between performance and self-portraiture is evident in the works. There are also political reasons for making self-portraits. For example, some women artists say that they trust their own views of themselves as subjects/objects much more than the way they have previously been photographed by men. To change that picture they have to make new pictures. The economic advantages as well as the potential spontaneity (who knows when the light will be perfect?) have always been pluses for using oneself as the subject. Carolee Schneemann's own photographs of her own performance are landmark achievements within this network of conditions, both as formal works of art and as documentation.

Among contemporary photographers, self-portraiture is a means to understanding oneself and one's world. The method is that of pictorial description of one's relationship to and reaction within one's own environment. These common explorations and descriptions make pictures that have much more of a story-telling psychological and political content than the formal self-portraits of earlier times. The photographers are much more involved with the "me" of their individual personalities than the "my" of their roles as photographers. It is a recent development that photographers view their per-

sonal lives as worthy of intimate sharing. The artist as the work of art was not necessarily an inevitability for photographers. Finally, for photographers, self-portraits provide a chance for the subject to have a visible organic relationship to the picture as the posture is being simultaneously created, conducted, and controlled by the poser. The subject is posing for the subject, and the results, rather than being narcissistic, are holistic.

The undisguised, unashamed role of the self in the art of the '70s is by now not arguable. From Joan Didion's personal and experiential (as opposed to empirical) journalism about the last fifteen years in America—to Chantal Akerman's movie about three days in the life of a young avant-garde Belgian film-maker, the line between portrait and self-portrait is fast being erased.

In the last few years many contemporary artists who use photography as a method for their autobiographies or self-portraits have made books, which include photographs, on the subjects of their lives. They are, again, for the most part books in which the subjects are exploring their positions in their families—actually more accurately they are reliving (this time the nightmare version) Baby's first step, Bobby's first paper route, Susie's first marriage. . . . The procedure is more shamanist than formalist—role-playing, disguises, transferral, and confession: Charles Simmonds' documenting his birth from the earth, Juergen Klauke, Hansik Gilbert, and Urs Lüthi dressing up as various kinds of men and women, Braco Dimitrijevíc's self-portraits after Rembrandt and Michuel Perez, Miller and Ringma's paparazzi self-portraits of themselves with such celebrities as Bella Abzug, Joseph Hirshhorn, and Angela Davis, Martha Wilson's autobiography, which ends with a photograph of herself as a baby in her mother's arms, Skinner box behind her, Larry Williams' book of his face and all of its possible manipulations and distortions, and Marcia Resnick's naughty, witty, nostalgic pictures, such as the one of herself kissing a doll dressed up as a television idol of her youth. Often, in these books, the authors are not their own photographers.

On the other hand, a question that Lucas Samaras asks himself in his autointerview in the *Samaras Album* is "Is it significant that you took the polaroids yourself? His answer: "I suppose so, I was my own Peeping Tom. Because of the absence of people I could do anything, and if it wasn't good I could destroy it without damaging myself in the presence of others. In that sense I was my own clay. I formulated myself, I mated with myself, and I gave birth to myself.

And my real self was the product—the Polaroids." Once again I need suggest the difference between photographers who are making pictures and photographers who are using pictures.

In the same way that national portraits provided their respective nations with self-portraits it follows that all of the available self-portraits could help determine new national portraits. Doubtless their sums would also provide an accurate self-portrait of photography, these histories being photography's biography. Photographers are a species, like birds. In fact they seem to be making the same kinds of catalogues that they began by making—records of specific personalities, which through additive deduction provide the common properties that separate races within species. These records are never generalized and the specific problem of identity is never a question of Gestalt perceptions on the part of observers. Only, the subjects (or means) have slightly altered to become quite literally "the self" rather than ourselves. Instead of illustrating Charles Darwin, Athena Tacha makes *Heredity Studies I and II* (1972) (photographs, biological and psychological of her mother, father, and two brothers, with text) and she makes *Expressions I* (1972) (a study of her facial motions). Instead of photographing American Indian artifacts, Sol LeWitt is making a catalogue (Sears Roebuck style) of all his possessions. He thinks of it as an autobiography.

Note

1. I would like to thank John Szarkowksi for telling me about these field guides to birds and for the idea of there being interesting differences.

20

Toward a Critical Pluralism

Andy Grundberg

I would like to propose a provisional typology of photographic criticism, based on its historical and contemporary practice, in an attempt to decipher and clarify its mission vis à vis the medium. To begin with, one can perceive two basic and dialectical approaches to the mission of criticism, which I would call the applied and the theoretical.

Applied Criticism is essentially practical, immediate, and directed at specific objects that we call "the work." It tends toward journalism and functions to "review" the work. Theoretical criticism, on the other hand, is ontological; it endeavors to tell us what photography's nature is. In this respect its references to specific photographs or bodies of photographs are tangential, even if they are intriguing. If applied criticism tends toward journalism, then theoretical criticism tends toward philosophy. In practice, of course, these two approaches can, and usually do, overlap.

The major modes of applied criticism, as I apprehend them, are based on models that pre-date or exist independently of photography. Perhaps the most basic, the most used and ill used throughout

Reprinted by permission from *Afterimage*, October 1980.

photographic history, resides in the notion of connoisseurship. In essence, connoisseurship as a critical instrument depends on the existence of an "educated eye"—an eye, in other words, that has surveyed the breadth and depth of the art and therefore is able to judge how a new work compares to the traditions from which it springs. Connoisseurship asks, "Is this good or bad?," an elementary question in the critical realm but one that the connoisseur is unable to go beyond. Connoisseurship's major flaw is that its judgments cannot be disputed except in terms of taste; the rudimentary theoretical structure latent in the connoisseur's values (e.g., "quality," "beauty," "the vintage print") is neither disclosed nor discussed.

A more useful critical mode is based on conventions established by art-critical and art-historical writings. Such an approach—really a locus of approaches—focuses on specific works or bodies of work and attempts to locate their esthetic temporality, to define their relationship to other art works (inside or outside the medium), to explicate their formal means and, generally, to place them within the context of art culture. This is comparable, in most respects, to conventional literary criticism, in which the text is examined either as an entity within a history of texts (as literary culture) or as an entity that defines its own esthetic field (as in New Criticism, a form of formalism).

The art-historical aspect of this approach has been fostered in photography by the rise of university graduate programs in the history of photography within traditional art-history departments. The art-critical aspect received its impetus from the photo/art crossovers of the '70s, and by the increasing attention paid to the medium by art magazines and by writers who are schooled in the traditions of painting and sculpture. One of the questions the former asks is, "How does this fit into the history of the medium as we know it?" The latter may ask, "On what terms does this operate? How does it claim our attention?" What is not asked in this sort of art criticism is whether the work is socially useful, whether it reflects the culture of which it is a part, or whether it critiques that culture.

Another model, which is often used in art criticism though not coterminate with it, is the psychological or biographical. Here the work is seen as revelatory of its creator's character or life, and vice versa. Biographical criticism merely posits a connection between the appearance of art and the circumstances of its maker. A more psychological approach finds in the work symbols that reveal hitherto

unknown traits of its maker. The interpretation of these symbols can be Freudian, post-Freudian or whatever. Such criticism asks, "How do the artist and the art intersect?" Its great Achilles' heel is intentionality; too often we are led to accept an account of the art as told by the artist—Edward Weston comes to mind—when in fact that account deserves skepticism.

Yet another model brings political and cultural issues into the realm of art photography. One subspecies is Marxist, another post-Marxist. This model has the virtue of functioning like alternating current: it can critique the work by applying political and cultural criteria, and it can critique the culture by applying the work. In some cases it can be a radical critique, as we have seen with Susan Sontag, or it can be normalized under the scholastic banner of American studies or anthropology. In any case, photographs are viewed as tools for uncovering social realities.

Recently the prospect of a science of languages has given rise to an ancillary critical mode, based on linguistics and its branches, which seeks to unravel the photograph's hidden "code" or structure. To the extent that the meanings it reveals have a culturally radical content, such criticism is another form of political/cultural critique. Its most convincing advocate has been Roland Barthes, although the photographic examples analyzed in Barthes' writings are limited to such images as an ad for Italian food and a politician's campaign poster.

These are some of what I would call the acceptable modes of applied photographic criticism, each based—implicitly if not explicitly—on some system of value or theory, and each addressing itself from that base to "the work." There are others that constitute debased modes and deserve to disappear. One of these proceeds from the feeling of the critic at the time he or she viewed the work in question. Usually laced with the first person singular, such criticism abjures analysis and concentrates on free-floating, *ad hoc* perorations and recommendations. Such a mode asks no questions because it lacks the foresight to formulate them.

Another debased form I call the adjectival mode, simply because word play is what appears to occupy the critic's mind more than the work itself. This is a tendency, I suspect, to which all writers who love language fall prey. Sometimes it is just too easy to string out adjectives, or to make phrases in multiples of three.

All of the modes broached so far are obviously linked to critical

traditions outside the medium; none can claim exemplary status as photography's most-favored language. Historically, though, there has been at least one practical attempt to find a critical mode uniquely suited to a unique art. I am thinking of Beaumont Newhall's *History of Photography*, which represents still another applied critical approach, the technological. While Newhall is never explicit about it, his history is ordered according to the development of processes and materials, which are seen as enabling and even enforcing certain new means of expression. One could argue with some validity that this identification with the technological is part of the way Western history as a whole is taught—that is, as the history of science— but I believe Newhall was attempting something more profound. He was, I think, formulating a critical approach that would account for photography's existence as an esthetic instrument based on the machine.

Other than Newhall's attempt, theoretical criticism has been the level at which the search for a critical language indigenous to photography has developed. Ironically, most of these theoretical attempts rely on paradigms from other fields, be they poetic, fictional, or linguistic. (Interestingly, there are more examples of paradigms from literature and language than from the visual arts.) Theories that are nonparadigmatic usually are based on the history of photographic practice—John Szarkowski's idea of pointing, or Rosalind Krauss' idea of the cut.

We now arrive at a question that is central to our current perception of criticism's mission: given the wealth of critical modes and models available to both applied and theoretical criticism, why is it that we have persisted in our expectation of finding a critical language mated perfectly to the project of discoursing about photographs?

Let me be clear: I am not begrudging theoretical criticism in general or ontological premises in specific. Rather, I am wondering whether the Holy Grail exists, and whether we should go on looking for it.

In 1937 a Bauhaus refugee named Laszlo Moholy-Nagy came to this country to set up a school based on some rather peculiar ideas. One was that each medium has its own nature, depending on its materials and first principles, and that the project of art is to investigate that nature. Another of his ideas was that photography is a unique and independent medium, and that as such it requires its

own full-scale formal investigation. The school Moholy founded became the Institute of Design in Chicago, an institution that is in large part responsible for the exalted existence of photographic education in the United States today. At the same time, he set in motion forces that would make the years from World War II to today an era increasingly devoted to photographic formalism.

It is possible to suspect that this formalist era evolved in response to certain needs of the photographic organism. One need would be to prove its seriousness as a medium of esthetic expression, especially in relation to the other, less mechanistic visual arts. A second would be to understand, through exploration and experimentation, its own capabilities. Together these needs brought photography into line with Modernism's historical imperatives.

At the same time that formalism enlarged the possibilities of certain aspects of photography, it purged certain other aspects from consideration, even though they were already part of the photo-historical tradition. These casualties included an overt orientation toward subject matter as content, as is the case in most portraits; the Stieglitzian concept of "equivalence" as fostered by Minor White; and seductiveness as a pictorial virtue. Even accessibility came to be looked on askance.

Today there are signs that the dominion of formalism in photography is on the wane, and that as a result we are entering a more pluralistic climate, of the kind that painting experienced in the past decade. Some work I have seen recently moves past conventionally defined formal issues to engage new notions of content and meaning; other work seems to reinject and revivify those aspects of photographic tradition previously purged.

As color has attained status as the formal issue of our day, accounting in part for the large numbers of still lifes being shown of late, it has also been put to new uses—new in the sense that they have been reborn. I am thinking of color used decoratively by people such as Jan Groover, Harry Bowers, Steve Collins, and even Michael Bishop; of color used for its documentary value, as in some of Stephen Shore's and Wayne Sorce's work; and of color used in a picturesque or lyrical fashion by the likes of Joel Meyerowitz, Joe Maloney, Mitch Epstein, and Len Jenshel.

Other aspects of contemporary practice that seem outside the rubric of formalism include photographic narratives that combine texts and images, such as Robert Heinecken's recent SX-70 work; texts in

251

photographs, in which pure "photographicness" is no longer at issue, as in the work of Paul Berger, Victor Schrager, and Tom Barrow; and softer, more personally inflected styles—edging at times into pictorialism—as in the recent work of Lee Friedlander, Linda Connor's *Solos*, the rash of Diana-camera pictures shown of late, and the photographs of Elaine Mayes and Phil Perkis.

One also finds a kind of "New 'New Topographics' " emerging, one in which people not only appear but take precedence over the landscape that the photographer nominally controls; I'm thinking of Nick Nixon's recent pictures, and Joel Sternfeld's American landscapes. Lastly, though my list is not meant to be inclusive, there are photographs that function as performance art, since part of their intrinsic interest is that they document some activity of the photographer—as in John Pfahl's, Les Krims's, Carl Toth's, and John Divola's pictures. This kind of documentation seems to relate directly to art-world antecedents, a relationship that automatically places it outside a strictly formalist sphere.

These aspects of contemporary picturemaking activity seem to me divergent enough to comprise the first signs of a more pluralistic period in the consideration of photography as an art. In such a climate, it would seem logical to posit, criticism should be pluralistic also. I'm not suggesting that every critic learn to switch hit; only that the critical atmosphere should engender diversity. Just as the art world no longer needs the monolithic presence of a Clement Greenberg, photography no longer need concern itself with inventing a single mode of discourse—even if an adequate indigenous model existed, which it doesn't.

Let me summarize a few of my feelings:

I believe that photography does not need to search for a critical language uniquely suited to it and it alone, and that the notion of such a language, engendered by a formalist perception of the medium, is hubristic on photography's part.

I believe that certain models proposed in recent years as uniquely suited to the medium can be useful in specific cases but fail to account for the variety of photographic practice in the medium as a whole.

I believe that the level of photographic discourse can be improved merely by recognizing the models on which it is based.

I believe that criticism should be measured by the degree to which it illuminates the work it considers, and not by the degree to which

the work is made to fit into a critical theory. We should recognize that an incomplete, peripheral, and unsatisfying critical account has the virtue of returning us to the work. (I do not mean this last, apparently contradictory sentence to sanction bad criticism; the elementary attributes of good criticism—among them style, imagination, and logic—must be present before we can appreciate its applications.) Criticism's task is to make arguments, not pronouncements.

And I believe that a pluralistic critical climate is the best we can hope for, and that such a climate is in fact being created within photography today.

Contributors

Thomas F. Barrow is a photographer and professor of art at the University of New Mexico.

Shelley Armitage is a writer, critic, and graduate student at the University of New Mexico.

William E. Tydeman is a graduate student of the history of photography.

John Szarkowski is director of the Department of Photography at the Museum of Modern Art. He is the author of numerous works on photography including *The Photographer's Eye* and *Looking at Photographs*.

Nathan Lyons is a photographer, writer, and director of the Visual Studies Workshop in Rochester, New York.

Hollis Frampton is a filmmaker, writer, and a professor in the Department of Media Study, State University of New York, Buffalo.

Robert Adams is a photographer and writer. His most recent book is *Beauty in Photography: Essays in Defense of Traditional Values*.

William Jenkins is a photographer and writer. He is associate professor of art at Arizona State University.

Lewis Baltz is a photographer. His most recent book is *Park City*.

Joel Snyder is associate professor of humanities and of art and design at the University of Chicago.

Neil Walsh Allen is a producer of educational audiovisual materials and has designed permanent exhibits on the history and applications of photography for the Smithsonian Institution.

Sanford Schwartz lives in New York City.

Owen Barfield is the author of many books on English language and literature, among them *Poetic Diction: A Study in Meaning* and *Worlds Apart: A Dialogue of the 1960s*.

Rosalind Krauss is coeditor of *October* magazine and the author of, among other works, *Passages in Modern Sculpture*.

Susan P. Compton is an English art historian.

Dennis P. Grady is an instructor in photography at Buffalo State University.

Daniel A. Lindley, Jr., is an associate professor of English at the University of Illinois, Chicago Circle.

Eugenia Parry Janis is professor of the history of art at Wellesley College.

James C. A. Kaufmann is a member of the American Studies Department at the University of Iowa.

James Hugunin is a critic and editor of *The Dumb Ox*.

Carl Chiarenza, a writer and photographer, is professor of the history of art at Boston University.

Ingrid Sischy is editor of *Artforum*.

Andy Grundberg is the picture editor of *Modern Photography* and a regular contributor to the *New York Times*.